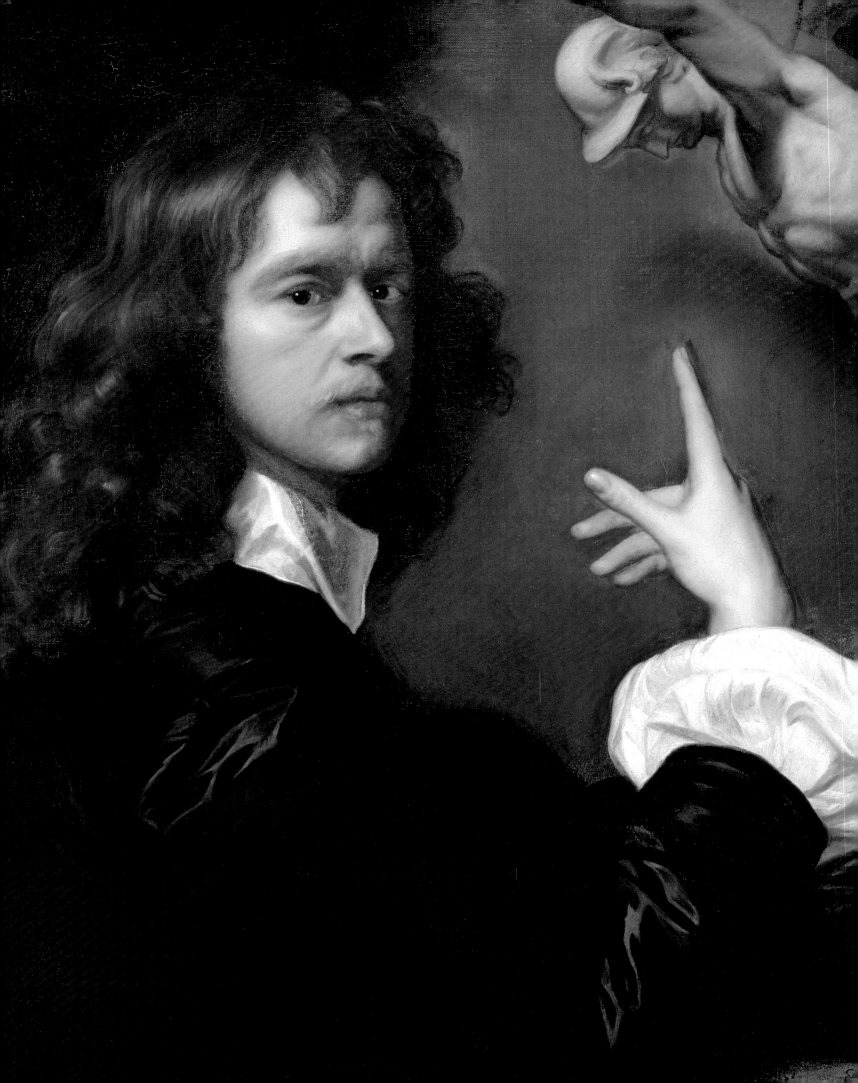

PORTRAITS OF
The English Civil Wars

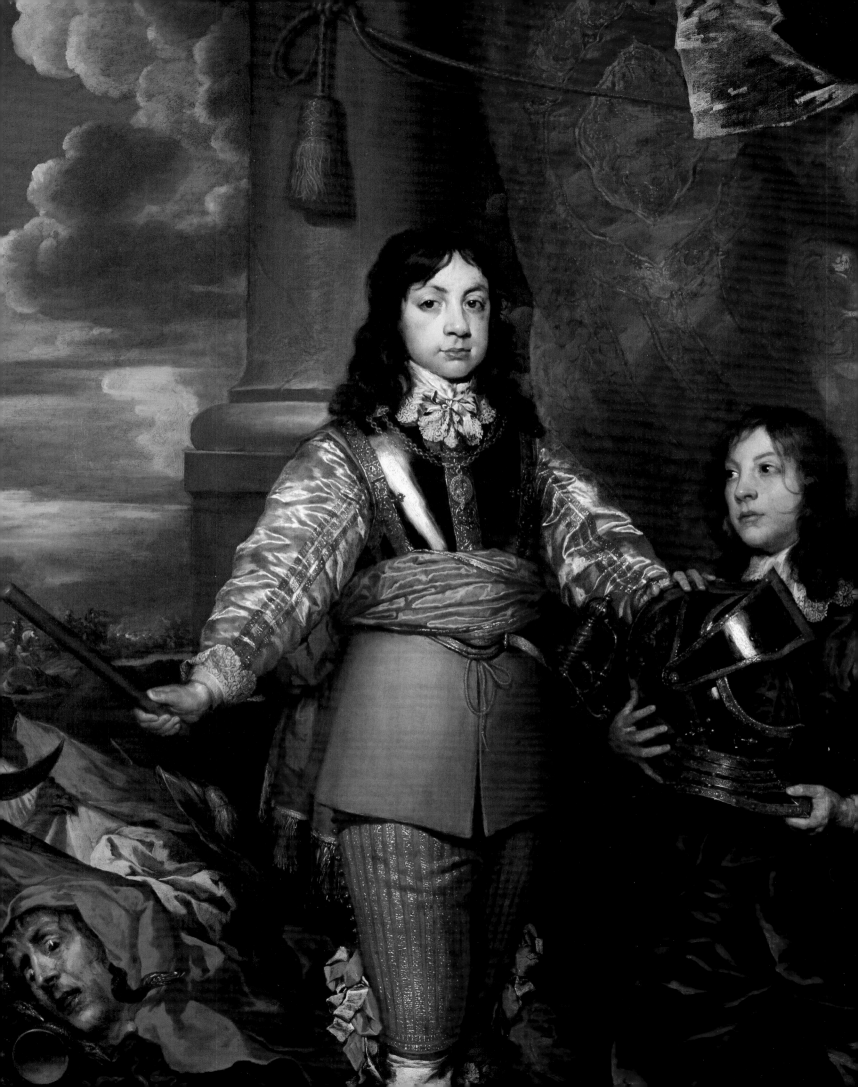

THE FACE OF WAR

PORTRAITS OF
The English Civil Wars

Angus Haldane

UNICORN

PAINTINGS

eservations

GEORGE MONCK, 1st DUKE OF ALBEMARLE (1608–70)

PORTRAIT AFTER SAMUEL COOPER

ROYALIST, PARLIAMENTARIAN AND COMMONWEALTH ARMY OFFICER

'Monck was ravenous, as well as his wife, who was a mean, contemptible creature. They both asked, and sold all that was within their reach, nothing being denied them for some time, till he became so useless, that little personal regard could be paid him … the king thought it fit to treat him with distinction, even after he saw into him, and despised him.' [1]

A vigorous soldier and statesman, Albemarle fought for both the king and Parliament. He defended the Commonwealth, and in his later years served as an advisor for King Charles II. He is the perfect embodiment of the survivor, the political chameleon who successfully predicted the changing fortunes of various individuals and circumstances. The sources are unkind to Albemarle but they are also consistent on both his military talent as well as what many perceived as a venal nature, motivated by a desire to monetise almost any situation.

Albemarle was the second son of Sir Thomas Monck. He joined the army and gained valuable military experience during the English expeditions to Cadiz in 1626, La Rochelle in 1627 and the siege of Breda in 1637. He displayed great courage and military skill and, in 1641, was sent to Ireland to suppress the rebellion. He was recalled to England to take part in the English Civil Wars on the royalist side, but was captured at the siege of Nantwich in 1644 and spent the next two years in the Tower of London, during which time he wrote his *Observations on Military and Political Affairs*. He subsequently served Parliament under the command of Cromwell and took part in the campaigns in Ireland and Scotland. He briefly held a naval command.

There are no surely identifiable portraits of Albemarle during the period of the Civil Wars. The earliest identifiable portrait would appear to be the miniature by Hoskins executed in 1658. The present work derives from a miniature portrait by Samuel Cooper (Duke of Buccleuch and Queensberry), which probably accounts for why the artist has painted an oval as an internal framing mechanism. Five unfinished sketches of Monk by Cooper are in the Royal Collection. These must have been painted *ad vivum* in order for Cooper to work up finished miniature versions. The purpose of the miniature portraits must have been for intimate gifts whereas the purpose of the larger compositions was, presumably, for the wider dissemination of the sitter's image and the raising of his diplomatic profile, as well as for exchange amongst the nobility.

A contemporary account describes Albemarle as 'of the middle size, of a stout and square-built make, of a complexion partly sanguine and partly phlegmatic … his face is fair, but somewhat wrinkled from age … his hair is grey and his features not particularly fine or noble'.[2] It is perhaps illustrative of Albemarle's gruff, unassuming character that he was unconcerned in the early stages of his life and military career by having his portrait painted. It was perhaps also a politically astute decision for a man who had always displayed caution when revealing where his loyalties lay.

The present portrait shows Albemarle as a professional soldier and as a loyal Royalist since he wears the sash of the Order of the Garter, into which he was installed in 1661 by Charles II. In the present work the blue pigment has oxidised to leave the sash looking a rather jaundiced yellow/green colour. His lawn collar is rather askew, giving the impression of a man who has put on his armour in a hurry. This could be the fault of the copyist, however the asymmetry might also be a deliberate attempt to show how the lines of the collar might change when the sitter turns his head and ruches the linen with his double chin.

1 Burnet, p.66
2 Reynolds, pp.138–39

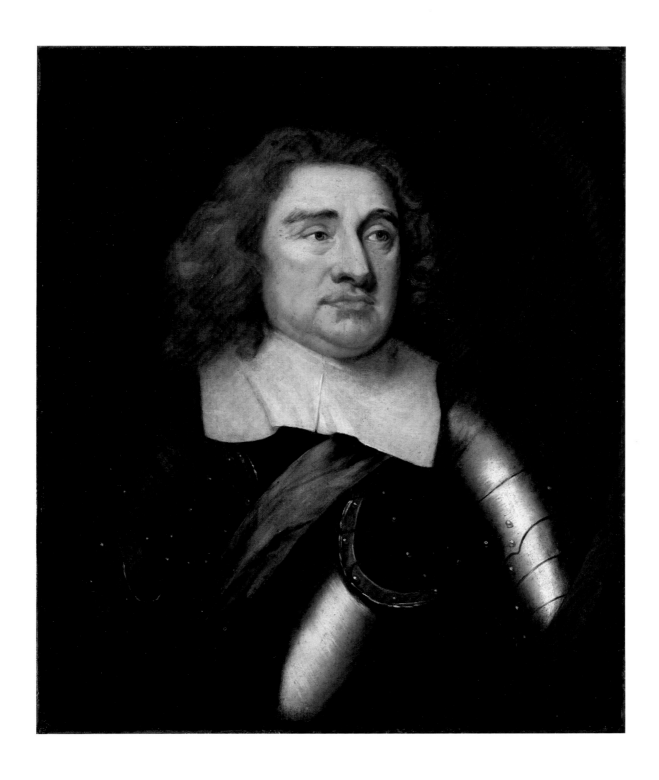

HENRY FREDERICK HOWARD, 15TH EARL OF ARUNDEL (1608–52)

PORTRAIT BY SIR ANTHONY VAN DYCK

ROYALIST OFFICER

'A broken tho' great estate and a distracted family' [1]

A loyal patriot to his king but a manipulative villain to his undeserving mother, the Earl of Arundel seems to have spent his life convinced of his own rightness.

The sitter was the son of Thomas Howard, 14th Earl of Arundel, 'The Collector Earl' and his wife, Lady Alathea Talbot. It was his fortune to be born to one of the most cultured and well-travelled members of the English court who largely instigated what would later become known as The Grand Tour. Although he shared his father's passion for connoisseurship and art collecting, it seems to have been the sitter's misfortune to be overshadowed by the boundless curiosity, exotic travel and chivalric nature of his father.

The motto *droit et avant*, inscribed on the stone ledge, translates as 'right and forward'. Presumably this motto was intended to mean that one should be convinced of the correct course of action before moving ahead with it. Given the sitter's martial dress, the motto would seem to imply that he is ready for battle on the side of rightness and Charles I. However, his biography indicates that *droit et avant* was as much a personal mantra for the pursuit of his own interests.

In 1626 Arundel married Lady Elizabeth Stuart. This marriage was arranged without the knowledge of the king who had intended Lady Elizabeth to marry another courtier. Despite this indelicacy, Arundel seems to have escaped significant censure. Some years later, he was sent to the Tower of London for having engaged the Earl of Pembroke, during a parliamentary committee session, first in a battle of words which quickly escalated to the use of fists.

At the outbreak of war, Arundel was one of the first lords to sign a promise of fidelity to the king's 'person, crown and dignity', and he served with the king at the Battle of Edgehill. He served as a member of the king's Council of War in Oxford and whilst there, in a glorious moment of court pageantry, he was admitted Master of Arts alongside the Duke of York and a train of other Royalists. As an aside, it is recorded that Charles enjoyed awarding a large number of honorary degrees, until the Univeristy of Oxford persuaded him to stop. [2]

His father's declining health led him to travel to see him in Padua in 1645, where The Collector Earl died the following year. Even before the Civil Wars, the sitter's father owed debts of nearly £125,000 and, on succeeding his father to the Earldom in 1646, Arundel refused to return to London for fear of creditors. This effectively removed him from further involvement in the Civil Wars, making this bold statement of martial strength more poignant than believable. In clear contravention of his father's will, Arundel set about trying to seize all his mother's entitlements, jewels and property. He placed spies amongst her servants, accused her of popery and persuaded anyone and everyone to speak against her. By extending legal actions against his mother, he hoped that she would die before the conclusion of proceedings. Fate thwarted this less than filial behaviour, and he predeceased his mother who was allowed to keep her property.

It was common practice for courtiers to emulate the fashion of clothing and hairstyle of their monarchs and Arundel's hair falls in the spaniel-like curls accompanied by a neatly manicured beard by which Charles I and his Royalists have long been recognised over the centuries.

The quotation above, spoken by Sir Edward Nicholas on the sitter's death, illustrates the sense of a great family laid low. Notwithstanding this, there is a great deal of character and hauteur to this portrait. Van Dyck has employed one of his conventional poses, casting the sitter in armour with his helmet resting on a stone ledge. The composition would seem to derive from Van Dyck's portrait of King Charles I, which also hangs at Arundel. In choosing such a composition, the sitter may have been keen to align himself, pictorially, with his monarch.

Van Dyck has energised the composition by forcing the sitter's baton into the viewer's space, emphasising this with his subtle use of shadow. It is striking, however, that the sitter seems ill at ease. The body seems a little too small for the head, which is ironic given the sitter's remarkable opinion of himself.

1 Sir Edward Nicholas – see Barnes, De Poorter, Millar and Vey, IV.12, p.438
2 Exh. cat., London, 1983–84, p.16

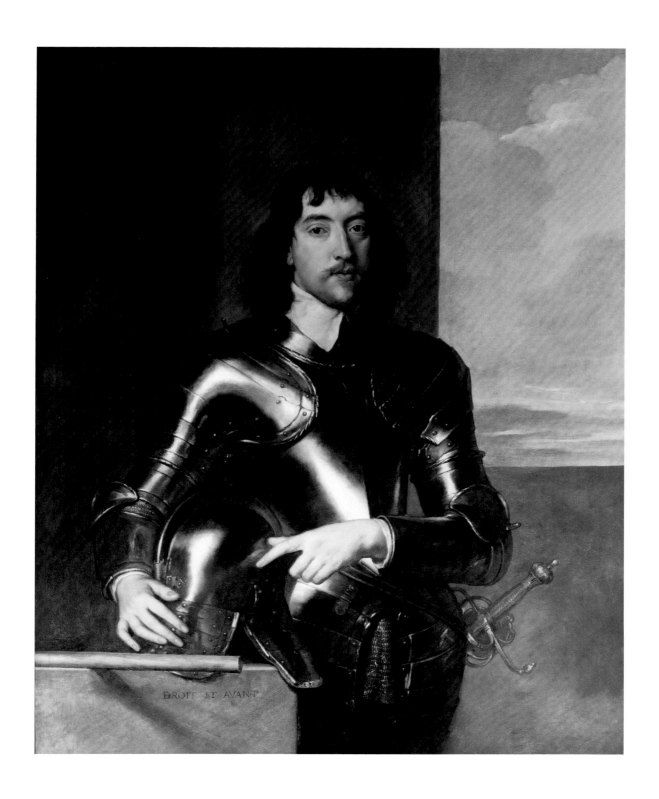

DROIT ET AVANT

JACOB ASTLEY, 1st BARON ASTLEY OF READING (1579–1652)

PORTRAIT ATTRIBUTED TO ADRIAEN HANNEMAN

ROYALIST INFANTRY OFFICER

'*Sir Jacob was an honest, brave, plain man, and as fit for the office he exercised, of
Major General of the Foot, as Christendom yielded.*'[1]

A stley remains one of the best known figures of the Civil Wars. He was respected by both Royalists and Parliamentarians for his military ability, as well as for his honest and brave loyalty to a cause in which he believed. He rose above the political squabbling which prolonged the conflict and seems always to have inspired devotion in those he led.

Astley was the son of Isaac Astley, of Melton Constable, Norfolk, and his wife, Mary Waldegrave. He fought under Sir Francis Vere in the Netherlands and joined the household of Queen Elizabeth of Bohemia. He is said to have instructed Prince Rupert in the art of war, and he must have been dismayed at the erratic and irresponsible fashion in which Prince Rupert at times led the cavalry that was supposed to protect and support his infantry regiments.

During the Bishops' War, Astley held the important post of Sergeant Major General in the Army of the North and by the outbreak of the Civil Wars he had become a key member of the king's council. At the Battle of Edgehill in 1642, during which he himself was wounded, Astley commanded a force of 10,000 men. He is perhaps best known for his moving prayer before the engagement: 'O Lord! Thou knowest how busy I must be this day; if I forget thee, do not thou forget me … March on, boys!'.[2]

The king appointed Astley as Governor of Oxford, but he was replaced in this capacity so that he was free to lead the army of foot to Reading and then to the siege of Gloucester. At the Battle of Naseby on 14th June 1645, he commanded the main body of infantry in the centre. His flank was left exposed by Prince Rupert's uncontrolled cavalry and, despite heroic resistance, his regiment was forced to surrender. Astley spent some time imprisoned in Warwick Castle and Leeds Castle, but eventually he was able to lead his retirement in relative peace.

Painted in 1640, this luminous portrait captures much of the sitter's character. His beard is neatly manicured and his grey hair coiffured in a style which recalls contemporary portraits of the king. There are touches of flamboyance indicative of the sitter's social position. His doublet is expensively embroidered in gold with the motif of a trailing vine, his breastplate is ornamented with gold studs and elaborate ends to the leather straps, and his stance, with an arm akimbo, is one of hauteur. Fundamentally, however, the iconography of this portrait is understated and if one compares the portrait of John Byron, 1st Baron Byron with that of Astley, the distinction is clear between the glamour of the cavalry officer and the subdued nature of the infantry commander. Cavalry commanders were, by their nature, men of wealth and standing. Astley, by contrast, was a man of more modest means. Although the style and handling is close to that of Hanneman, the painting is not of the highest quality and we do not know for sure who painted this portrait. Astley's choice of artist may have been determined either by an innate sense of modesty or, more persuasively, by a financial cost.

The muted nature of this portrait may also have been determined by a simple factor of where, geographically, it was painted. Sir Jacob Astley's family came from Melton Constable in the heart of Norfolk, a county with strongly Puritan tendencies and one associated with the emergence of radical sects such as Anabaptists, Brownists and the Family of Love. Norfolk was a county remote from London, with very few important peers. Only the Arundel family at Castle Rising had any prominence at court in the early seventeenth century. By the outbreak of war, Thomas Arundel, Earl of Howard, was an elderly man who chose to accompany Queen Henrietta Maria to exile in France rather than take part in hostilities.

A consequence of this was that the landed gentry, such as the Astley family, was the dominant political force. The gentry relied upon sea trade for much of their wealth and the issue of 'ship money' had been viewed with particular dislike. In 1638 the Sheriff of Norfolk was the sitter's cousin, Sir Francis Astley. He had been required to raise £7,800 in ship money, and had subsequently written to the Privy Council complaining of his difficulty, and distaste, in achieving this. Notwithstanding these tensions, Sir Jacob remained a loyal follower of the king. His two nephews, however, Sir Isaac and Sir Edward Astley, chose to support the parliamentary cause, offering one of many examples of families divided by the Civil Wars.

1 Clarendon, 1826, Vol. III, p.358
2 Warwick, p.229.

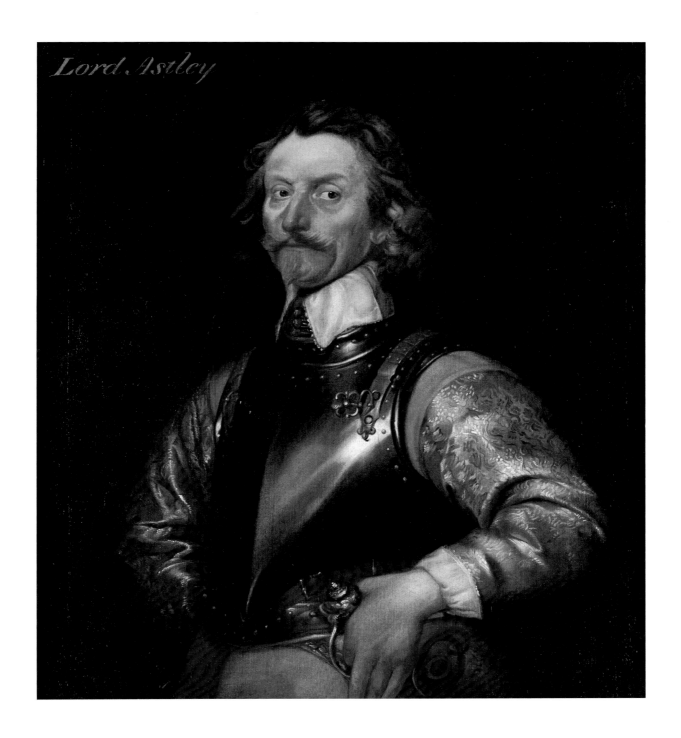

Lord Astley

JOHN BELASYSE, 1st LORD BELASYSE OF WORLABY (1614–89)

PORTRAIT BY SIR ANTHONY VAN DYCK

ROYALIST CAVALRY COMMANDER

'A gallant gentleman, of much honour and courage' [1]

T he sitter was 22 years old when he was immortalised by Van Dyck with his distracted gaze, his swagger and the suggestion of effortless confidence. Van Dyck portrayed him as the archetypal romantic hero, part-adventurer, part-soldier, part-elegant courtier. Certainly there cannot have been many men who could have received a shot to the head but recovered within a month, embraced espionage, and between all of this still found time to meet Pope Innocent X and serve as Governor of Tangiers.

John Belasyse was the second son of Thomas, 1st Viscount Fauconberg and his wife, Barbara, daughter of Sir Henry Cholmondeley. He was an active royalist commander and raised six regiments of horse and foot at his own expense. He fought at the battles of Edgehill, Newbury, Naseby and the sieges of Reading, Bristol and Newark, suffering injuries on a number of occasions. He was Lieutenant-General of the king's forces in York and Nottingham, Governor of York and Newark, and General of the King's Horse Guards.

During the Protectorship of Cromwell, Lord Belasyse was a member of The Sealed Knot, a secret organisation which sought to restore the king to the throne. Some years after the Restoration, Belasyse recounted to Pepys how King Charles II had once sent him a secret message 'in a Slugg-bullet, being writ in cypher and wrapped up in lead and swallowed. So the messanger came to my Lord and told him he had a message from the king, but it was yet in his belly; so they give him some physic, and out it came.' [2]

At the Restoration he was appointed Lord Lieutenant of the East Riding and Governor of Hull. He was implicated by Titus Oates in the Catholic conspiracy, but was cleared when it was shown that Oates had lied. He found favour with James II, who made him first Lord Commissioner of the Treasury. He married three times, firstly Jane, daughter of Sir Robert Boteler, secondly Anne, daughter of Sir Robert Crane, and thirdly Anne, daughter of Sir John Pawlet, 5th Marquess of Winchester.

From 1671 until his death he lived at Whitton near Twickenham where Samuel Pepys visited him and was impressed by the large collection of paintings.

This fine portrait demonstrates the natural flamboyance of royalist portraiture. The slashed doublet with white lace and crimson satin emphasises the sitter's vanity and importance. The sitter touches his sash with affection. This red silk sash has often been thought to indicate his membership of the King's Lifeguard, thus endorsing his loyalty to the king. Certainly, during the Civil Wars, royalist officers were reputed to wear red sashes in the battlefield and the Parliamentarians, a reddish-orange one. However, there seems to have been no formal military uniform and this red sash may simply be a symbol of wealth. A half-length portrait by Van Dyck seems to have cost in the region of £20 [3,4] and it is interesting to note that the costume worn by Van Dyck's sitters often vastly exceeded the cost of the portrait itself. This outfit would certainly not have been appropriate for combat.

1 Clarendon, 1826, Vol. IV, p.615 (under Appendix C)

2 Samuel Pepys, diary entry, 4th February 1665 – see Wheatley, 1918, Vol. IV, p.326

3 Brown, p.162

4 £20 in 1640 is the equivalent of approximately £2,300 in modern currency. This has been calculated using the currency converter available from the National Archives, which provides data until 2005, and then by applying an allowance for inflation based on data from the Bank of England.

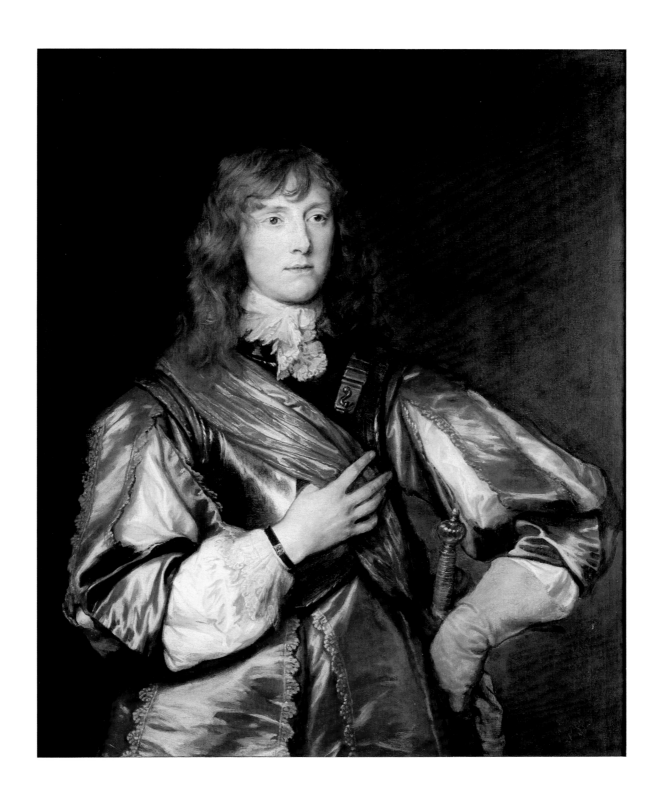

JOHN BRADSHAW (1602–59)

PORTRAIT BY CIRCLE OF WILLIAM DOBSON

PARLIAMENTARIAN LAWYER AND REGICIDE

'A stout man and learned in his profession' [1]

'A man of execrable memory, of whom nothing good is remembered' [2]

B radshaw seems to have been a man of talent and ambition. However, he will forever be remembered for the dubious distinction of having been the only Englishman to pass a sentence of death upon his monarch. Certainly, the two antithetical quotations above illustrate the hatred and admiration, in equal measure, which Bradshaw inspired for his part in the trial and subsequent execution of King Charles I.

On 10th January 1649, he was appointed as Lord President of the High Court of Justice established to try King Charles I. The trial was marked by oratorical duelling between Bradshaw and the king, with Bradshaw frequently frustrated by Charles's refusal to enter a plea. Perhaps as a result of this, Bradshaw did not allow Charles to address any final words to the court. On the final day of the trial Bradshaw wore a scarlet robe, noted by some as a sign of *hybris*, and there have been persistent rumours that he wore a fur hat lined with steel to protect him against potential assassins. A hat which fits this description, and which is said to be Bradshaw's, is in the Ashmolean Museum, Oxford.

After the king's execution, Bradshaw was elected President of the Council of State which acted as the executive governing body in England and which replaced the monarchy and the House of Lords. Tensions between Bradshaw and Cromwell increased during the Commonwealth and Protectorate and, from 1654, he seems to have held no official role. He died in October 1659, a fact which allowed his living body to escape the punishment and mutilation which was delivered upon his exhumed corpse. In 1661 Bradshaw's corpse was displayed in chains on the gallows at Tyburn, together with those of Cromwell and Ireton. Their bodies were then beheaded and the heads displayed on spikes at Westminster Hall.

This engaging dual portrait is likely to have been painted *circa* 1650, shortly after the king's execution, and shows Bradshaw (left-hand side) accompanied by the Rev. Hugh Peters (right-hand side). It seems to be the only extant portrait in oil of the sitter. Stylistically, this portrait is not by Dobson, who had died in 1646, and who is unlikely to have painted two men of such puritanical spirit so vocally opposed to the king. Nevertheless, the artist would appear to be an English follower of Van Dyck. He has chosen to depict his sitters with their faces turned three-quarters; Peters engaging the viewer whilst Bradshaw looks at Peters. This arrangement is sophisticated and it lends the work a conversational and intimate quality. The landscape format of the double portrait is both unusual and slightly awkward, with both sitters cut off at the waist and it is possible that the artist originally intended to paint a three-quarter length composition.

Bradshaw is dressed in simple clothing, with un-coiffured hair and beard. He is the sartorial embodiment of modesty and the puritanical spirit, and his eyes do not meet the viewer's gaze. One wonders if royalist sympathisers would view this as a sign of guilt, in contrast with Parliamentarian supporters who might see it is as the mournfulness of necessity.

[See No. 50 for a discussion of the Rev. Hugh Peters]

1 Whitelocke, p.686
2 Fuller, p.70

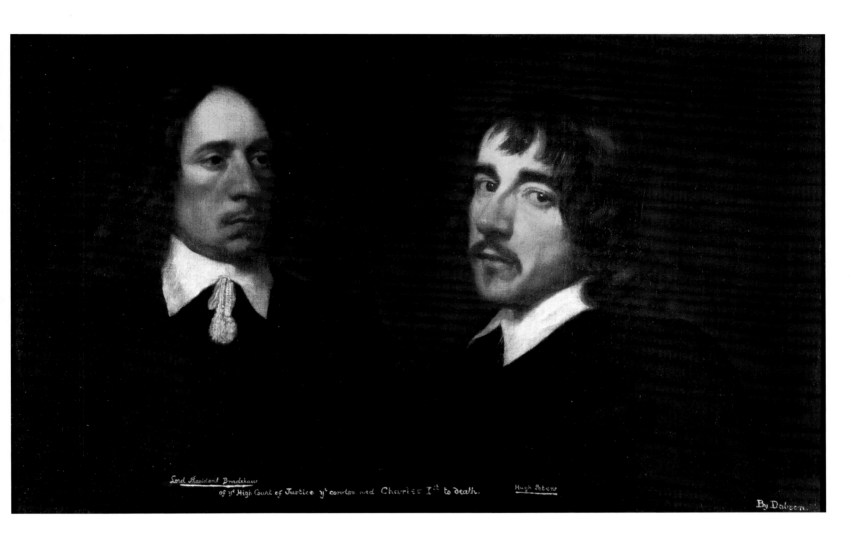

Lord President Bradshaw
of ye High Court of Justice yt condemned Charles Ist to death. Hugh Peters

By Dobson.

GEORGE DIGBY, 2ND EARL OF BRISTOL (1612–76)

PORTRAIT BY JUSTUS VAN EGMONT

ROYALIST COUNSELLOR AND CAVALRY COMMANDER

'Single against the world' [1]

Digby was a man who reached the end of the Civil Wars with considerably fewer friends and admirers than with which he had started. He consistently managed to position himself to good advantage but could always be relied upon to squander whatever capital he had accrued, only to re-acquire it with uncanny ease. He was a man who seems to have displayed brilliance, naïve ineptitude and slippery charm in equal measure.

The sitter was the son of John Digby, 1st Earl of Bristol and his wife, Beatrix, daughter of Charles Walcot. He entered Magdalen College, Oxford, in 1626 and then travelled abroad. In 1632 he married Anne, daughter of Francis Russell, 4th Earl of Bedford. He served as an MP for Dorset in both the Short and the Long Parliaments. He supported the impeachment of Strafford but did not countenance the subsequent bill of attainder against him. Digby became increasingly drawn to the king's cause and at the Battle of Edgehill led the cavalry charge on the left wing. After the death of Lord Falkland at the Battle of Newbury, Digby was appointed to the post of Secretary of State and given a seat on the Privy Council. He was part of the intimate council of King Charles I, which also included Edward Hyde, Lord Culpeper and Prince Rupert. Digby succeeded in losing the trust of each of these men in turn. The sources seem to indicate that this was due to his habit of undermining each of these men's reputations to the king. There may also have been a professional jealousy between Prince Rupert and Digby as the main commanders. Nevertheless, the result was to leave the king increasingly isolated. Digby is generally blamed for the defeat at the Battle of Naseby in 1645. A few months later, Prince Rupert was forced to surrender Bristol, as a consequence of which he was dismissed from his post and Digby appointed as Lieutenant General of the king's forces north of the Trent. He was eventually defeated at Sherburn in Yorkshire, after which he fled, not to return until the Restoration when the same pattern of extraordinary favour, luck and fall from grace repeated itself.

This portrait may have been painted in France in 1653 where the artist, Justus van Egmont, was a court painter. The sitter's armour is particularly flamboyant and is illustrative of his social standing. Although it is unlikely that the armour is damascened, which was the technique of inlaying silver or gold into a steel background, it is probably fire-gilded, which was still an expensive process. The vignette of the engagement in the background is interesting for the details of seventeenth-century 'battle-craft' which it shows, namely the advance of musketeers followed by pike men, accompanied by detachments of cavalry on the flanks.

By 1653, Digby had recently acceded to the earldom and had somehow persuaded the exiled Charles II to make him a Knight of the Garter. At this time Digby was serving with the French army as Lieutenant General, a role he held until the next inevitable instance of grand offence, the distinguished victim of which was Cardinal Mazarin, Chief Minister to Louis XIV, leaving him, truly, 'single against the world'.

1 Public Records Office, SP 16/510/74

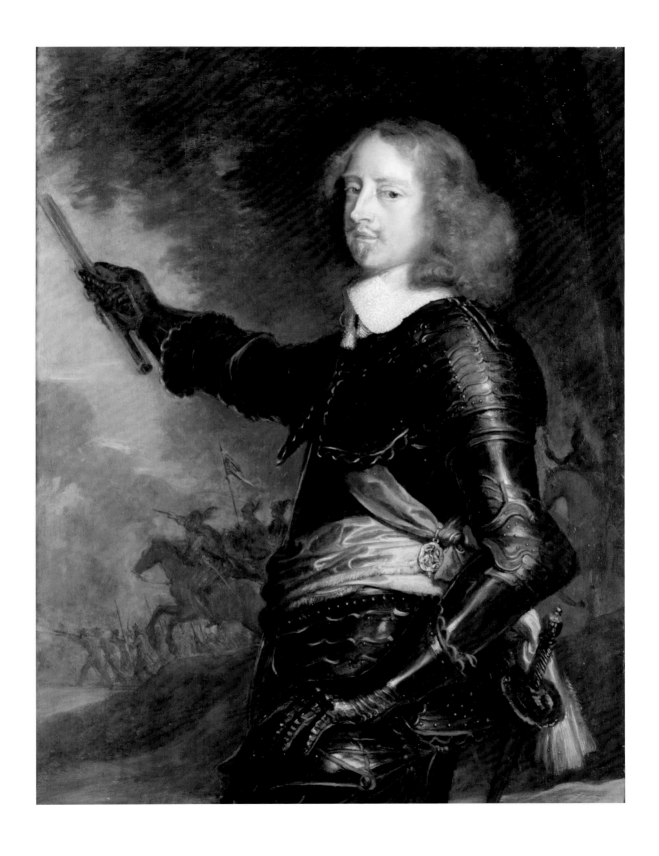

JOHN BYRON, 1st BARON BYRON (1598/9–1652)

PORTRAIT BY WILLIAM DOBSON

ROYALIST CAVALRY OFFICER

'Bred up in arms' [1]

B yron had an active, if not effective, military career on behalf of the king. His legacy will perhaps be to be remembered as a courageous officer with a tendency to engage the enemy when it might have been better not to do so.

The sitter was the eldest son of Sir John Byron of Newstead Abbey, Nottinghamshire and his wife, Anne Molyneux. Charles I created him a Knight of the Bath and in 1642 he left London to join the king's forces at York where he was made a colonel of a cavalry regiment. Byron and his regiment performed courageously but impetuously at the Battle of Edgehill, and it seems that he allowed his troops to pursue the Parliamentarian cavalry at the expense of defending their own infantry. At Burford the following year, he drove a band of Parliamentarians out of the town, but in the process suffered a wound to his cheek from a halberd. Later in 1643 Sir John was created Baron Byron of Rochdale. Byron displayed another lack of control over his troops at the Battle of Marston Moor. He had been instructed to hold his troops back but either forgot or ignored his orders and engaged the enemy in conventional fashion, causing the royalist right wing to disintegrate.

A series of further disasters blighted Byron's career. He raised forces to mount an attack against Montgomery, but despite a numerical advantage only 100 of his men escaped, the result being to give Parliament control of central Wales. Byron then found himself besieged in Chester and was finally forced to surrender on 2nd February 1646. In Anglesey he was met with assassination attempts, and he was finally forced to abandon Caernarvon to parliamentary forces. Following such an ignominious series of military performances Byron fled to the court of St Germain and served the Duke of York until his death in 1652. He married twice, on the second occasion to Eleanor Warburton, daughter of prominent Cheshire Royalist Robert Needham, Viscount Kilmorey. Byron was a man who was clearly close – or thought himself close – to the king, which was fortunate given his distinct lack of success.

A remarkably assured portrait, the present work was painted by Dobson *circa* 1643. It shows a confident and overbearing man who vaingloriously bears the scar of his wound received at Burford. Behind the sitter rises a pair of Solomonic columns, and beyond this a cavalry skirmish rages. Such columns were thought to have been used in the Temple of Solomon, and Dobson may have been keen, or may have been instructed, to make an allegorical link between the justice of Solomon and the legitimacy of both the royalist cause

and Byron's flawed military judgement in the pursuit of this cause. The Solomonic columns also echo the spiral columns on the façade of St Mary's church, Oxford (Fig. 1) adjacent to which Dobson had his studio.

Oxford was the royalist capital of Charles's court from 1642 to 1646, and Dobson was clearly keen to emphasise the sitter's loyalties to the king. This is reinforced by the fact that the head of Byron's grey stallion directly echoes that of the horse in Van Dyck's portrait of *Charles I on horseback* (Royal Collection, UK) painted *circa* 1628. Both portraits show men of power accompanied by adoring servants, Monsieur de St Antoine in the case of the king, and a black page in the case of Byron.

During the period of the Civil Wars it was common for royalist supporters to be portrayed with attendants in their portraits. The king had his equerry, Queen Henrietta Maria had her dwarf, Jeffrey Hudson, and many sitters, most notably, Thomas Wentworth, Earl of Strafford, had a mastiff hound which served as a substitute for an attendant. Only a few years later, parliamentary commanders such as Cromwell saw the advantage of adopting such iconography for their own purposes. Robert Walker's portrait of Cromwell attended by a page was painted *circa* 1649, shortly after the execution of the king, when the iconography of privilege and power could easily be adopted for propagandist purposes.

Fig. 1

1 Hutchinson, p.27

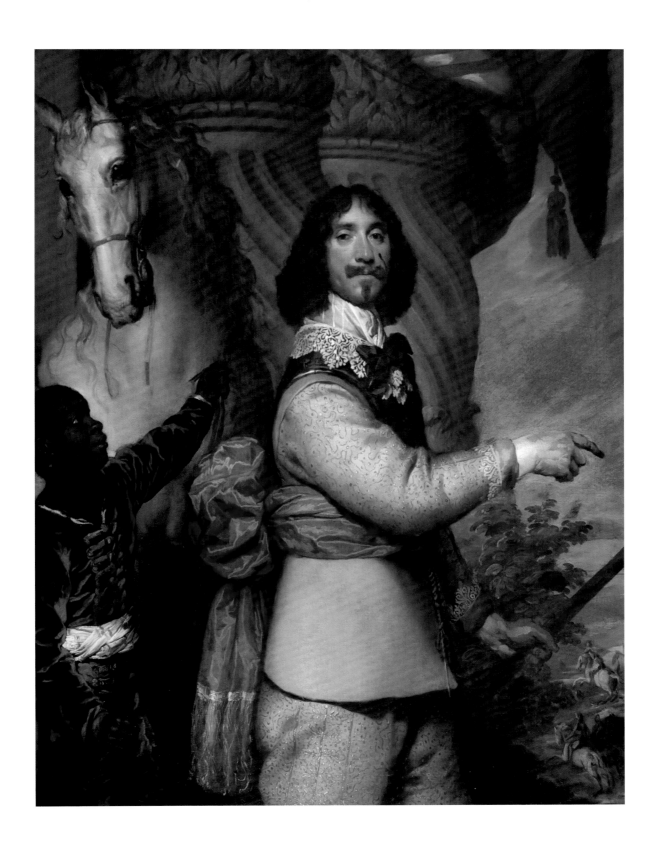

KING CHARLES I of ENGLAND, SCOTLAND AND IRELAND (1600–49)

PORTRAIT BY SIR ANTHONY VAN DYCK

MONARCH AND COMMANDER-IN-CHIEF OF ROYALIST FORCES

'Princes are not bound to give an account of their Actions but to God alone.' [1]

C harles was the son of James I and his wife, Anne of Denmark. After his accession to the throne in 1625, Charles frequently argued with Parliament, which was keen to curb his Royal Prerogative. Charles remained convinced of his 'divine right' to rule and levied taxes without the consent of Parliament, spent vast sums on a personal art collection, and supported the unpopular High Church of Archbishop Laud. He attempted to force Scotland to adopt Episcopal, high Anglican, practices which led to the Bishops' Wars of 1639–41.

This conflict was a prelude to the Civil Wars and, on 22nd August 1642, King Charles raised his standard at Nottingham Castle, marking the official declaration of war. Charles chose to establish his court in Oxford. He fled from Oxford in 1646 and was arrested the following year. He was imprisoned in Hampton Court Palace, escaped to the Isle of Wight where he was then confined in Carisbrooke Castle. A second Civil War erupted, which was promptly crushed by Cromwell's New Model Army and Charles became known amongst the Parliamentarians as the 'man of blood'. Parliament was 'purged' of every member with moderate or monarchic loyalties and a High Court of Justice charged Charles I with treason in January 1649. The king was beheaded outside the Banqueting House, Whitehall, on 30th January. His death shocked every European court and he rapidly became a martyr, something that was reinforced by the publication of the *Eikon Basilike* which purported to be an autobiography of the king's life in his final months of imprisonment. Although possibly not written by the king himself, this publication sustained the royalist movement abroad.

An analysis of the portraiture of the king, before, during and after the Civil Wars offers an instructive insight into the ways in which he and others perceived the royal image.

When Van Dyck painted this portrait, *circa* 1637, Charles's troubles with Parliament were well established. John Hampden was prosecuted for non-payment of Ship Money in 1637–38 and Charles's financial difficulties have been well documented. In November 1638 Charles's introduction of a new prayer book into Scotland had been roundly rejected and, as Charles sat on his horse, the First Bishops' War was about to begin.

The purpose of this equestrian portrait was to counteract any negative perceptions of the king, and Van Dyck's primary concern was to create a true icon of power. Charles had been a sickly infant. He only grew to a height of approximately five feet and retained in adulthood traces of a stammer. An important aspect of Van Dyck's role as court painter was to aggrandise the monarch and to imbue him, in paint, with a kingly iconography that in body he lacked.

Charles sits proudly astride his charger. Many art historians over the years have observed that the horse has an unrealistically large chest and a rather small head. These exaggerated aspects of physique allowed Van Dyck to imbue the animal with the true sense of a tamed beast. The horse foams at the mouth, keen to break from a stately walk into an energetic gallop, yet Charles effortlessly controls this animal, maintaining the lightest of touches on the reins. This light touch is intended as a metaphor for Charles's effortless control of Great Britain. The inscription *Carolus Rex Magnae Britanniae* attached to the tree further emphasises this. Van Dyck's inclusion of an extensive landscape is striking and it gives the work an expansive feel, which was intended to emphasise the great, topographical extent of Charles's rule.

It is interesting to note that at the auction of the king's goods in 1650, this picture was acquired by Balthasar Gerbier, a former ambassador and picture collector on the king's behalf. It eventually passed through a number of hands to John Churchill, 1st Duke of Marlborough, whose descendant, the 8th Duke, allowed the National Gallery to acquire it. Such a magnificent work was truly both a triumph of peace and a spoil of war.

It is instructive to compare this portrait with an engraving by Wenceslaus Hollar which was printed in 1644 after the outbreak of war (Fig. 1 – National Portrait Gallery, London). In this image, instead of the king's charger taking a stately step, Charles rears his horse in a *levade*, a difficult move of dressage. The iconography of the *levade*

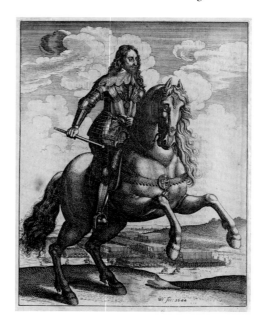

Fig. 1

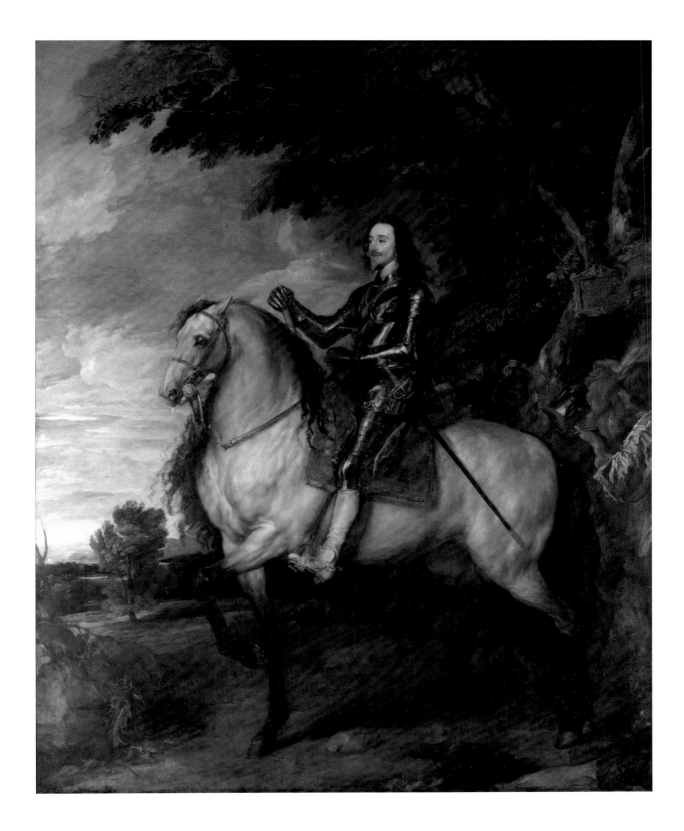

had been employed by Roman Emperors and leaders for centuries. It would continue to be used so, famously with Jacques-Louis David's portrait of Napoleon crossing the Alps. Here again, the movement of the horse functions as a shorthand for the subject's horsemanship and control of his people. This image would have existed in hundreds of impressions and the imagery of the army in the background with neat serried ranks was intended to convey the language of order, hierarchy and royal command. It is interesting to note that the term 'Commander-in-Chief' seems first to have been used during the English Civil Wars.[2]

1 Declaration on the dissolution of Parliament, 10th March 1628, quoted in John Rushworth's papers – see Browne, p.1

2 The term seems to first appear in the *Journal of the House of Lords*, 15th March 1642: '... this House joins and agrees with the House of Commons in this Vote; and that the Lord Admiral is hereby desired, from both Houses of Parliament, that the Commander in Chief of this Summer's Fleet under his Lordship, may be the Earl of Warwicke'.

KING CHARLES I of ENGLAND, SCOTLAND AND IRELAND (1600–1649)

PORTRAIT BY EDWARD BOWER

MONARCH AND COMMANDER-IN-CHIEF OF ROYALIST FORCES

'I go from a corruptible to an incorruptible crown, where no disturbance can be.'[1]

This engaging portrait reveals something of the defiance and courage which characterised Charles during his trial. He wears an interesting combination of simple, almost puritanical dress of black and white lace, combined with the traditional ornamentation of the star, sash and medallion of the Order of the Garter. The Garter was a chivalric order for which Charles had always shown great loyalty and passion, and he was never seen without his 'George', which he regarded as a symbol of the flower of England's nobility.

Charles had always displayed considerable vanity when it came to his beard and hair. Nevertheless, for the period of the trial Charles had dismissed his barber and, possibly as a means of arousing sympathy, had chosen to allow his hair and beard to grow. Bower hints at the longer facial hair but it still looks neat. There is an alternative interpretation which relates that, as a result of a plot to help Charles escape, all the king's servants had been dismissed. From this point onwards, Charles would not allow anyone near his throat with a razor, which resulted in a slightly dishevelled appearance.[2]

The conventional wisdom is that the king's chief opponent and President of the Court, John Bradshaw, was implacably opposed to Charles. Nevertheless, it seems to have been Bradshaw who ordered the king's chair to be covered with crimson velvet, presumably at great expense. Certainly the object of furniture on which Charles sits is neither a simple chair, nor a luxurious throne. It is a hybrid which may have been as equally uncomfortable for the king's body as the experience of the trial was for his soul. The text on the manuscript which Charles holds is not legible but it is not too fanciful to imagine that this is a copy of the speech which he intended to address to his accusers.

It seems improbable that Charles would have chosen Bower as his artist and there are no records that indicate that Bower was given the official task of painting the king. Bower's clientele seems mainly to have been the well-to-do but not aristocratic. By 1637 he had a studio at Temple Bar and, given the inscriptions on some of his works, maintained his studio here until at least 1648. He became Upper Warden of the Painter-Stainers' Company in 1656 and Master in 1661 but his talent as an artist is naïve and pedestrian in contrast with most artists who have served the kings and queens of England. Despite his status as a prisoner, Charles would certainly have regarded Bower as beneath his consideration and the portrait is, traditionally, said to have been commissioned by Sir John Carew, 3rd Baronet. Little is known about Sir John Carew but he served in the Cavalier Parliament of Charles II and is likely to have been a loyal Royalist.

Bower certainly made some sketches of the king during his trial and, from these drawings, he must have worked up the finished oil on behalf of his patron. After the king's execution, this portrait was much copied and is one of a number of autograph versions, rapidly becoming a royalist icon.

Although the painting is dated 1648, this date is from the Old Style calendar, in which the New Year did not begin until March 25th. The date, therefore, would have been 1649, New Style, which fits correctly with the date of the king's trial.

1 King's Charles's words on the scaffold before his execution, 30th January 1649 – see Whitelocke, Vol. II, p.515
2 See Gregg, p.422

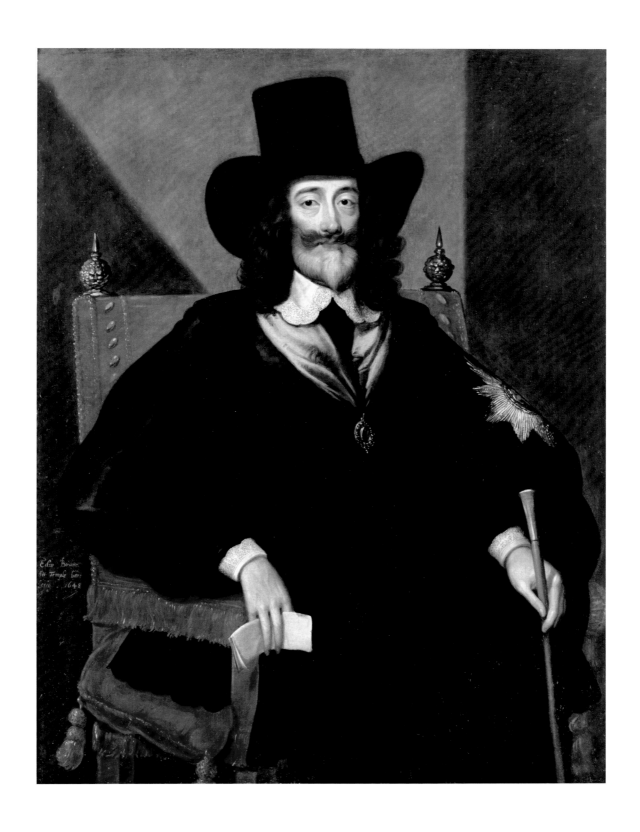

CHARLES, PRINCE OF WALES (1630–85)

PORTRAIT BY WILLIAM DOBSON

ROYALIST COMMANDER, HEIR TO THE THRONE

'Never … yield to any conditions that are dishonourable, unsafe for your person, or
derogatory to regal authority, upon any considerations whatsoever.' [1]

Charles was the eldest son of King Charles I and Henrietta Maria. Charismatic, good looking and brave, Charles was the embodiment of the royalist cause during the Civil Wars.

At the outbreak of conflict, Charles spent much of the wars in the company of his father who had 'no resolution more fixed in him, than that the Prince should never be absent from him'.[2] Charles was present at the Battle of Edgehill and, although only 12 years old, he seems to have displayed considerable courage when Sir William Balfour broke through the royalist line. Charles was in danger of being captured and was rapidly hurried from the field but not before he had wound his wheel-lock pistol and, reportedly, cried 'I fear them not'.

Charles accompanied his father to Oxford and eventually was appointed as commander of the English forces in the West Country. After his father's execution in 1649, Charles raised an army, which, despite Scottish support, was eventually defeated at the Battle of Worcester on 3rd September 1651. Charles's subsequent escape from England to safety on the Continent, although in many respects ignominious, quickly became a romantic legend.

After an impoverished exile in France, Germany and the Spanish Netherlands, Charles was restored to the throne in 1660 following Cromwell's death in 1658.

This magnificent portrait was said to have been painted to celebrate the participation of Charles, Prince of Wales, in the Battle of Edgehill on 23rd October 1642. Presumably it was painted by Dobson in Oxford a few years later, *circa* 1645, when the sitter was 15 years old.

In addition to the traditional buff coat of ox-skin, which was worn by officers during the Civil Wars, Charles also wears expensively engraved armour and breeches embroidered with gold. These breeches are identical to those worn by Edward Sackville, Earl of Dorset, whose responsibility it was at the Battle of Edgehill to protect the young prince. The armour itself is still held in the Royal Armouries.

In the lower left-hand corner, the head of Medusa is buried beneath weapons, military bugles and pennants. The detail of Medusa's severed head seems to be a quotation from Rubens's picture (Künsthistorisches Museum, Vienna) which, at the time, was in the possession of the Duke of Buckingham. Dobson's choice of Medusa might indicate that he was keen to illustrate Charles as the equivalent of Perseus, the mythological hero who defeated the Gorgon. Certainly, Medusa wears an expression of surprise and fear, as if afraid that she is to be struck again by Charles's baton of command which he holds over her head.

There is a luminosity and saturation of colour in this picture which goes beyond allusion to Van Dyck and recalls the painting of sixteenth-century Venice. Certainly the compositional detail of a commander aided by a page was used by a number of Venetian painters, including Paris Bordone (*Portrait of a Man in Armour with Two Pages* – Metropolitan Museum of Art, New York). Charles's page is likely to be Mr Windham, the son of the Prince's governess, Christabella Windham.

1 King Charles's words to his son – see Clarendon, 1826, Vol. V, pp.361–62

2 Clarendon, *op. cit.*, Vol. V, p.9

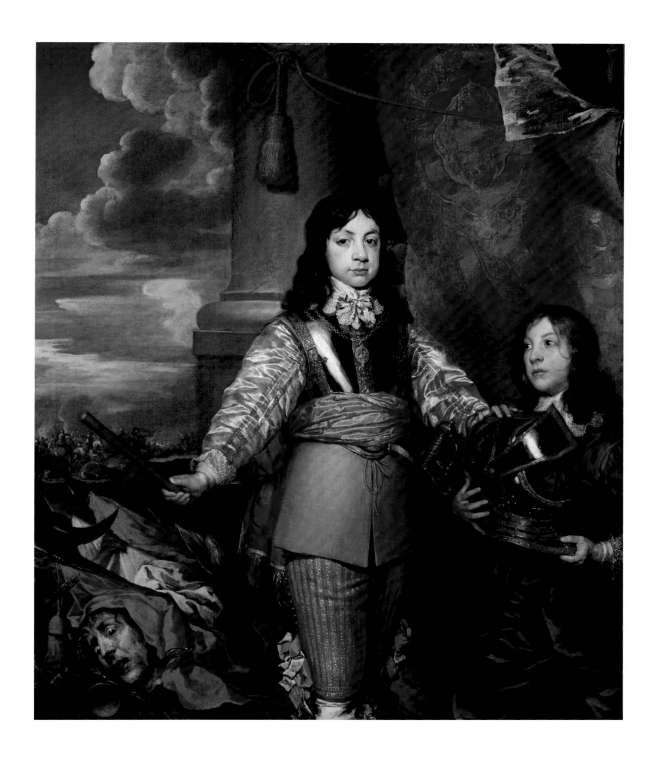

KING CHARLES II (1630–85)

PORTRAITS BY ISAAC FULLER

ROYALIST COMMANDER AND KING

'God bless our good and gracious King,
Whose promise none relies on;
Who never did a foolish thing,
Nor ever did a wise one.' [1]

I mmediately after the Battle of Worcester, Charles was forced to depend on the help of a network of royalist supporters in order to escape from England.

Richard Penderel assisted the king by giving him some rough worker's clothes and by hiding him on his farm (A). Richard Penderel then introduced the king to his next protector, Colonel Careless, who had fought at the Battle of Worcester (B). Colonel Careless and Charles spent an uncomfortable night in an oak tree at Boscobel (C). After his night spent in the 'Royal Oak', Charles travelled on to another safe hiding place, Moseley Hall. On his journey he was obliged to ride the mill horse of Richard's brother, Humphrey (D). When Charles remarked that his mount was 'the heaviest dull jade he ever rode on', Penderel replied, 'Can you blame the horse to go heavily, when he has the weight of three kingdoms on his back?'. Finally, Jane Lane disguised Charles as her servant and they rode together to Bristol (E).

The story of Charles's escape was ignominious. He had failed as a military commander, had been forced to abandon his fine clothes, constrained to cut his hair, sleep in a tree and feign a false identity as a servant. Somehow, however, partly by virtue of his eventual Restoration and partly by constant retelling, this story became a legend as opposed to an embarrassment. Painted *circa* 1661, these pictures were intended to lend weight to the revisionist history.

In each episode of this series Charles is shown as a confident man as opposed to a desperate youth and in each scene he is depicted as a king in control of his destiny who calmly accepts danger. These monumental canvases represent a restoration drama with Charles as the heroic protagonist.

This series was painted by Isaac Fuller. He was an artist capable of great technical skill, as is attested by his two self-portraits (National Portrait Gallery, London and Bodleian Library, Oxford). However, the present works are painted with broad brushstrokes and a loose application of paint. The function was to create visual impact and some of Fuller's technique has been sacrificed to this end. Although the early provenance of these works is unclear, it is possible that the works were commissioned by Henry Carey, 4th Viscount Falkland. Falkland was one of 12 men chosen to visit Charles II in the Netherlands and return with him for the Restoration and his coronation. Falkland may have wished to celebrate his loyalty to the newly restored king and these monumental images would have dominated a room with their royalist imagery and propaganda.

Lely is said to have lamented 'that so great a genius should besot or neglect so great a talent',[2] yet Fuller's influence on the English school of painting is difficult to assess since much of his oeuvre has been lost. He certainly seems to have favoured large-scale compositions, such as the present works, which were regarded as predominantly decorative and therefore were not highly valued. He is known to have painted 'coarsely robust mythologies'[3] for The Mitre Tavern in Fenchurch Street and for The Sun, near the Royal Exchange. John Evelyn remarks that he painted altarpieces at Magdalen College and All Souls College, Oxford: 'Thence to see the picture on the wall over the altar at All Souls, being the largest piece of fresco painting … in England; not ill designed by the hand of one Fuller, yet I fear it will not hold long. It seems too full of nakeds for a chapel'.[4]

1 Epigram by John Wilmot, Earl of Rochester – see Vieth, p.134
2 Piper, 1963, p.131
3 Collins Baker, 1912, Vol. I, p.125
4 John Evelyn, diary entry, 24th October 1664 – Bray, p.267

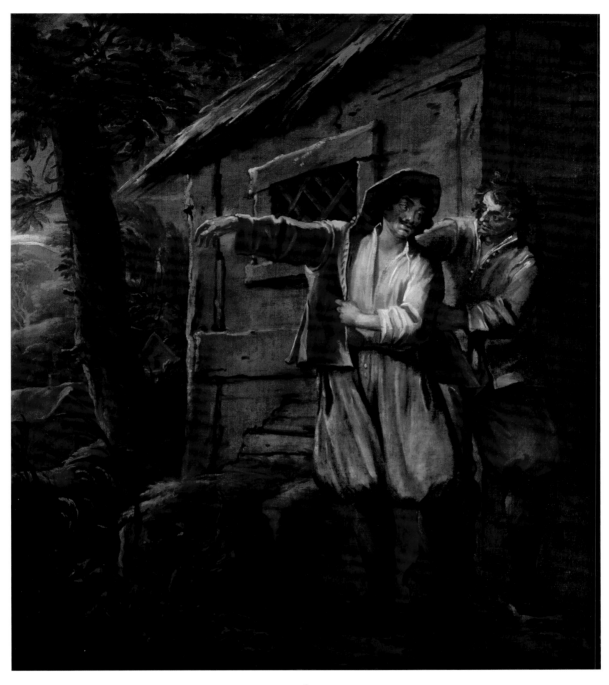

A

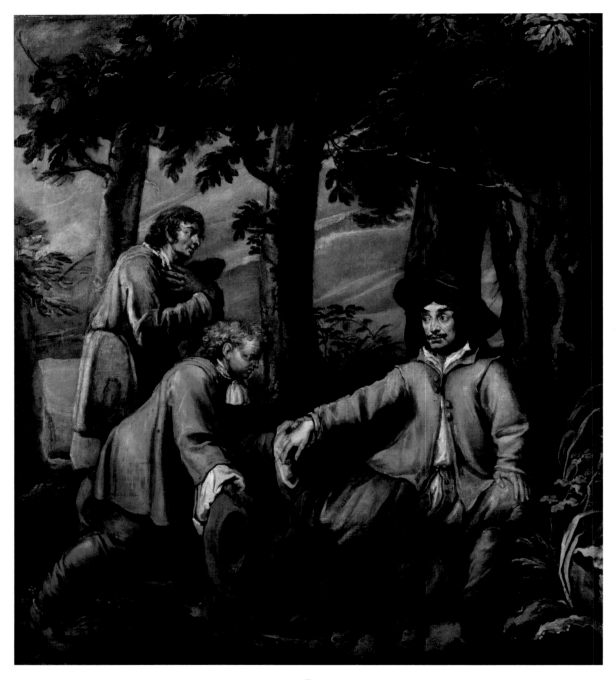

B

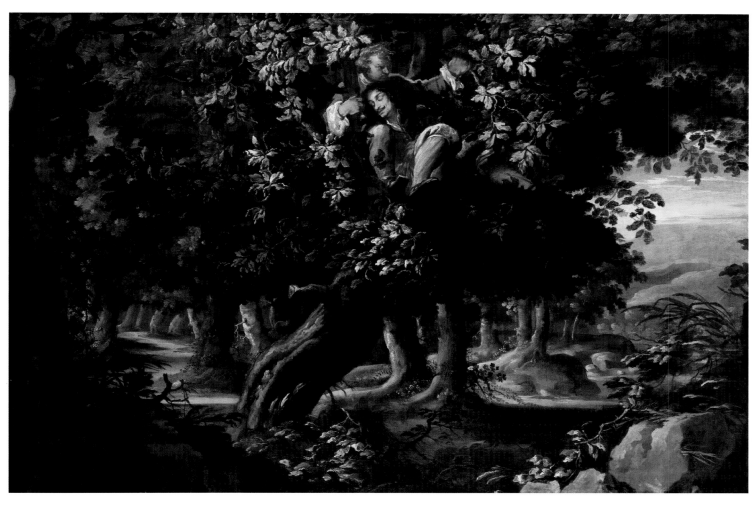

C

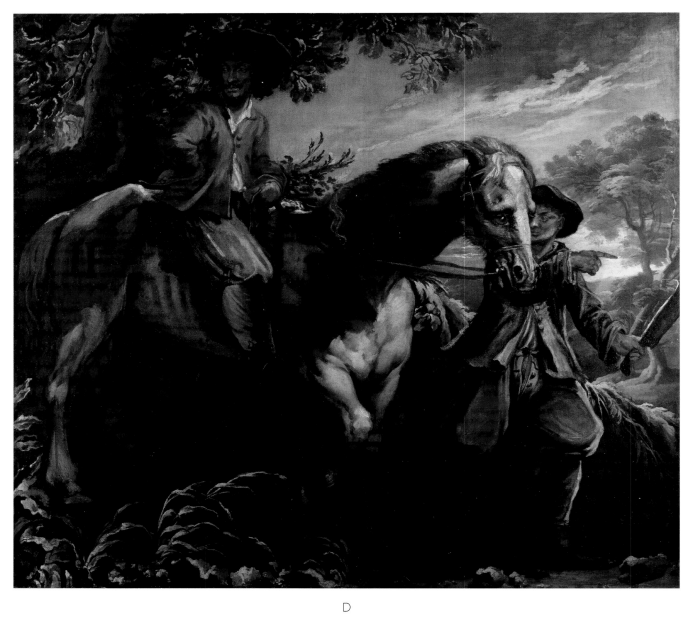

D

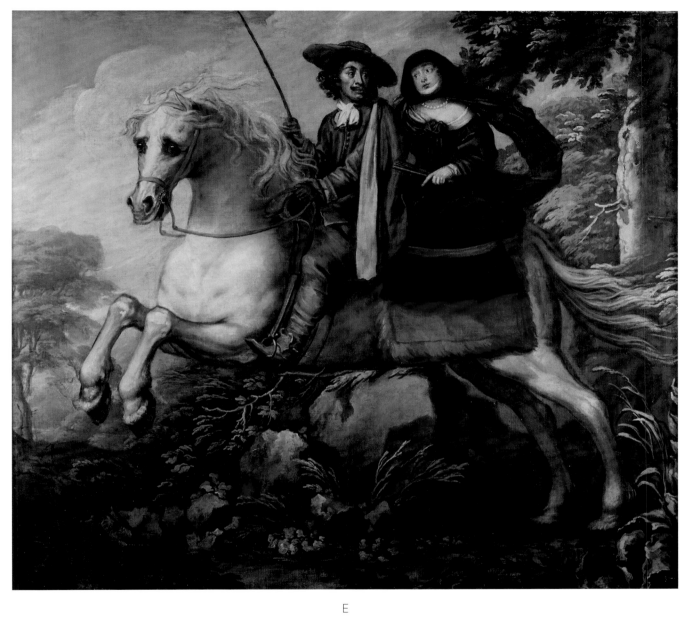

E

SIR THOMAS CHICHELEY (1614–99)

PORTRAIT BY WILLIAM DOBSON

ROYALIST CAVALRY COMMANDER

'A man that lives in mighty great fashion, with all things in a most extraordinary manner noble and rich about him.' [1]

S ir Thomas Chicheley was extravagant, generous and vain in equal measure, as well as a talented tennis player.

He was the son of Sir Thomas Chicheley and his wife, Dorothy. As a young man, in the 1630s, he spent almost £40,000,[2] an extraordinary sum, on his house at Wimpole. He was elected as MP for Cambridgeshire in 1640 but at the outbreak of war he left Westminster and joined the king in Oxford, where the present portrait was painted.

He lent Charles I a great deal of money, most of which was repaid at the Restoration. He was regarded with suspicion during the Commonwealth but his fortunes prospered at the restoration of Charles II when he became Deputy Lieutenant of Cambridgeshire in 1660 and MP for the county the following year. It was at this time that Pepys visited him at home in Great Queen Street and made the observation quoted above. He was appointed Master-General of the Ordnance in June 1670 and was knighted the same month. In the same house visit, Pepys referred to Chicheley as 'a great defender of the Church of England', and it was these strongly held Anglican beliefs which did not find favour with King James II. He was restored to public office after the Glorious Revolution in 1688 but seems to have enjoyed some quieter years before his death in 1699.

It is an inevitable impact of war on artistic activity that it can prove more difficult to obtain materials. Dobson often stitched together a number of small pieces of coarse canvas and, in the instance of this work, it is made up of three pieces of canvas. As if to counteract this parsimoniousness, Dobson has depicted Chicheley with a number of over-exaggerated features. Chicheley's sash is so broad and fulsome, it seems as if he may have wrapped himself in a curtain. The hound seems to have noticed this and the exaggeratedly large head of a mastiff gazes up at his master with a look of mild surprise. The sleeves of Chicheley's expensively embroidered tunic seem so inflated and billowing that his hands and his head appear disproportionally small.

Dobson continues his attempt at aggrandisement of his sitter with the inclusion of a classical sculpture which looms behind Chicheley's shoulder. Dobson's desire to imbue his sitters with gravitas, by associating them with classical allegory and sculpture, is a stock trope of his compositional armoury. In this instance, however, the sculpture cannot firmly be identified as a particular allegorical figure which is more bathetic than heroic.

1 Samuel Pepys, diary entry, 11th March 1668 – see Wheatley, Vol. VII, p.334

2 £40,000 in 1640 is the equivalent of, approximately, £4.6 million in today's currency.

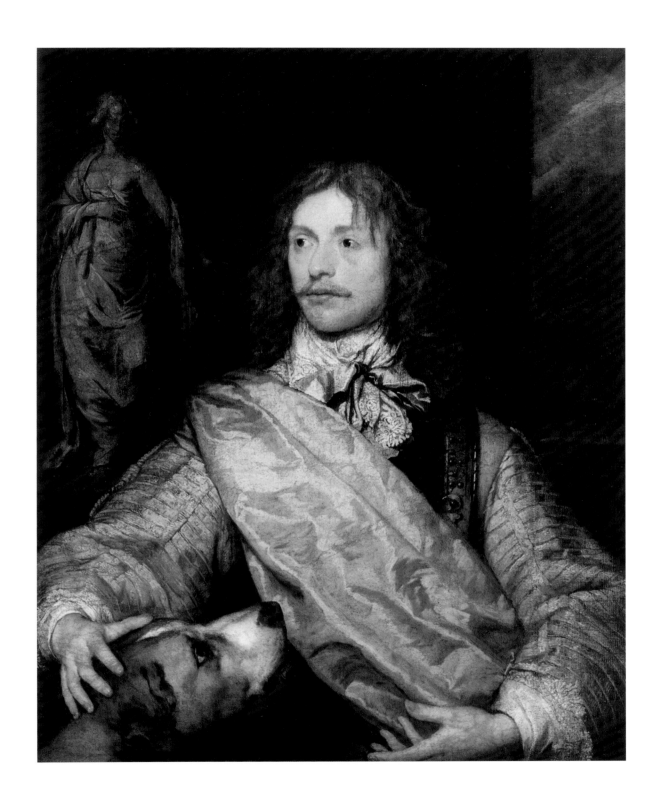

SIR WILLIAM COMPTON (1625–63)

ROYALIST ARMY COMMANDER

'The sober young man, and the godly cavalier' [1]

C ompton was a man of courage and piety. He was one of six royalist brothers and, having served his king with distinction during the Civil Wars, he became one of six founding members of The Sealed Knot who conspired for the restoration of Charles II.

He was the son of Spencer Compton, 2nd Earl of Northampton and his wife, Mary Beaumont. Compton began his military career as part of his father's regiment at the capture of Banbury in 1642. During this engagement he led his men on to three attacks, and had two horses shot under him. On the surrender of the town and castle he was made Lieutenant-Governor under his father and the following year he was knighted at Oxford.

In 1644 Banbury was besieged by parliamentary forces. Although only 19 years old, Compton withstood the siege for 13 weeks until he was finally relieved by his brother, James Compton, 3rd Earl of Northampton. Compton's spirited resistance seems to have been widely admired for the role model of endurance and piety which he set for his men. Compton continued to serve as Governor of Banbury until in 1646 he was ordered to surrender the garrison to Parliament.

Compton had estates in Kent and in 1648 he was part of the royalist 'Kentish Rebellion', led by George Goring, 1st Earl of Norwich. The Kent rebels eventually joined forces with the Essex rebels and Compton was finally trapped in Colchester, besieged by General Fairfax. At the city's surrender, Compton escaped punishment, unlike his fellow commanders, Sir Charles Lucas and Sir George Lisle, who were executed. It was after the siege of Colchester that Cromwell made the flattering remark quoted above.

After the execution of the king, Compton plotted for the Restoration. He endured two separate imprisonments in the Tower of London in 1655 and 1658, after which he received the somewhat headmasterly warning from John Thurloe that he should not expect any mercy if he continued to conspire against the government. After this, Compton wisely decided that discretion was the better part of valour. After the Restoration he was elected MP for Cambridge. Charles II appointed him Master of the Ordnance and even Samuel Pepys wrote with grudging admiration that he was 'of the best temper, value, abilities of mind, integrity … of any one man he hath left behind him'. [2]

This is a striking portrait by Henry Paert. Little is known about the artist although two other portraits by Paert are held by the National Portrait Gallery, London; one of Arthur Capel, 1st Baron Capel and a second of Spencer Compton, 2nd Earl of Northampton, the sitter's father.

It has been the bane of portraitists for centuries to decide what to do with the hands of their sitters. The easiest solution is for the sitter to hold something. In the sixteenth century a compositional trope of aristocratic portraiture became the hand on the hip. However, the position of the heel of the hand resting on the hip, as with Compton – as opposed to the fingers firmly planted on the hip – seems to have been an innovation utilised first by Van Dyck. His portrait of the Stuart brothers is a particularly good example of this (National Gallery, London). To modern eyes, this stance can look somewhat fey, whereas clearly the intention was to suggest a moment of romantic repose. In this portrait, the sitter's sword does not hang from his waist but he holds it by the hilt in a pose of casual disregard.

1 Oliver Cromwell quoted in Samuel Pepys's diary entry, 19th October 1663 – see Wheatley, Vol. III, p.286

2 *Ibid*

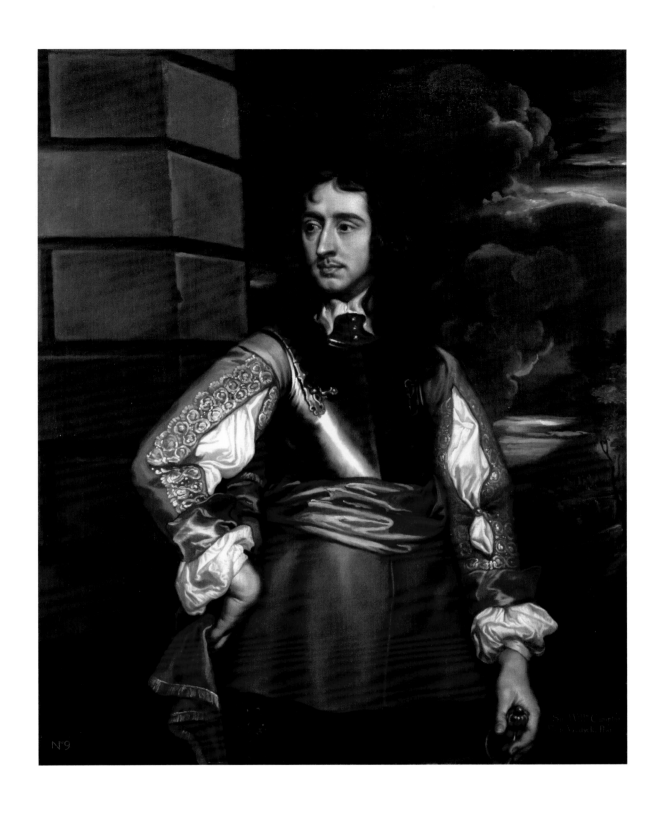

OLIVER CROMWELL (1599–1658)

PARLIAMENTARIAN GENERAL AND LORD PROTECTOR

*'No hypocrite or actor of plays … no victim of ambition, no seeker after sovereignty
or temporal power. That he was a man whose every thought was with the Eternal
– a man of a great, robust, massive, mind and an honest, stout English heart.'* [1]

Oliver Cromwell, Lord Protector of England, Ireland and Scotland, Captain-General of the New Model Army, and Regicide, was born in Huntingdon, the son of Robert Cromwell and his wife, Elizabeth.

For a man who rose to such greatness, very little is known about his early life. His father died when he was 18, an event which precipitated the abandonment of his education at Cambridge in favour of assuming a role as head of the family. A number of other important factors emerge from these early years, namely his marriage in 1620 to Elizabeth Bourchier with whom he had a relationship of deep affection and loyalty, the birth of his children, of whom there were five sons and four daughters and, perhaps most importantly, his intense Puritan faith: 'If here I may serve my God either by my doing or by my suffering, I shall be most glad.'[2]

In 1640 Cromwell was returned as MP for the city of Cambridge. He established a reputation in the House of Commons as an enthusiastic supporter of religious reform and he was a courageous opponent of ecclesiastical power. At the outbreak of war, Cromwell was sent by the Commons to prevent Charles I from seizing the university silver. This he achieved with courage, bravado and only 200 lightly armed men. He quickly raised a troop of cavalry and fought at the Battle of Edgehill. In 1643 he was appointed as colonel of the six Parliamentarian counties of East Anglia and his letters reveal an open-minded approach to social class and religious tolerance, expressing the view that 'I had rather have a plain russet-coated captain that knows what he fights for, and loves what he knows, than that which you call a gentleman and is nothing else. I honour a gentleman that is so indeed.'[3] He demonstrated an admirable understanding of military strategy and in February 1644 was appointed as Lieutenant-General of Horse in the Earl of Manchester's army. In this capacity he fought at the head of the left wing at the Battle of Marston Moor on 2nd July 1644. Cromwell's letters after the battle reveal his belief that he was there to serve God's will: 'an absolute victory obtained by the Lord's blessing upon the godly party principally … Give glory, all the glory, to God.'[4]

Newly appointed as Lieutenant-General of the New Model Army, he swept away the enemy horse at the Battle of Naseby, achieving the soubriquet 'Ironside', a term which was later extended to his whole regiment. He subsequently besieged and negotiated the surrender of the royalist strongholds of Exeter and Oxford. Until this moment Cromwell had played the part of a powerful soldier, but between the years 1645–47 he emerged as a skilful politician, negotiating between Parliament and the king for a peaceful outcome. The outbreak of the Second Civil War in 1647, however, led Cromwell to become convinced of the king's hypocrisy and led him to abandon any lingering objections to regicide. The king was executed in January 1649, leaving a constitutional vacuum in which Cromwell was perceived by many as the most powerful man in Parliament.

At the behest of Parliament, Cromwell campaigned in Ireland and in Scotland from July 1649 until September 1651. He defeated Alexander Leslie, Earl of Leven, at the Battle of Dunbar and achieved the 'crowing mercy' and final victory over Lord Newark's army at the Battle of Worcester. Cromwell returned triumphant to London and was received with such delight that some were led to predict that he would assume absolute power for himself. It is a measure of Cromwell's integrity and lack of monarchic ambition that he did not do so. He supported the Rump Parliament until its pride and inefficacy led him forcibly to replace it with a Council of State. In December 1653 Cromwell was sworn in as Lord Protector. He served in this role until his death in 1658 on the anniversary of his victory at Dunbar.

Three important English artists are known to have painted Cromwell during his lifetime: Samuel Cooper, Sir Peter Lely and Robert Walker.

The earliest compositional type produced by Walker is likely to be his portrait of Cromwell, standing, three-quarter length, wearing armour and holding a marshal's baton which was painted *circa* 1649. The iconography of Walker's portrait is borrowed directly from Van Dyck's portrait of Sir Edmund Verney (No. 56) painted a decade earlier, *circa* 1639–40. Sir Edmund Verney was a committed Royalist and the Standard Bearer of King Charles at the Battle of Edgehill. On the basis of Cromwell's antipathy towards the king, it might seem strange for Cromwell to have allowed himself to be portrayed as King Charles's standard bearer, in all but face.

It is likely that Cromwell was unaware of the iconographic parallel. There is no evidence to suggest that Cromwell was a close acquaintance of the Verneys and in the seventeenth century portraits in a family collection were unlikely to be seen by those other than the family. Furthermore, there is no evidence to suggest that Cromwell or the other leading Parliamentarians were intimately familiar with the paintings of Van Dyck. Piper emphasises this view, remarking that, 'few, if any, of the Parliamentary Generals who sat to him [Walker] are likely to have realised that they were being immortalised in the

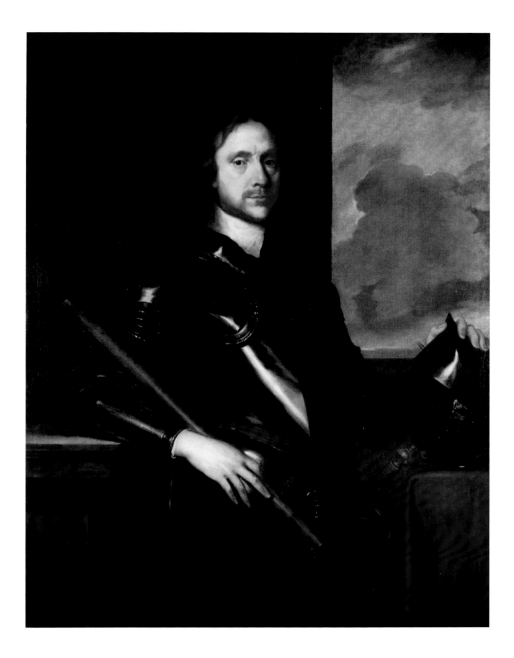

shape in which Van Dyck had defined their authoritarian Royalist opponents'.[5] The initial choice of such a pose is likely, therefore, to have lain with Walker who was familiar with the works of Van Dyck and the stock compositions of his studio.

However, the choice of Verney as the compositional prototype was a skilful and a deliberate one. Verney was an honourable and loyal supporter of the king, but he was dismayed at a conflict which created divisions between families, including his own. He supported the king, but did not necessarily support everything done by the king. Cromwell was keen to cast himself as a similar man who had acted out of loyalty to his country and to God, but who did not inherently oppose the institution of monarchy. Walker's portrait presents Cromwell as a martial but moderate man. Cromwell may have hoped that the projection of this image, combined with the direct imitation of the royalist portraiture of Van Dyck, would resonate with both parliamentary and royalist factions at a time when the country was politically and socially fractured. Walker's subsequent portraits of Cromwell illustrate a similarly attuned attitude to imagery and propaganda.

Whilst it is unlikely that Cromwell would have owned a suit of armour, it is striking that, in the case of every contemporary portrait, he is portrayed wearing one. At the time Cromwell was painted, full armour had long ceased to be a practical choice on the battlefield but had 'more to do with dignity than with reality'.[6] The endlessly repeated portrayals of Cromwell wearing armour were intended to project a sense of martial and chivalric strength. It was rather convenient that full armour was no longer worn in battle since this 'costume' could then be employed by Walker as a timeless emblem of Cromwell's prestige and heroism.

1 John Forster, see Davies, p.237

2 Oliver Cromwell's letter to his cousin, Elizabeth, 13th October 1638, see Carlyle, p.101

3 Oliver Cromwell's letter to his friends, Sir William Spring, Bt, and Maurice Barrow, 11th September 1643, *ibid*, p.170

4 Oliver Cromwell's letter to Colonel Valentine Walton, 5th July 1644, *ibid*, p.193

5 Piper, 1963, p.28

6 Stevenson, p.370

OLIVER CROMWELL (1599–1658)

REGICIDE

'There would never be a good time in England till we had done with Lords ... If he [Cromwell] met the King in battle, he would fire his pistol at the King as at another.' [1]

Samuel Cooper, the miniaturist, was known to have been working for Cromwell at the same time as Walker. This is evident from a letter written by Miles Woodshaw on 7th November 1650 to Lord Conway: 'I spoke to Mr Cooper, the painter, who desires you to excuse him one month longer, as he has some work to finish for Lord General Cromwell and his family.'[2] The work referred to by Miles Woodshaw could well be the present miniature portrait of Cromwell, now in the National Portrait Gallery, which is signed with initials and dated 1649.

This would appear to be Cooper's earliest recorded portrait of Cromwell and it shows him looking youthful and strong, having achieved an ascendancy over the king, Parliament and the army. In terms of both iconography and physiognomy, the portrait bears a strong resemblance to the portraits of Walker which were produced in 1649, emphasising the fact that both artists are likely to have worked *ad vivum* from their sitter.

Cooper's portraits, however, must have served a different purpose from those of Walker. Walker's full-length portraits could be displayed on walls and used as propagandist emblems of the new order. It would have been difficult for images only a few centimetres high to achieve the same effect and these miniature portraits must have been produced for dispersal amongst Cromwell's friends, family and political contemporaries.

1 Oliver Cromwell – see Carlyle, Vol. I, p. 175
2 Long, p. 85

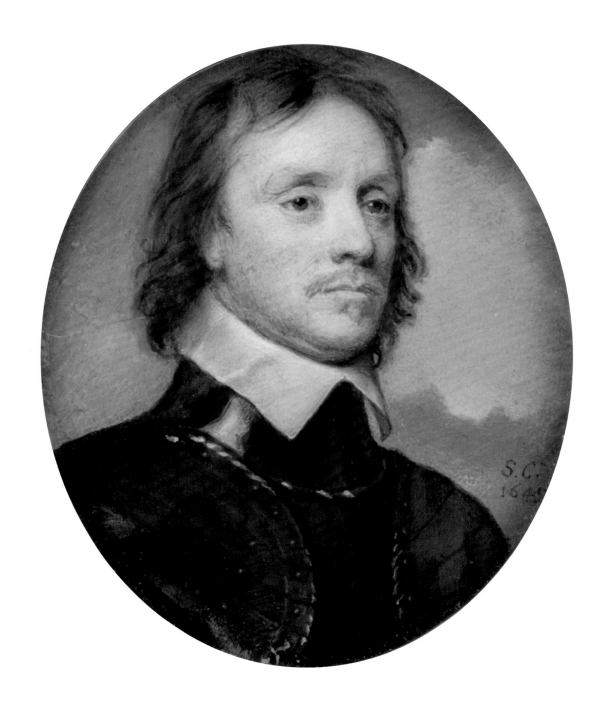

OLIVER CROMWELL (1599–1658)

PORTRAIT BY SIR PETER LELY

LORD PROTECTOR

'Mr Lely, I desire that you would use all your skill to paint my picture truly like me, and not flatter me at all; but remark all these roughnesses, pimples, warts and everything; otherwise I will never pay a farthing for it.' [1]

The finest portrait of Cromwell by Sir Peter Lely is the painting in the Birmingham City Art Gallery, painted in 1653–54 after Cromwell's acceptance of the Protectorate. This portrait has long been associated with the words reported by George Vertue, quoted above.

There is a striking resemblance in terms of physiognomy between this painting by Lely and the portrait miniature by Cooper belonging to the Duke of Buccleuch, and there has been intense debate as to whether Lely derived his paintings from Cooper, or *vice versa*. A simple explanation, however, for the similarity is that both Cooper and Lely were working *ad vivum* from their sitter and, in 1653, Cromwell was portrayed by both artists as he in fact looked.

As with so many other portraits of Cromwell, there is a plethora of portraits of this type by Lely or his studio. In a letter, dated 6th October 1654, James Waynwright writes to Richard Bradshaw, who was serving as an ambassador in Copenhagen, 'I have bought you a curious picture, exactly done by Mr Lilley, who drew it for his Highness, and hath since drawn it for the Portuguese and Dutch ambassadors it cost me 12 l. present money; I could [have] had it cheaper, but not so good.' [2] This letter clearly indicates that Lely's portrait was being used as a diplomatic tool and as the Lord Protector's iconography of power.

The composition of Cromwell, framed as an oval within a cartouche is striking. Although primarily intended as a decorative device, the design gives the work a sculptural quality and it was often used by Lely and his pupil, Mary Beale. Nevertheless, the compositional device was often used earlier in the seventeenth century by the Flemish and Jesuit painter, Daniel Seghers, with whose work Lely is likely to have been familiar. It is interesting to see Lely combining a sober portrait of a sober gentleman with the more flamboyant Baroque styles of painting from the Continent. Cromwell clearly did not object to this flamboyance and the idea that all Parliamentarians were killjoys who lived their lives in monochrome does not stand up to scrutiny.

1 Vertue, Vol. XVIII, p.91

2 *Sixth Report of the Royal Commission on Historical Manuscripts*, 1877, pp.426b, 437b–438a

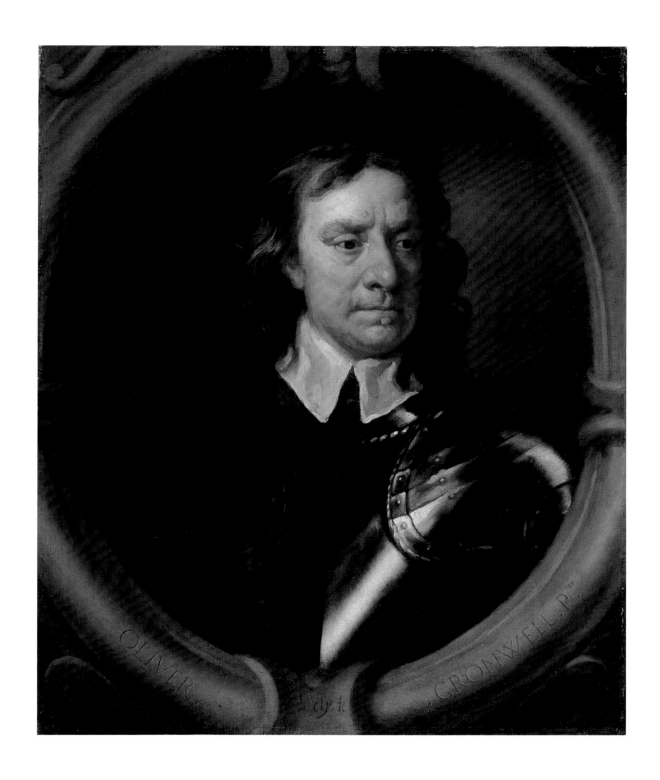

OLIVER CROMWELL (1599–1658)

PORTRAIT ATTRIBUTED TO THOMAS WYCK

KING OLIVER

*'I will now say something for myself. As for my own mind, I do profess it, I am not
a man scrupulous about words, or names, or such things.'* [1]

This brings the analysis of the iconography of Cromwellian portraiture to the last years of the Protector's life and it is through these portraits that we finally see the emergence of an unashamedly royal and Cromwellian imagery. In early 1657 Parliament proposed the *Humble Petition and Advice*, which was the constitutional instrument for the return of monarchical rule, the granting of the crown to Cromwell and the re-introduction of dynastic rule. There was even talk of Cromwell's daughter being married to Charles II, thereby ensuring a succession back to the Stuarts. Cromwell declined the offer of the crown, and the *Humble Petition* was amended, but this did not prevent him being portrayed in portraiture as a king.

This equestrian portrait, painted *circa* 1658, is very similar, in terms of composition, to Van Dyck's portrait of King Charles I with his equerry, M. de St Anthoine (Fig. 1 – Royal Collection, UK).

In Cromwell's portrait, the black page stands in the position which Van Dyck fills with the coat of arms of the United Kingdom, a statement of Charles's extent of power. The presence of the black page in this picture may allude to the Commonwealth's success at establishing a colony in Jamaica.

Most strikingly, however, Pierre Lombart made an engraving after the same equestrian portrait of King Charles I by Van Dyck (Fig. 2). In this engraving, Lombart replaces the head of the king with that of Cromwell. There can be no more powerful imagery than this to illustrate the substitution of King Charles for 'King' Oliver.

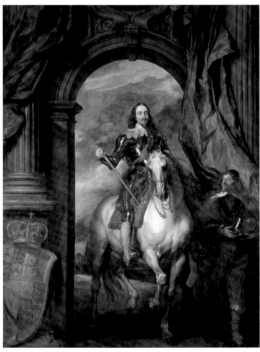

Fig. 1

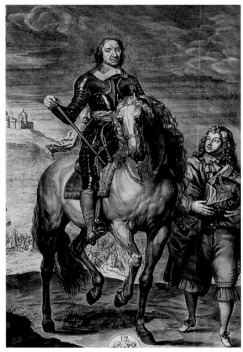

Fig. 2

1 Oliver Cromwell – see Carlyle, Vol. II, p.530

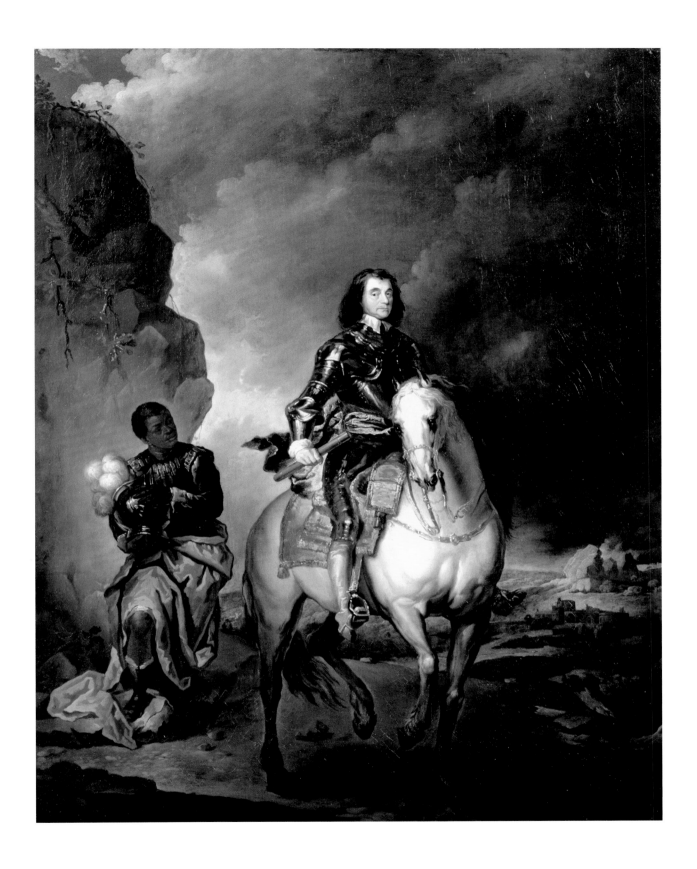

RICHARD CROMWELL (1626–1712)

PORTRAIT BY JOHN HAYLS

LORD PROTECTOR

'I would have him mind and understand business, read a little history, study the mathematics and cosmography: these are good, with subordination to the things of God. Better than idleness, or mere outward worldly contents.' [1]

These less than encouraging, and far from paternal, words seem to sum up the dismal opinion in which Richard Cromwell has been held since the seventeenth century. As many children of successful fathers discover, it can be hard to live up to expectations.

Notwithstanding Oliver Cromwell's refusal to accept the crown of monarchy, he nevertheless created a dynastic succession when the role of Lord Protector passed to his son. Oliver and Richard Cromwell remain the only commoners ever to have become the Head of State.

Richard Cromwell served as Lord Protector of England, Ireland and Scotland for only nine months. He seems to have lacked the character, aggression or charm to dominate both the army and the forces of civil influence. He was deposed by what was, in effect, a military coup and quickly acquired the nickname 'Tumbledown Dick'. There is no evidence that he fought in either of the Civil Wars between 1642 and 1649. Certainly the letter which the sitter's father wrote to Richard's father-in-law, cited above, indicates a concern with his son's role in life. Richard married Dorothy Maijor and served as a Justice of the Peace for the county.

His first public role was as MP for Hampshire in 1653 and, thereafter, he seems to have become increasingly involved with the politics of the Protectorate. He held the role of Chancellor of the University of Oxford in 1657.

He was deposed and returned to his country estate at Hursley. Shortly before the Restoration, Cromwell fled to France and spent the next 20 years as an itinerant guest at many of the courts of the Continent. He returned to England *circa* 1680 and died in obscurity.

The iconography of Richard Cromwell is far from clear. The best starting point is Wenceslaus Hollar's contemporary engraving of *circa* 1658. The iconography of this image seems to confirm the identity of this portrait as Richard Cromwell. It is interesting to observe that it was not painted by Robert Walker. One might have expected the Lord Protector's son to have been painted by the 'court' artist. It is perhaps a measure of Richard's dislocation from the central axis of power that Walker was not summoned to paint him. Had he done so, he would almost certainly have painted his sitter three-quarter turned to the right. Walker favours this side with almost every one of his single sitter portraits.

Nevertheless, the task fell to John Hayls, a competent and often characterful artist. Hayls seems to have trained in the Netherlands and Richard Symonds, the royalist soldier, makes some interesting notes about his technique.

'To grind vermilion:– grind it first in piss; then lay it drying on a Stone. Then grynd in Vinegar, then in fair water without mixing anything therewith. This receipt Mr. Hales learnt from Mirevelt who lived in Holland in P. Henry's time … Mr Hales cleanses his pencils with common oyl & linseed. And often dips in oyl of turps, rubbing ym. On a tin & never in soap.' [2]

Hayls was a cousin of the miniaturist Samuel Cooper, he had a studio on Southampton Street and, subsequently, in the fashionable area of Long Acre. He seems to have been successful and he dropped dead in Covent Garden 'being drest in a velvet suit to go to a Ld Mayors feast'. [3]

Hayls chose to turn his sitter three-quarters to the left, perhaps in a deliberate snub to the style of Walker and the parliamentary elite. He successfully captures a sense of his sitter's melancholy whilst simultaneously suggesting a self-awareness. The fact that Cromwell is shown in armour might be interpreted as confirmation of the rumour that he was part of Sir Thomas Fairfax's lifeguard. This must remain hypothesis but any martial iconography could only have improved Richard Cromwell's dismal reputation.

The portrait is, nonetheless, an intimate work and this intimacy is partly created by the use of the oval format. Although one does see seventeenth-century oval portraits, in many cases the spandrels were filled to create a rectangle and the true oval portrait was a format usually reserved for miniatures. An oval stretcher would have been more complicated to create and would, correspondingly, have added cost to the construction.

1 Oliver Cromwell's letter to Richard Maijor, 13 August 1649 – see Carlyle, pp.446–7
2 Collins Baker, 1912, Vol. II p.182
3 Vertue, Vol. XVIII, p.31

RICHARD CROMWELL (1626–1712)

TUMBLEDOWN DICK

'It might have pleased God, and the nation too, to have chosen out a person more fit and able for this work than I am.' [1]

An oval portrait of Richard Cromwell floats at the centre of the picture. This portrait seems to derive from a miniature by Samuel Cooper.

Moving clockwise from nine o'clock, the four putti would seem to represent the four Cardinal Virtues: Prudence, Fortitude, Temperance and Justice.

The putto carrying the snake represents Prudence. Traditionally, Prudence is depicted with a snake and a mirror which reflects human actions. In this particular case, the mirror has been replaced with a book. It is possible that this is a Bible, but the artist has made no attempt to indicate this.

The putto in the top left-hand corner, who holds a baton, represents Fortitude, who is often represented as a warrior holding a spear, shield or sword. The absence of any martial attribute may suggest a negative, or certainly neutral, perception of Richard Cromwell's fortitude.

In the top right-hand corner, a putto represents Temperance. In traditional iconography, Temperance is depicted as a woman decanting one vessel into another to indicate her aversion to an excessive amount of alcohol. In this depiction, the vessel seems to have been inadvertently turned upside down, again perhaps suggesting a pejorative interpretation of Richard Cromwell's virtue.

Finally, the putto representing Justice carries a sword as an emblem of power, with the traditional emblems of the scales and the blindfold.

Usually, both the scales and the blindfold represent impartiality but in Renaissance iconography the blindfold can also represent an absence of judgement. The depiction of the scales which are heavily off-set in this picture would seem to suggest injustice and reinforce this interpretation.

Two further putti remain, both crouched in an ungainly manner, beneath the miniature portrait. These two putti, as well as the figure of Prudence, have adult male faces. There is a faint resemblance in each of the faces to Oliver Cromwell but it is impossible to identify the figure with any certainty.

The putto at six o'clock holds a shield which bears the Arms of the Protectorate. However, rather than presenting this shield to Richard Cromwell, the putto seems to act as a barrier to Richard obtaining them. These arms were used on the Great Seal between 1655 and 1659 and this shield is compositionally juxtaposed with the crown which is being held above the head of Richard Cromwell. The crown itself is the French crown and behind the crown the sky is aflame.

The overwhelming tone of this picture is of satire. A possible date would be shortly after 1660 when Charles II had been restored to the throne, when Richard himself was in France and when propaganda against the erstwhile Lord Protector would have been encouraged.

1 Richard Cromwell – Guizot, Vol. I, pp.17–18

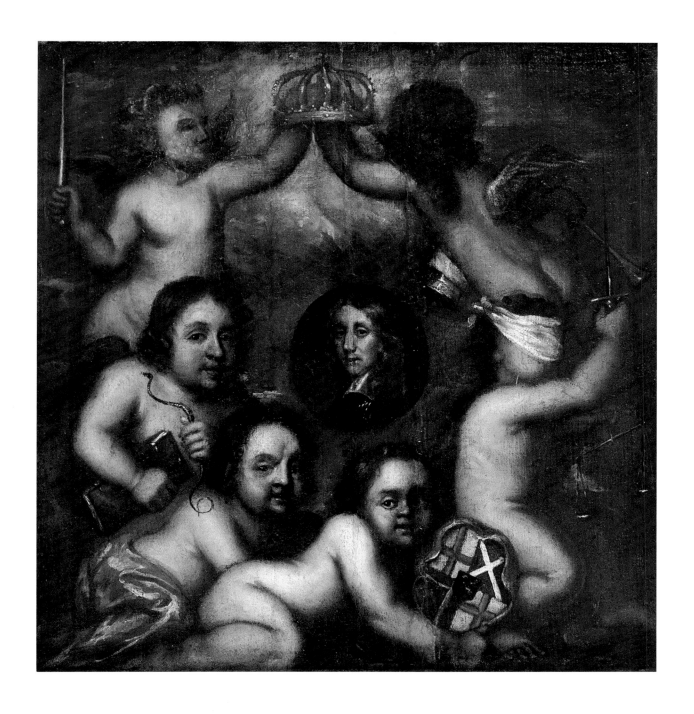

WILLIAM DOBSON (1611–46)

PORTRAIT AFTER WILLIAM DOBSON

ROYALIST PAINTER

[Dobson was indebted] *'to King Charles I, who took him into his immediate Protection, kept him in Oxford all the while his Majesty continu'd in that City, sat several times to him for his picture; and obliged the Prince of Wales, Prince Rupert, and most of the Lords of his Court to do the like.'* [1]

obson was a talented portraitist and a loyal servant of the king. Sadly, however, we do not know a great deal about him.

According to Richard Graham, who wrote in 1695 a *Short Account of the Most Eminent Painters both Ancient and Modern*, Dobson was 'a Gentleman descended of a Family very eminent (at that time) in St. Albans … born in St. Andrew's Parish, in Holbourn'.[2]

Dobson worked as an apprentice of William Peake, the son of Robert Peake, Serjeant-Painter to James I. He seems later to have worked in the studio of the German painter, Francis Cleyn, but we do not know much about his paintings until he arrived in Oxford, *circa* 1643. Dobson had his studio on the High Street, close to St Mary's, where he worked with his assistant, Mr Hesketh, in order to paint the increasingly forlorn aristocratic elite.

Whether he was officially invested with the title or not, *de facto*, Dobson became the king's court painter. An etching executed after Dobson's self-portrait exists and carries the description *'pictor Regiae Majestatis Angliae'* – Painter of His Majesty, King of England. In a manuscript which records the remarks of an antiquary, William Oldys, Dobson is referred to as one of the 'Grooms of his Majesty's Privy Chamber and Serjeant-Painter to the said King'.[3]

Dobson was clearly familiar with the works of Van Dyck and his pictures also demonstrate a familiarity with the Venetian School, in particular the jewel tones of Titian and Veronese. Dobson particularly liked the addition of a sculptural relief. This trope derives from Titian and Rubens and may relate to works which Dobson had seen in the

London collections of the Earl of Arundel, the Duke of Buckingham and the king himself.

As soon as Oxford was abandoned by the king, Dobson's career seems to have been seriously compromised. In 1646, he is listed as one of those nominated to serve as Steward of the Painter-Stainers' Company, but by October the same year he was dead. According to Graham, Dobson 'died very poor, at his House in St. Martin's Lane'.[4] He seems to have married twice and we are blessed with even more scant information about his two wives than about Dobson himself.

The present portrait derives from the oval portrait (The Earl of Jersey) which was painted in direct imitation of Van Dyck's *Self-Portrait* (National Portrait Gallery, London) as well as possibly Van Dyck's other *Self-Portrait with a Sunflower* (Duke of Westminster, Eaton Hall). In this particular work, the oval format has been extended at a later date to make a rectangle.

In this portrait Dobson appears as a neat, dashing Cavalier, who could stand shoulder to shoulder with any of the royalist patrons with whom he shared the city of Oxford in the mid 1640s. Like Van Dyck and Rubens before him, Dobson was keen to send a message that he was not inferior in stature to many of those who sat to him. Dobson represents himself not as an artist but rather as a gentleman of the court. The pose of glancing behind his shoulder must partly have been determined by the technique of looking in a mirror. However, it also creates a suggestion of aristocratic insouciance.

1 Exh. cat., London, 1983–84, p.15
2 Du Fresnoy, p.339
3 BL, Add.MS 19027
4 Du Fresnoy, p.340

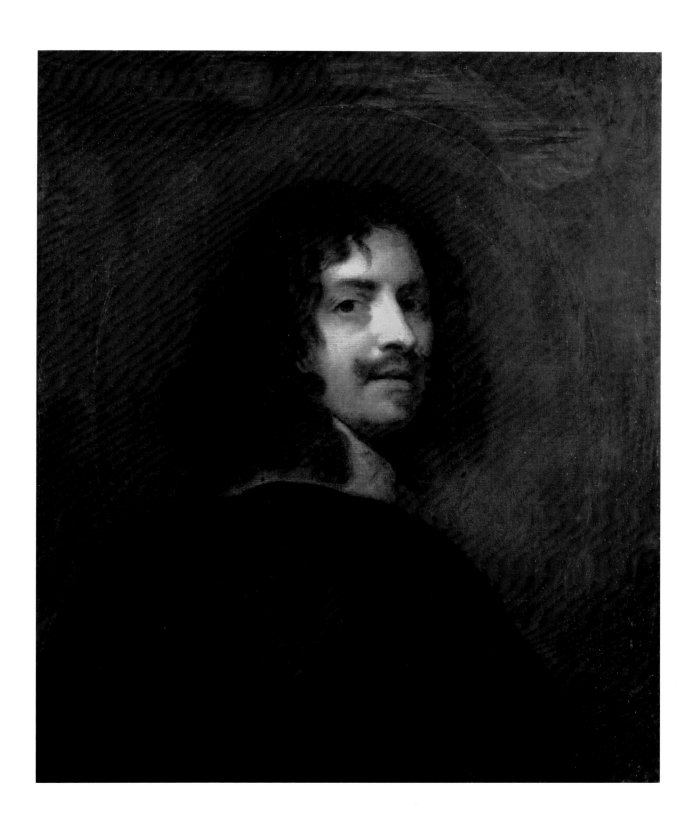

HENRY PIERREPONT, MARQUESS OF DORCHESTER (1607–80)

PORTRAIT BY ENGLISH SCHOOL SEVENTEENTH CENTURY

ROYALIST

'I see abundance of wealth doth not satisfy all men's minds.' [1]

Henry Pierrepont was a member of the king's war council in December 1642, and a member of the royalist Parliament in Oxford. Despite these close affiliations with the royalist cause, the only portrait of him which exists is of a humble man wearing legal dress.

He was the eldest son of Robert Pierrepont, 1st Earl of Kingston upon Hull, and his wife, Gertrude Talbot. He was educated at Emmanuel College, Cambridge, and was elected as MP for the town. He made a famous speech in Nottinghamshire, explaining the reasons for the king's revival of a 'commission of array' which allowed the king to raise a militia army at the beginning of the Civil Wars. A month after this speech, he was blacklisted as one of the Royalists to whom the Parliament took particular exception for behaviour which was perceived as unconstitutional. This seems hypocritical given that Parliament had employed the 'Militia Ordinance' for exactly the same purpose.

He was created Marquess of Dorchester in March 1645. He established a botanical garden with an estimated 2,600 species. This garden was regarded as comparable to the famous 'Seminary of Vegetables' at Blois belonging to King Louis XIV's uncle, Gaston, Duc d'Orleans. [2] He left the catalogue of his library to the Royal College of Physicians. In June 1651 Pierrepont was admitted to Gray's Inn, and in 1658 he was made an honorary fellow of the College of Physicians.

The iconography of the portrait is modest and deliberately under-stated. It was certainly a rarity for a peer to practise law in the seventeenth century, and it led Sir Edward Nicholas to make the quotation above. Another explanation, however, could be that the sitter was keen to forget his participation in the Civil Wars. The portrait emphasises both to himself, and to the viewer, his new interests in law and the natural sciences, and obscures any awkward questions of divided loyalty. The portrait seems to have been in the family collection for some centuries before being acquired by the Royal College of Physicians and it perhaps brought daily comfort to the sitter to see himself in the sober guise of an academic.

1 Sir Edward Nicholas – see Warner, Vol. 1, p.307
2 Wiles, p.216.

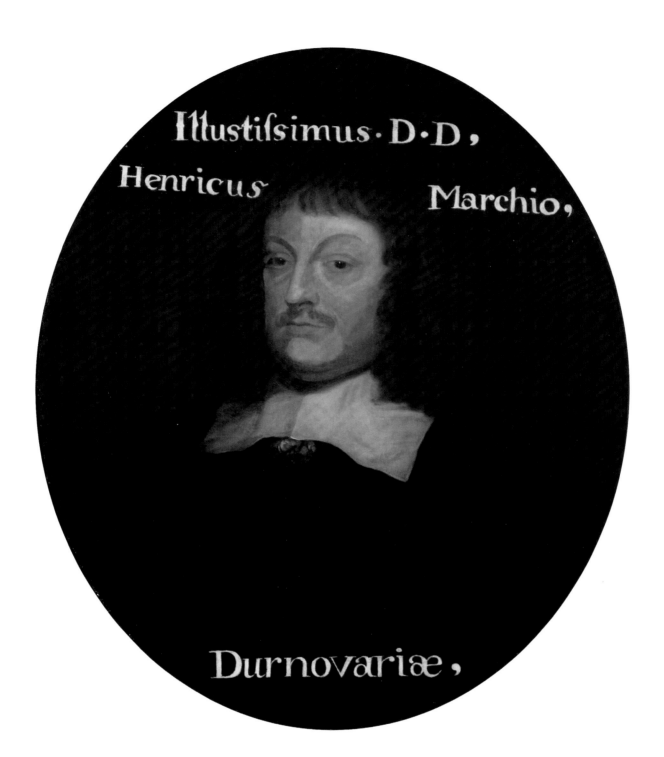

EDWARD SACKVILLE, 4TH EARL OF DORSET (1591–1661)

PORTRAIT BY STUDIO OF SIR ANTHONY VAN DYCK

ROYALIST CAVALRY COMMANDER

*'Beautiful, graceful, and vigorous: his wit pleasant, sparkling and sublime …
The vices he had were of the age, which he was not stubborn enough to
condemn or resist.'* [1]

The hauteur and swagger of this portrait portrays a dashing Royalist of supreme loyalty to the Crown. Nevertheless, it belies the doubts and feelings of ambivalence which plagued Dorset throughout the years of Civil Wars.

Dorset's prominence at court was particularly strong during the 1620s when he was both installed as a Knight of the Garter and became Lord Chamberlain of the Queen's household. He wears his key of office suspended from his waist sash.

As the prospect of war became more likely throughout the summer of 1642, Dorset offered to raise a company of 60 horses for the king. Nevertheless, he strenuously hoped for a reconciliation 'to keepe the more violent spirits from passinge the Rubicon' and when the king's standard was raised in August he commented, 'behold into whatt a sad condition blind zeale, pride, ambition, envy, malice and avarice … hath plunged the honor … of this late, very late, most happy kingdome'.[2]

At the Battle of Edgehill he appears to have been in charge of the king's eldest sons, Charles and James.

When the king opened his Parliament in Oxford in January 1644, Dorset was appointed Lord Chamberlain, indicating his status within the king's inner circle of advisors. Nevertheless, his influence seems to have waned quickly and, having taken no part in the Second Civil War, he died in penury as a 'poore unsuccessfull Cavalier'.[3]

This full-length portrait was painted *circa* 1635 and the style recalls the works of Daniel Mytens, whom Van Dyck supplanted as court painter. The key of office as Lord Chamberlain to the queen hangs from his waistband and he is wearing fashionable, and extremely expensive, doublet and hose, decorated with a narrow metal braid applied in parallel lines which would have created a shimmering effect as the sitter walked.

Dorset is lightly armed with a breastplate, helmet and rapier. It is interesting to note that, unlike some of Van Dyck's Royalist sitters, and many of Walker's Parliamentarian clientele, the helmet depicted was actually a light cavalry helmet as opposed to an anachronistic design which would never have been worn. This design was sometimes referred to as the 'Lobster tailed pot helmet', also known as harquebusier's pot. The hinged peak with the sliding nasal bar is raised in this portrait, perhaps to indicate times of peace. Nevertheless, Dorset is ready to ride and his calf-skin Cavalier boots have their spurs clearly visible.

Dorset pushes his hips forward in a pose of *contrapposto*. Nevertheless, this is as much caused by the high heels on his boots as by his desire to adopt a fashionable Italianate pose. It is sometimes assumed that these so-called 'Cavalier boots' were peculiar to the royal faction. They were in fact a universal fashion, often worn by the parliamentary elite. However, one rarely sees a portrait from the Civil Wars showing a Parliamentarian wearing this fashion since, in order to show the footwear of a sitter, you must commission a full-length portrait. Most portraits of Parliamentarians are half or three-quarter length and the depictions of fashion stop at the thigh.

1 Clarendon, 1826, Vol. I, p.106
2 Dorset's letter to the Countess of Middlesex, August 1642, fols 1r–1v, 3v, CKS, uncatalogued Cranfield MSS
3 *Ibid*, fols U269/C8

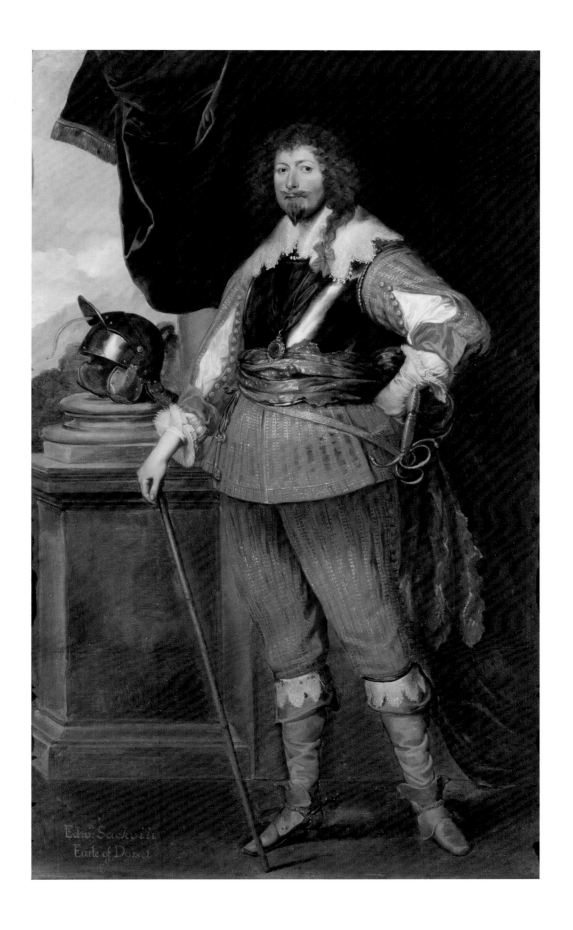

Edw. Sackvill
Earle of Dorset

ROBERT DEVEREUX, 3RD EARL OF ESSEX (1591–1646)

PORTRAIT BY DANIEL MYTENS

LORD-GENERAL OF PARLIAMENTARIAN FORCES

'His courage was great, his honour was inflexible; but he rather waited, than sought for opportunities of fighting; and knew better how to gain, than improve a victory. When he took command of the parliament army, he was better qualified than any man in the kingdom for that post; but was soon eclipsed by a new race of soldiers, who, if not his superiors in the art of war, went far beyond him in spirit and enterprise.' [1]

R obert Devereux was a better commander than a courtier and yet he never seemed to reach the heights to which he aspired or which he deserved.

He was born to one of the most influential and powerful families of the kingdom and his father, Robert, 2nd Earl of Essex and cultural patron worthy of Maecenas, had almost succeeded in his designs to marry Queen Elizabeth I. Notwithstanding such a pedigree, or perhaps because of it, Essex suffered a bruising introduction to court life. He was publicly cuckolded, the victim of a public annulment on the grounds of impotence and was subjected to the additional injustice of imprisonment.

Quite sensibly he retired to his country home only to emerge again at the prospect of serving in the Protestant armies in the Rhineland, under Sir Horace Vere. His experiences fighting in the Low Countries for a number of years crystallised Essex's 'art of war' which was to re-emerge in the Civil Wars. On 12th July 1642, the Commons named Essex as general of the army which was to be raised for the safety of the king and the defence of Parliament.

He commanded the parliamentary forces at the Battle of Edgehill but the vague outcome of his various engagements seem to indicate that he was a non-committal warrior, perhaps overly cautious and predictable. Despite rising to the position of Lord-General of the parliamentary army, he eventually suffered a severe loss at Fawey in 1644. Essex lost his command and, with it, his sense of purpose.

On his death he was accorded a grand state funeral, which may have given him some comfort for all the disappointments of his life. However, even this legacy was partly denied him when, at the Restoration, King Charles II ordered that Essex's effigy in Westminster Abbey be destroyed.

Although in many respects a minor figure in the history of the Civil Wars, it is central to the thesis of this volume to illustrate the profound emotional and iconographic shift which both he and his portraiture underwent during the period 1620–45.

In the primary oil portrait by Mytens, Essex is shown as the epitome of the court figure. He stands on an expensive Turkish carpet displaying his rich fashions and slim, handsome legs. The fashion is Jacobean

and the collar, cuffs and garters are all items which quickly disappeared from Caroline court portraiture. As discussed, his life at court was plagued by disappointment and almost certainly resentment.

In the heat of battle he was offered the opportunity to be a strong, stern leader, a reinvention of spirit which required a more earnest and sober iconography. This was provided for him by Robert Walker in a portrait where the soft silks have hardened into martial steel and the lace ruff has flattened into a functional lawn collar. There is nothing extraneous about this portrait. It conveys its message of military competence with harsh brevity (Fig.1: T.A. Dean, stipple engraving after Robert Walker – National Portrait Gallery, London).[2]

Fig. 1

1 Granger, Vol. III, pp.61–62

2 This engraving, published in 1827, states that the original oil on canvas by Robert Walker was in the collection of the Marquis of Stafford. The portrait appeared at Peter Wilson Auctioneers, Nantwich, 14th–15th July 1999, lot 81, where it was acquired by a private buyer.

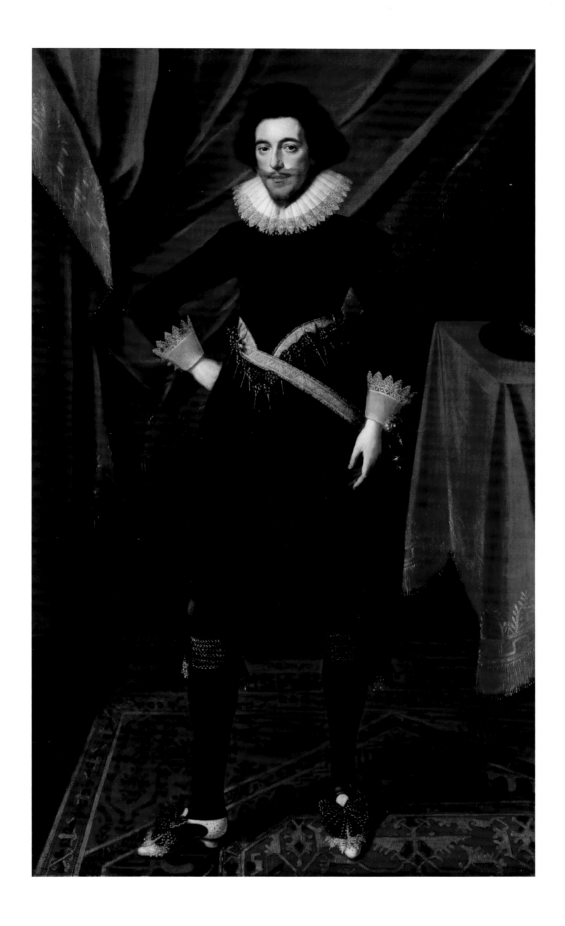

SIR THOMAS FAIRFAX (1612–71)

PORTRAIT BY EDWARD BOWER

PARLIAMENTARIAN ARMY GENERAL

'The man most beloved and relyed upon by the rebels in the north' [1]

Thomas Fairfax was arguably the most influential parliamentary commander throughout the period of the Civil Wars. He encapsulates the complex political tension between fighting for a belief in better government whilst at no point condemning the institution of monarchy.

Born on 17th January 1612, he was the son of Ferdinando Fairfax, 2nd Baron Fairfax of Cameron, and his wife, Mary Sheffield. Between 1629 and 1632 he fought in the Low Countries under Horace Vere, Baron Vere of Tilbury. Some years later he married Anne Vere, the daughter of his former commander.

Fairfax fought for Charles I in the First Bishops' War against the Scots in 1639. Two years later, shortly before the outbreak of Civil War, the king knighted him, probably in an attempt to assure his allegiance to the crown. Despite this honour, Fairfax sided with the supporters of Parliament. It is important, however, not to regard Fairfax as an anti-Royalist. Much later in the campaign Fairfax remarked to Prince Rupert, the king's nephew, that he was fighting 'to maintain the rights of the crown and kingdom jointly; a principal part whereof is, that the king … is … to be advised … by his Parliament, the great Counsel of the Kingdom'.[2] In this view Fairfax was echoing the sentiments of his father who had proclaimed on his own battle flag, 'Long live the king, but death to bad government.'[3]

Between 1642 and 1645 Fairfax fought with great success, effectively containing Lord Newcastle and his army in the north of England, thereby preventing them from marching south and joining forces with the king. On 2nd July 1644 Fairfax fought at the Battle of Marston Moor, the largest battle ever to be fought on English soil. Fairfax commanded the cavalry on the right wing, and although much of his division was routed, the Parliamentarian forces were ultimately victorious. Soon after the victory at Marston Moor, the Commons voted that Fairfax be named commander-in-chief of a newly amalgamated army, called the New Model Army. Fairfax consolidated the momentum with victory at the Battle of Naseby and, by 1646, Fairfax had welded the New Model Army into an efficient fighting force rendering the Civil Wars all but won.

At such a highpoint in his military career, it is not surprising that Fairfax should have commissioned such a swaggering portrait. The portrait is a vibrant and colourful representation of a man fresh from military success. Fairfax's costume, with the green sash at his waist and the slashed sleeves, recalls many of the Royalist cavalry commanders. This emphasises the synthesis, ever present in Fairfax's character, of loyal Parliamentarian combined with an instinctive allegiance to monarchy. Bower has emphasised this synthesis by reworking the iconography originally used by Van Dyck for his portrait of King Charles I, painted in 1638 (Fig. 1 – Hermitage Museum, St Petersburg). Both King Charles and Fairfax hold their batons of command, both men rest their left hands either on, or above, the sword hilt in a pose of Italianate *contrapposto*, and the helmets of both men shimmer with a martial menace just below head height.

Bower has further flattered his sitter, omitting the unsightly wound on Fairfax's left cheek which he sustained at Marston Moor. Unlike John, 1st Baron Byron who bore his scar with pride, Fairfax was keen to be portrayed as the physical ideal of the parliamentary cause. The portrait is a glamorous work for a Parliamentarian commander still in the heat of civil hostilities and is an expression of the manner in which Parliamentarians were learning to harness the iconography of power.

Another, ostensibly unusual iconographic element of this portrait of a parliamentary commander is the jewel which Fairfax ostentatiously wears at his chest. This is likely to be the jewel which was voted to

1 BL, Add. MS 18980, fol.33v

2 Sprigge, p.98.

3 BL, Sloane, MS 5247, fol.20v

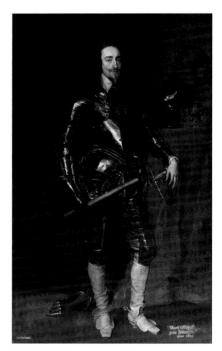

Fig. 1

him by Parliament in thanks after the Battle of Marston Moor. The remarkable sum of £700 was set aside for the creation of this jewel and Fairfax wears it with pride. This portrait of Fairfax is a perfect indication of how as the Civil War continued and, as one side edged closer to victory, the iconographic distinctions between Royalist and Parliamentarian became blurred.

Fairfax's temperament was ill suited to the political manoeuvring which followed the end of the Civil Wars and, although he remained consistently loyal to the parliamentary cause and would seem to have approved of the subsequent trial and deposition of Charles I, he vehemently refused to countenance the king's execution and did not serve on the court which tried the king.

Fairfax spent most of the interregnum in political retirement at his home at Nun Appleton, Yorkshire. He subsequently supported the restoration of Charles II and, at his coronation, the king rode a chestnut horse which had been a gift from Fairfax's own stables. Fairfax died on 12th November 1671 and was buried at Bilborough Parish Church, near York, together with his wife.

JANE, LADY FISHER (*c.*1629–89)

PORTRAIT BY JOHN HAYLS

ROYALIST

'An acute wit … an excellent disputant' [1]

Jane Lane, later Lady Fisher, was at the centre of one of the most romantic stories of the Civil Wars. She played a key role in helping Charles II to escape from England after the Battle of Worcester, she subsequently maintained a lively correspondence with the king in exile and was handsomely rewarded for her loyalty at the Restoration.

Jane was daughter of Thomas Lane and Jane Bagot, and lived in a small village in Staffordshire. Her brother, John, served as a colonel in the royalist army during the Civil Wars.

At the Battle of Worcester, on 3rd September 1651, the Civil Wars largely came to an end. Cromwell's New Model Army defeated Charles II's troops, the king escaped, and a reward of £1,000 was immediately offered for his capture.

Charles II, accompanied by Henry, Lord Wilmot, arrived at Bentley Hall, the house of Colonel John Lane. Wilmot discovered that Jane had a permit to travel to Bristol to visit a relative who was pregnant. Wilmot's theory was that it would be possible for Charles to escape to France from the port city of Bristol. The plan was devised that Charles would travel as Jane's servant. Given that Charles was the king, and arguably the single most famous men in the kingdom, it seems remarkable that the ruse should have worked so effortlessly. As Charles was a very tall man, one might think that it would be easy to recognise someone of 6ft 2 in, with curly hair to his shoulders and a regal bearing.

However, it seems likely that no-one, in the intervening towns between Jane's home and Bristol, had ever seen the monarch in the flesh or, if they had, it was from a considerable distance on the battlefield. Most common people would have been familiar with the engraved images of the king from pamphlets and, with a change of clothes, a trim of the hair and beard and a stoop, it was possible for Charles to affect a passable disguise.

It subsequently came to the attention of the Council of State that Jane Lane had been involved in the king's escape and she escaped to France. Charles arranged for her to take up a position as a lady-in-waiting to his sister, Princess Mary of Orange. Jane's father and brother were not so fortunate and a letter from Charles to Jane reveals that they both languished in prison in England as a result of his escape. At the Restoration, Jane returned to England and in 1663 she married Sir Clement Fisher, 2nd Baronet of Great Packingham. The Archbishop of Canterbury presided over the ceremony.

This portrait is likely to have been painted shortly after the Restoration. It is a work which triumphantly celebrates Jane's, now Lady Fisher's, achievements and, in all likelihood, Jane herself was the one to have commissioned the portrait. She ostentatiously wears at her breast the jewel which was voted to her by Parliament to commemorate her service to the crown and which cost £1,000, exactly the same amount as the reward which had been offered for Charles's arrest after the Battle of Worcester. Jane wears her hair in tight corkscrew curls in emulation of the hairstyle of the queen, Catherine of Braganza, and her oyster coloured dress is made of expensive satin.

Jane holds a crown over which she lightly trails a black gauze. This is clearly an allusion to Jane disguising, or veiling, the king during his escape. By her actions, Jane held the fate of Charles's crown in her hands. There may well be an additional verbal joke, namely that, on 11th September 1651, Charles, Jane and her travelling party spent the night at the Crown Inn. There was a persistent and, probably scurrilous, rumour that Jane and the king had been lovers. Jane alludes to this herself with her choice of inscription *Sic, sic, iuvat ire sub umbra*. This is a verse, spoken by another female hero, Dido, moments before her suicide in Book IV of Virgil's *Aeneid*. The poetry translates as *Thus, in this way it is pleasing to pass into death*.

Dido and Aeneas had a passionate affair and, although one could interpret, and translate, *sub umbra* as an allusion to disguise and actions which take place in the shadows, it is nevertheless a provocative allusion for the sitter to make. A related portrait, which descended in the sitter's family until it hung at Packington Hall, shows a similar vision of Jane but there is an additional element of the Hydra in the background. The Hydra was a mythological beast which was only vanquished by the demi-god, Hercules, as one of his Twelve Labours. The allusion of course is that Jane represents the female Hercules of Restoration England and it is clear that she was not afraid of bold statements to match her bold actions.

1 John Eveyln – see Kelsey, fn.60

LIEUTENANT GENERAL CHARLES FLEETWOOD (*c.*1618–92)

PORTRAIT BY ROBERT WALKER

PARLIAMENTARIAN GENERAL

'This General Fleetwood was a weak man, but very popular with all the praying part of the army.' [1]

'He would, in the midst of any discourse, invite them all to prayer, and put himself on his knees.' [2]

A fervent Puritan, a ruthless general, a talented administrator and Oliver Cromwell's son-in-law, Fleetwood was a key member of the parliamentary cause.

Fleetwood was the son of Sir Miles Fleetwood of Aldwinkle, Northamptonshire and his wife, Anne. He initially began his career at the bar in Gray's Inn in 1638. At the outbreak of war he served in the lifeguard of Thomas Fairfax. He subsequently was rewarded with the command of a regiment and fought bravely at Naseby. In 1646 he was elected as MP for Marlborough.

At the conclusion of hostilities in England, he was fortunate enough, or sufficiently wise, not to participate in the king's trial and was subsequently appointed Governor of the Isle of Wight. He was appointed Lieutenant-General of the Horse and took part in Cromwell's campaigns in Scotland.

In 1652 he married Cromwell's daughter, Bridget, who had formerly been married to another of Cromwell's loyal generals, Henry Ireton, who had died the previous year. In the same year he was appointed Lord Deputy of Ireland and he enforced the Act of Settlement which settled former soldiers of the New Model Army on the confiscated lands of Catholic landowners. He was a central figure during the Protectorate but lost influence as soon as Monck's army began the process of the Restoration.

The present portrait is a standard product of Walker's studio and, in its composition with the sitter in armour, it bears strong resemblances to many royalist portraits by Van Dyck, in particular the portrait of Charles I (Arundel Castle) or the portrait of George, Lord Goring (formerly in the collection of the Earls of Clarendon[3]), Thomas Wentworth, 1st Earl of Strafford, and others.

However, there is a ten-year difference between the portraits painted by Van Dyck and those created by Walker. The intervening decade had seen intense and bloody fighting, rarely experienced by those whom Van Dyck portrayed in armour.

By the time of this portrait, *circa* 1650, such full armour would no longer have been worn. Walker's use of this iconographic motif shows how Parliamentarian figures of authority were keen to be shown in the antiquated and anachronistic style of previous decades. Equally, however, this choice of simple, martial iconography might have had something to do with the fervent Puritan faith which Fleetwood shared with Cromwell. These portraits exist as emblems of the 'soldiers of God', archangels whose mission was to combat the heresy propagated by the king and his followers. Viewed in this context, the portraits cease to be mundane, repeated representations of 'men in armour'. Instead, they take on the collective, iconographic power of a martial and spiritual army.

1 Clarendon, 1826, Vol. VII, p.367

2 *Ibid*, p.391

3 This portrait was sold at Sotheby's, 8th December 2010, lot 17.

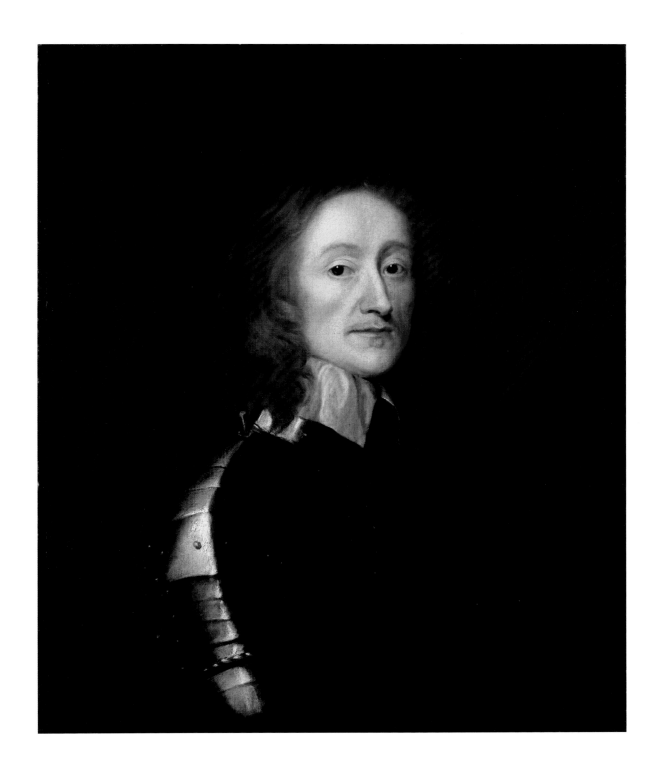

ARTHUR GOODWIN (1593/94–1643)

PARLIAMENTARIAN CAVALRY COMMANDER

'One of the active patriots in this reign' [1]

Goodwin was a committed Puritan and Parliamentarian. In May 1640 he signed the protestation pledging to support the Protestant religion and the privileges of Parliament. Later that year he contributed £1,000 towards a loan of £100,000 to allow the raising of an army, in the event that the king should dissolve Parliament. A man of substantial financial means, he regularly used his wealth for the parliamentary cause.

He fought at Edgehill and Turnham Green as colonel of his cavalry regiment, serving under Robert Devereux, Earl of Essex. Goodwin saw most fighting in the county of Buckinghamshire, where he had served as MP for both High Wycombe and Aylesbury, and in which role he had frequently opposed the policies of Charles I. Buckinghamshire was a key county on account of its strategic position between London and Parliament on the one side and Oxford and the king on the other.

Throughout 1642 Goodwin had great success. Together with Bulstrode Whitelocke and his old school friend, John Hampden, he captured the Earl of Berkshire who was in the process of raising troops for the king at Oxford. He prevented the royalist seizure of Daventry, in the process of which he also captured the Earl of Northampton. These successes contributed to his appointment, in January 1643, as commander-in-chief of parliamentary forces in Buckinghamshire.

Later that year he was instrumental in forcing the retreat of Prince Rupert. He died in August 1643 of a 'camp fever'. Goodwin had married Jane, daughter of Richard, 2nd Viscount Wenman. They had one daughter, Jane, his 'deere Jenny'. His will left provision for the building of six almshouses, which were to be endowed with £30 a year.

The present portrait is a harmonious blend of the patrician and the puritanical. Goodwin was something of a dandy and Van Dyck employs an elegant *contrapposto* which gives his body an elegant twist and, theatrically, projects one booted foot into the viewer's space. The colouring, however, is muted. He wears brown-grey breeches and a golden brown doublet. Even the background curtain is a pale red. It is as though Goodwin was keen not to overemphasise his obvious wealth and position. The painting was executed *circa* 1639, two years after the marriage of his daughter to Philip Wharton, a fervent Puritan, and the sombre elegance of this portrait chimes well with such attitudes. Nothwithstanding this, Goodwin's short cloak represents high fashion and similar short cloaks are seen on the Stuart brothers in their portrait by Van Dyck (National Gallery, London).

The tasselled ends to Goodwin's breeches are similar to 'points' which, usually, were lengths of silk or ribbon with a metal aiglet at the end, rather like modern shoe laces. These points attached to the tops of the boot hose which were worn to protect the silk stockings from the leather of the boots. In this instance, Goodwin is not wearing any boot hose and the 'points' are clearly made of thick strips of leather. It is possible that these were riding trousers and, with the sitter still wearing his spurs, Goodwin is depicted as if ready to depart for action.

Perhaps most importantly, it is rare to find full-length portraits amongst the Parliamentarian elite during the Civil Wars. Such works would have been expensive and probably regarded as profligate expenditure. It is perhaps fortunate for the viewer therefore that Goodwin was able to commission Van Dyck for the portrait before such puritanical views took hold.

1 Granger, Vol. III, p.95

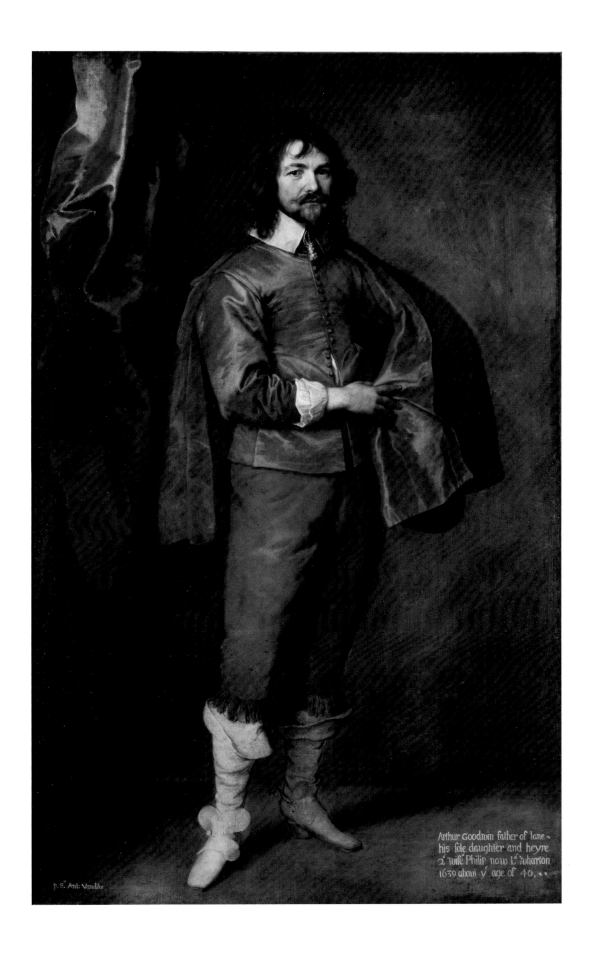

Arthur Goodwin father of Iane ~
his fole daughter and heyre
2 wife Philip now Lᵈ wharton
1639 about yᵉ age of 40, ⁕⁕

P.S. Ant: Vandike

73

GEORGE, LORD GORING (1608–57)

PORTRAIT BY SIR ANTHONY VAN DYCK

ROYALIST CAVALRY COMMANDER

'The most dextrous in any sudden emergency that I have ever seen' [1]

E xtraordinarily talented, extraordinarily unlucky, and almost universally self-serving, Goring seemed to encounter more emergencies than most of his contemporaries during the Civil Wars.

On 25th July 1629 Goring married Lettice, the daughter of Richard Boyle, Earl of Cork. This marriage carried with it a dowry of £10,000, a sum of money which Goring chose to invest in building a reputation as one of the most charming, dashing and profligate courtiers of the era. Needless to say, his £10,000 lasted a relatively short time, and his put-upon father-in-law was once again called upon to purchase a commission in a troop of English soldiers in Dutch service. He rewarded his father-in-law's indulgence by receiving a wound in the ankle at the Siege of Breda in 1637. Goring returned home to England and became Governor of Portsmouth. His military experience on the Continent, however, allowed him to be appointed as commander of a regiment of foot in the army raised by Charles I to suppress the Scottish covenanters in 1639.

In 1641 Goring became involved in the army plot, the basic premise of which was to arrange for the army to support Charles's government. When the plot became unsustainable he betrayed it himself, gaining the praise of Parliament, and somehow avoiding the censure of the king and queen. This double-dealing continued when, shortly before the outbreak of war, he openly received money from both Parliament and the queen to maintain control of the harbour at Portsmouth. When war had finally begun, Goring declared himself on the side of the king. His attempts to hold the harbour, however, lasted no more than a month, and he escaped to the Netherlands, where he, ostensibly, busied himself with raising funds and men for the royal cause.

Goring returned in December 1642, and was rewarded with the command of the horse regiments in the northern royalist army under the command of William Cavendish, Earl of Newcastle. He recorded a significant military success when he beat the parliamentary army commanded by Sir Thomas Fairfax on 30th March 1643. He was subsequently captured, committed to the Tower of London, and then exchanged for the Earl of Lothian. He joined the king at Oxford, and was immediately despatched to the north where he was to reinforce Prince Rupert's army.

Fig. 1

Goring commanded the cavalry of the left wing at Marston Moor, facing the cavalry of Sir Thomas Fairfax. Although he broke Parliament's right flank, his success was not matched by his fellow generals, and the battle was lost. Jealousy increasingly developed between Goring and Prince Rupert and, shortly before the Battle of Naseby, the king sent Goring to the West Country, commissioning him to command all the western forces. Although he had some success, Goring's forces were eventually defeated by the New Model Army which arrived in 1645. Goring escaped to the Continent and led an itinerant life for the next 12 years, eventually dying in Madrid.

The present dual portrait portrays Goring as the dashing cavalry officer (right-hand figure) and his comrade Mountjoy Blount, 1st Earl of Newport (left-hand figure). Goring lifts his right arm to allow his page to adjust his brightly coloured sash. The motif of the page seems to be Venetian in origin and Oliver Millar cites Giorgione's portrait of so-called Gaston de Foix at Castle Howard as a good early example of the iconography [2] (Fig. 1 – engraving by Anthony Cardon, *c.*1792–1813). In contrast with the Venetian prototype, Van Dyck has imbued the portrait with a hint of melancholy, as if his two sitters don their

1 Bulstrode, p.134
2 Barnes, De Poorter, Millar, and Vey, p.562

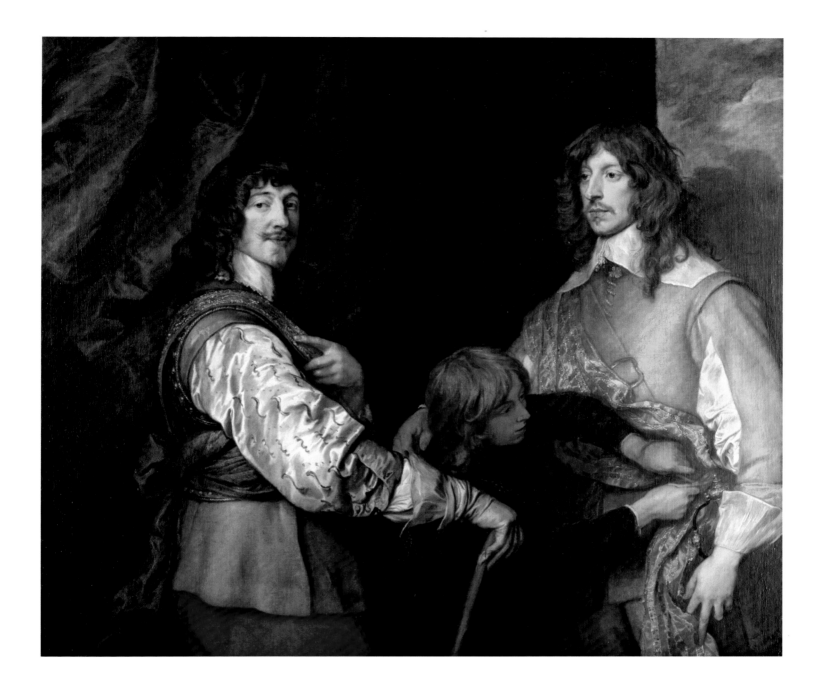

armour with reluctance and a sense of unavoidable fate. It was the critic, John Ruskin, who later opined that Van Dyck's sitters seemed afflicted by a sense of 'insecurity'.

Painted *circa* 1635–40, this portrait would seem to have been commissioned to celebrate Goring's and Newport's respective commands in the wars. Newport himself had recently been appointed as Commander of Ordnance in 1634. Van Dyck creates a sense of space and volume by rotating the three figures in different positions. Newport stands in profile, whereas the page is turned three-quarters, and Goring stands almost frontally.

The iconography of the sitter attended by their page was immediately adopted by Robert Walker, most notably in his portrait of Cromwell (National Portrait Gallery, London) but also with other members of the Cromwellian circle, for example Colonel Hutchinson.

SIR BEVIL GRENVILLE (1596–1643)

PORTRAIT BY A FOLLOWER OF CORNELIUS JOHNSON

ROYALIST INFANTRY COMMANDER

'He was a gallant and a sprightly gentleman, of the greatest reputation and interest in Cornwall, and had contributed to all the service that had been done there.' [1]

Grenville was a man of considerable, but reckless, valour. He had likely inherited this strain of hot bloodedness from his grandfather, Sir Richard Grenville, who as Captain of the *Revenge* had single-handedly engaged 53 Spanish vessels.

He was the son of Sir Bernard Grenville and his wife, Elizabeth. He served as MP for Cornwall and subsequently for Launceston but was eventually refused his seat in the House of Commons for failing to pay the 'Forced Loan'.

At the outbreak of war, Grenville raised a regiment of Cornish infantry whom, according to Clarendon, he maintained with his own funds.[2] He served briefly with this regiment, but always with distinction.

Under the command of Ralph Hopton, Grenville fought at the Battle of Braddock Down on 19th January 1643, where he led an infantry charge, uphill, which resulted in the death and capture of many of the opposing parliamentary army. Later that year he also fought at the Battle of Stratton on 16th May.

It is the Battle of Lansdown, however, on 5th July 1643, for which Grenville's valour will mostly be remembered. The battle was strategically important since the Royalists were keen to unite their forces in Cornwall to unite with those of Prince Maurice in Oxfordshire. Hopton ordered a frontal assault on Lansdown Hill. Grenville charged with his men, again uphill, but at the summit he received a fatal blow to the head with a pole-axe, a wound from which he died the following day. The relationship between Grenville and Hopton was clearly an effective one and, at Grenville's death, the loss of his talismanic charisma with which he charmed his Cornish infantry seems to have severely compromised royalist success in the west.

This portrait is, in one sense, resolutely formulaic. The pose is taken directly from a number of portraits by Van Dyck and the sitter wears costume familiar from dozens of similar portraits. Portraits of this type usually depict engagements with a generic quality. There is a peculiar viciousness to the detail of the cavalry engagement in the background which shows a cavalryman firing his pistol into the chest of his enemy as well as the detail of a dead horse. In the prime version (see Appendix) the rider from this horse is trapped under his mount as he is fired upon. It is tempting to hypothesise that this engagement is intended to depict the Battle of Lansdown.

Additionally, this portrait is known in an abundance of versions and copies. Grenville's leadership made him a martyr to the royalist cause and a hero with the common soldier. The abundance of versions attests to a form of 'cult', which saw its culmination in the erection of Sir Bevil Grenville's Monument, in 1720, on the site of his death.

1 Clarendon, 1826, Vol. IV, p.605
2 *Ibid*, Vol. II, p.452

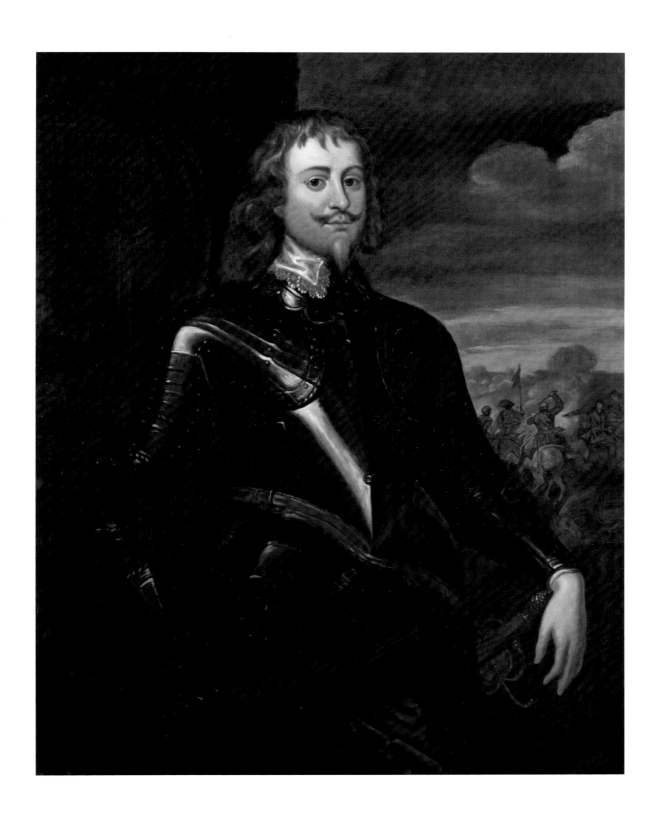

LADY BRILLIANA HARLEY (1598–1643)

PORTRAIT BY FOLLOWER OF THEODORE RUSSELL

PARLIAMENTARIAN SOLDIER AND WRITER

'The Lord direct me what to do; and, dear Ned, pray for me that the Lord in mercy may preserve me from my cruel and blood thirsty enemies.' [1]

Brilliana Harley was a woman of formidable strength, independent spirit and Puritan faith. The survival of approximately 375 letters to her husband, eldest son and others offers an unparalleled insight into the life of a family during times of war.

Brilliana was the daughter of Edward, 1st Viscount Conway and his wife, Dorothy. At the time of her birth, her father was Lieutenant-Governor of the city of Brill, in the Netherlands, leading to her unusual Christian name.

Brilliana married Sir Robert Harley. During the long periods of his absence at Parliament, Brilliana maintained the household. This role extended beyond the provision of medical, maternal and spiritual advice to her family and in the summer of 1643, she was required to defend her family's home against Sir William Vavasour. It seems clear that Brampton Bryan Castle was a legitimate military target, given that Brilliana had clearly supplied arms, horse and refuge to parliamentary forces. This did not prevent Brilliana from arguing in letters to Vavasour and to the king that she remained a loyal subject. The siege was raised when Vavasour was required at the Siege of Gloucester. Brilliana then organised the deconstruction of the royalist earthworks and, in what seems a rash moment of vindictiveness, despatched some of her soldiers to attack a royalist camp at the nearby town of Knighton. She died during the winter of the same year, perhaps exhausted by her efforts.

The present portrait is a simple vision of an attractive woman. The dress is fashionably cut and the exposed shoulders and the décolletage are, ostensibly, more provocative than one might expect in the portrait of someone often perceived as a Puritan hardliner. However, one must guard against anachronistic interpretations of fashion. Anne of Denmark had been painted in mourning dress with a plunging neckline (National Portrait Gallery, London) and Inigo Jones had designed a masque costume for Queen Henrietta Maria, which fully exposed both her breasts. In fact, the design of Brilliana's dress is not so different from the dress worn by Henrietta Maria, painted by Van Dyck *circa* 1663–38 (No. 31–San Diego Museum of Art, USA).

The present work was probably painted *circa* 1642, just before the beginning of the Civil Wars and it is not surprising that the sitter's fashion follows that of the royal family. This portrait is likely to have been commissioned, and paid for, by the sitter's husband who would have been keen for this portrait to convey a message of status and beauty. Brilliana's pearl necklace would have been expensive as would have been the jewels on her dress.

Given the sitter's subsequent puritan feelings, it is tempting to try and read this portrait as an abbreviated vision of her character and allegiances. However, it is unhelpful to try to distinguish between Parliamentarian and royalist iconographies since often the portraits, in particular portraits of ladies, on both sides of the political divide followed the same conventions and looked identical.

1 Brilliana Harley – letter to her son, 25th August 1643 – see Lewis, p.208

QUEEN HENRIETTA MARIA (1609–69)

PORTRAIT BY THE STUDIO OF SIR ANTHONY VAN DYCK

QUEEN AND CONSORT

*'Tis pity so noble and peaceful a soul should see, much more suffer, the rudeness
of those who take up their want of justice, with inhumanity and impudence …
Her sympathy with me in my afflictions, will make her vertues shine with greater
lustre, as stars in the darkest nights, and assure the envious world, that she loves
me, not my fortunes.'*[1]

The sitter was the wife of Charles I and the daughter of Henri IV of France and his wife, Marie de' Medici. Henrietta married Charles I in 1625 but, on account of her strong Catholic faith, she was never crowned.

At the outbreak of war, Henrietta travelled to the Netherlands to try and raise money for the royalist cause, in part by selling some of the Crown Jewels. She returned to England and spent the autumn and winter of 1643 in Oxford, in Merton College. She escaped to France in 1644 and only returned to England when her son had been restored to the throne in 1660.

This elegant portrait illustrates the queen in a technically difficult three-quarter seated pose. The sitter appears relaxed and her right hand seems to play with the hem of her sleeve as it trails from the ledge. Her left hand casually protects two rose stems which, presumably, by placing them close to the sitter's womb indicate fertility. Painted *circa* 1636, the queen had already borne four children and Henry, Duke of Gloucester would not be born until 1640.

Henrietta was, reportedly, petite and Van Dyck's choice of the seated composition disguises this fact. Her dress is low cut and, although this might seem provocative, the style was consistent with court and masque fashion. Henrietta is reported to have been a woman of vivacious charm and extravagant taste and, in the early years of her marriage to the king, spent a great deal of money on fashion and jewellery. Her satin gown of blue satin is decorated with jewels in the shape of cherubim who, playfully, seem to climb her arms and ascend the body of dress. The prime version of this composition is not known but two portraits of *'Une Reyne vestu en blu'* are listed in the list of pictures for which payment was made to Van Dyck. These two portraits cost £30 and £60 respectively.[2]

As Henrietta was not allowed to be crowned beside her husband, the presence of her crown in this portrait seems to make the point all the more deliberate. However, the grandeur of the crown is at odds with the modest seat in which she sits. There is a similarity between this seated pose and that of Van Dyck's *Portrait of Thomas Wentworth, Earl of Strafford with his Secretary, Sir Philip Mainwaring*. This portrait itself derives from Titian's *Portrait of George d'Armagnac with his Secretary, Guillaume Philandrier* (Fig. 1 – Duke of Northumberland) and the idea that Van Dyck painted the queen in an unadorned chair to suggest her role as confidante, advisor or secretary is a tempting interpretation. Certainly the sense of informality conveyed by the composition resonates with the king's own views of his wife as someone in whom he could place his complete trust.

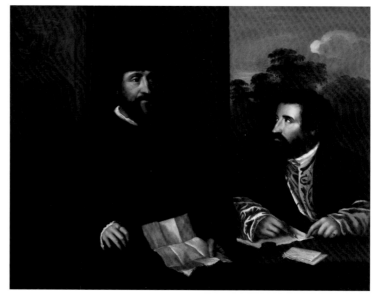

Fig. 1

1 Unknown author, *The Life and Death of Henrietta Maria de Bourbon, Queen to that Blessed King and Martyr, Charles I. Mother to his late glorious Majesty of Happy Memory, K. Charles II. And to Our Present Most Gracious Sovereign, James II*, London: Dorman Newman, 1685, reprinted 1820, p.29

2 £30 and £60 in 1640 are the equivalent of, £3,500 and £7,000 respectively in currency today.

GENERAL SIR ARTHUR HESILRIGE, 2ND BARONET (1601–61)

PORTRAIT BY ROBERT WALKER

PARLIAMENTARIAN ARMY OFFICER

'A man of disobliging carriage, sower and morose of temper, liable to be transported with passion, and to whom liberality seemed to be a vice' [1]

'The sincerity of his intentions … to keep the sword subservient to the civil magistrate' [2]

Clearly something of a stern fellow and an almost archetypal Puritan officer, Hesilrige was one of the preeminent Parliamentarians.

He was born in Noseley, Leicestershire, the son of Thomas Hesilrige, 1st Baronet, and his wife, Francis. He married, as his second wife, Dorothy Greville. He was a vocal opponent of Ship Money in Leicestershire and was closely associated with John Pym and other Puritans working to oppose Charles I's government.

In 1640 he was elected as MP for Leicestershire. The following year Hesilrige supported the impeachment of Thomas Wentworth, Earl of Strafford, as well as the Root and Branch Bill which called on Parliament to abolish archbishops and bishops. He was vehemently opposed to the Laudian church. Not surprisingly, King Charles I found his repeated opposition a severe irritation and, in 1642, together with John Hampden, Denzil Holles, John Pym and William Strode, he was one of the five MPs whom Charles I tried to arrest in the Commons.

As a consequence, Hesilrige introduced the Militia Bill which allowed Parliament the authority to appoint their choice of lord lieutenants in order to prevent armed force being used against Parliament in the future.

At the outbreak of war, Hesilrige fought at the Battle of Edgehill as part of the regiment of Sir William Balfour. By 1643 he was serving as second-in-command to Sir William Waller. He held the city of Newcastle against the Royalists in 1647 and campaigned with Cromwell in Scotland in 1650. During his years as Governor of Newcastle, Hesilrige acquired a substantial property portfolio by depriving defeated Royalists of their estates as well as the Bishop of Durham. The blatant hypocrisy of this behaviour was clear to all and the Leveller, John Lilburne, even suggested that Hesilrige had outperformed Strafford in his designs to trample civil liberty.

Although invited to sit as one of the king's judges, Hesilrige declined and, at the establishment of the Protectorate, he seems to have become a strong opponent of Cromwell. At the Restoration, his life was only spared after the personal intervention of General Monck with King Charles II. He eventually died in the Tower of London.

The present work is another of Walker's long list of the parliamentary great and the good, all modelled on the iconography of Van Dyck. Fascinatingly, although dated 1640, which would make it one of Walker's earliest portraits in the Van Dyck style, infra-red images have revealed that the work was painted over another image with similarities to the Cromwell Museum portrait of Cromwell (No. 14). If correct, this would make the dating closer to 1649–50 when Walker was establishing his Cromwellian iconography. The logic would then dictate that Walker simply painted over one of his stock images of Cromwell for his new patron, Hesilrige. The inscription which, erroneously, dates this work as 1640, is likely to have been added whilst in the family collection at Noseley, the date chosen as the important year in which the sitter first entered politics as a Member of Parliament.

Hesilrige was renowned on the battlefield for his regiment of cuirassiers who were often referred to as 'Lobsters', on account of their armour which, unusually for the time, stretched three-quarter length below the waist.

1 Ludlow, pp.133–4
2 *Ibid*

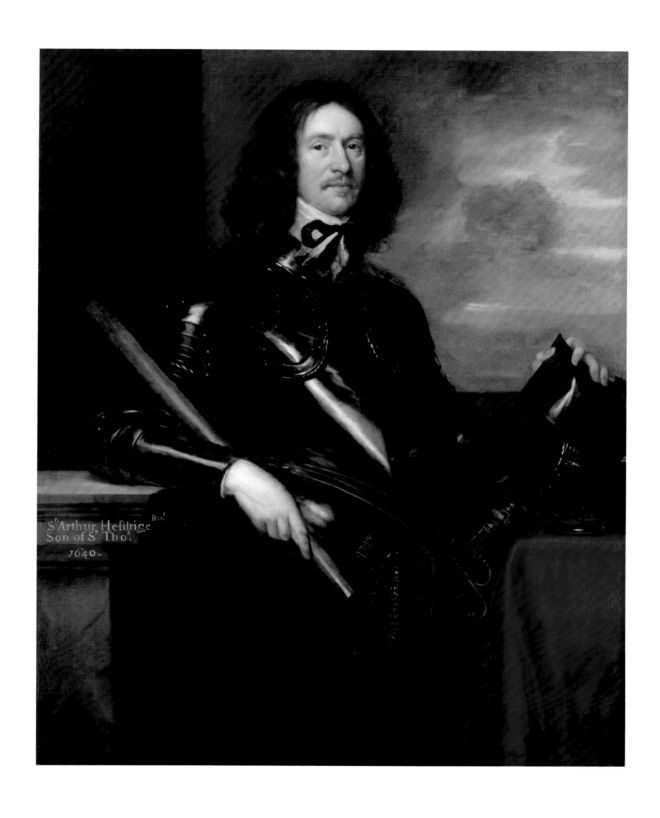

RALPH HOPTON, 1st BARON HOPTON OF STRATTON (1598–1652)

PORTRAIT BY A FOLLOWER OF SIR ANTHONY VAN DYCK

ROYALIST COMMANDER

'One whom we honour and esteem above any other of your party' [1]

'As faultless a person, as full of courage, industry, integrity and religion as ever I knew man' [2]

Seemingly rather under-appreciated during his life and largely forgotten at his death, Hopton was one of the more successful royalist generals during the Civil Wars.

More precisely, he remained almost unbeaten, provided that he fought his battles in Cornwall. The scorecard in Devon, Wiltshire and Hampshire was much more uneven. His main adversary was his close friend, Sir William Waller, leading Waller to complain about 'this war without an enemy'.[3]

Between 1628 and 1642 Hopton served as MP successively for Shaftesbury, Bath, Wells and Somerset. He had been installed as a Knight of the Bath at King Charles's coronation in 1626 and, at the outbreak of war, the king appointed him as Lieutenant-General of the king's forces in the West Country. He was raised to the peerage in 1643 for his, largely successful, efforts.

His final encounter of the Civil Wars was against General Fairfax at Torrington in North Devon in 1646 where he was wounded. Following the Torrington battle Hopton apparently carried a banner bearing the poignant statement, 'I will strive to serve my Sovereign King'. This was ignominiously captured by Fairfax after Torrington Church exploded. He escaped to Jersey with Charles, Prince of Wales, and died in Bruges of an 'ague' or fever. He was devoted to his wife, Elizabeth, daughter of Sir Arthur Capell, but they had no children and the fact that Parliament sold his estates may well account for his slightly hazy presence in the minds of most historians.

The present work is a sombre portrait of a man devoted to his duties. The stripe of red on the ribbon of the Order of the Bath and the plump tasselled cushion are the only details of colour and luxury to break the sober iconography.

There is a related double portrait of Hopton and his wife which is dated *Ao 1637*, which offers a possible date for this work. This was painted by a follower of Van Dyck and shows the couple seated on a bench holding hands. The composition of this double portrait is more satisfying that this single figure work. The full frontal view of Hopton seems combative, coarse and lacks elegance. Hopton's physique defiantly dominates the canvas space. One feels that he is on the point of sweeping his hat on to his head and abandoning the artist's studio in irritation. The hat itself is interesting. Despite some later restoration, it would originally have depicted a black felt hat, which was the fashionable choice for both men and women in the seventeenth century.

Hopton's arm rests on the ledge awkwardly, as if it the sitter needs the support of the stone to counterbalance the fact that only half his body is raised by the cushion. His tunic is ruched and there is good reason why artists tended to avoid this compositional pose since it inevitably compresses the body and give the impression of a sitter ill at ease.

1 Bailey, p.361. These words were written by Thomas Fairfax in a letter, dated 6th March, proposing that Hopton surrender after the Battle of Torrington (19th February 1646).

2 Clarendon, 1786, Vol. III, p.109

3 Polwhele, p.16

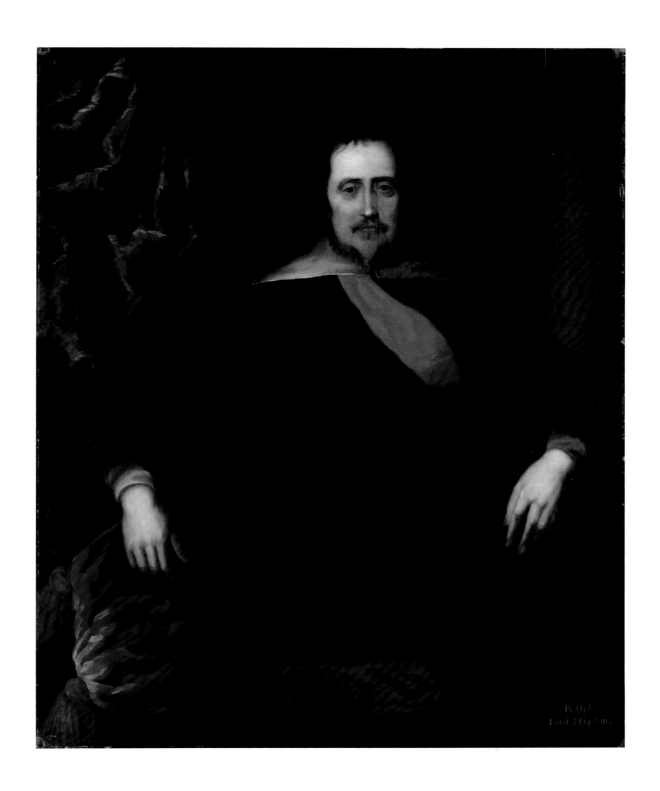

Ralph
Lord Hopton.

COLONEL JOHN HUTCHINSON (1615–64)

PORTRAIT BY ROBERT WALKER

PARLIAMENTARIAN ARMY COMMANDER

'To number his virtues is to give the epitome of his life, which was nothing
else but a progress from one degree of virtue to another.'[1]

'His faith being established in the truth, he was full of love to God and all
his saints. He hated persecution for religion, and was always a champion
for all religious people against all their oppressors.'[2]

'He had a noble spirit of government, both in civil, military and domestic
administrations, which forced even from unwilling subjects a love and
reverence for him.'[3]

Oh, to be so beloved! These quotations reveal a man whose noble temperament and fine talents were *non pareil*. The only qualifying factor would be that these words were all written by the same individual, his wife.

It is true that Colonel Hutchinson valiantly defended Nottingham on behalf of the Parliamentarian cause. It is true that he was one of the judges of King Charles, claiming himself 'obliged by the covenant of God'.[4] It is true that, having signed the king's death warrant, he served as a member of the Council of State and remained, ostensibly, a good Puritan.

However, were it not for the skill and elegance of his wife as an author, Hutchinson's fame might not have survived the ages. It was she who wrote the *Memoirs of the Life of Colonel Hutchinson*, in which the many details of her husband's principled and heroic life emerge, notwithstanding the fact that they remain largely unsubstantiated by other contemporary sources. One might go further and say that, without the endeavours of his wife, historians might have regarded the end of his life – imprisoned in Sandown Castle, Kent, for complicity in an alleged plot, impecunious and seemingly unrepentant – as ignominious at best.

Equally at odds with the God-fearing Puritan cliché, Hutchinson himself displayed a shrewd artistic eye. During the sale of the king's

art collection, between 1650–52, he acquired a number of works by Van Dyck and Titian, including the *Venus of El Pardo*, a magnificent work of Baroque eroticism which was subsequently acquired by the French ambassador and now hangs in the Louvre. Such a purchase well illustrates Hutchinson's sophistication and connoisseurship as a collector whilst simultaneously undercutting any simplistic notion that he was a humourless Puritan. Colonel Hutchinson's wife, Lucy, recalled that 'The only recreation he had during his residence in London was in seeking out all the rare artists he could heare of, and in considering their workes in paintings, sculptures, gravings and all other curiosities, insomuch that he became a greate virtuoso and patrone of ingenuity.'[5] However, these purchases also reveal the hypocrisy of Hutchinson proclaiming his actions as guided by God whilst simultaneously exploiting the losses of the Royalists for personal gain.

The present work was likely painted by Walker at the same time that he painted his portrait of Cromwell *circa* 1651. If this assumption is correct then there seems to have been a concerted decision amongst the parliamentary leaders to establish their status and prominence through the medium of portraiture. The quotation about Walker having painted 'that usurper, and almost all his officers, both by sea and land'[6] begins to sound like a group portrait of a modern day prime minister and his cabinet.

1 Hutchinson, p.24
2 *Ibid*, p.25
3 *Ibid*, p.27
4 *Ibid*, p.334
5 *Ibid*, p.367
6 Buckridge, p.434.

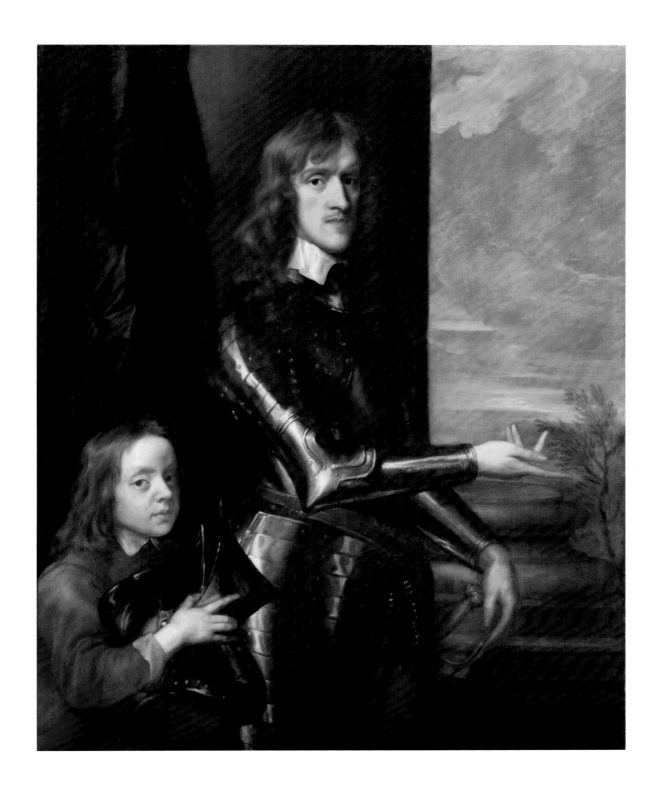

LUCY HUTCHINSON (1620–81)

PARLIAMENTARIAN WIFE AND LITERARY FIGURE

'My mother while she was with child of me, dreamed that she was walking in the garden with my father, and that a star came down into her hand … my father told her, her dream signified she should have a daughter of some extraordinary eminency.' [1]

A remarkable women, a talented scholar, and a writer of all-consuming vanity, Lucy Hutchinson writes about herself as if neither Calliope, Clio nor Euterpe could rival her talents.

Lucy was born in the Tower of London, the daughter of Sir Allen Apsley, Lieutenant of the Tower. However, it was her mother who was perhaps the more memorable parent. According to her daughter, Lady Apsley allowed Sir Walter Raleigh to conduct chemistry experiments at her cost in order to allow her to learn about the compounds, to apply them medicinally and to help the poor people who had no access to physicians. [2] Her mother's knowledge was clearly passed to her daughter since, later in the memoirs, Lucy Hutchinson represents herself as the surgeon during the Siege of Nottingham.

Once peace had returned to England during the 1650s Lucy began work on her translation of Lucretius's *De Rerum Natura*. During the late 1680s that she began to compose the *Life of John Hutchinson of Owthorpe in the County of Nottinghamshire*. Sadly, her manuscript was not published until 1804 but, notwithstanding her occasionally querulous Puritan tone, she seems justifiably to have remained a heroine of female achievement throughout the succeeding centuries.

The present work was probably painted about the same time and the laurel wreath which she holds seems intended to allude to Mount Parnassus, her devotion to the world of the Muses and her literary aspirations. However, the wreath may also serve a double function within the context of this marital diptych. In Ancient Rome, victorious generals would be crowned with laurel. In this portrait therefore, the wreath can conveniently allude to the talents both of a literary wife and a military husband.

The fluted column which rises behind Lucy's portrait seems also intended to recreate the atmosphere of the classical past. Interestingly, in Colonel Hutchinson's portrait, there is no column but merely a plain wall. Given that these portraits were composed as a companion pair, Walker may have been keen to create a horizontal rhythm between the two works. If so, the beat would rise from the martial helmet offered to John Hutchinson by his page. Colonel Hutchinson in turn gestures perhaps towards the tree in the landscape but, more likely, towards his wife who holds the laurel wreath. The rhythm concludes in an elegant diminuendo in the character of the second page who gazes up adoringly at the talented Mrs Hutchinson.

If correct, this pair of portraits could be read as the shift from times of war to times of peace more appropriate for the creation of literature. It is important to remember that these portraits would rarely have been seen by anyone other than the family and guests. The subtle messages contained within them would therefore have been for the consumption and enjoyment of this intimate community.

Lucy and her husband were blessed with a large family, the first children being twin boys, Thomas and Edward, born in September 1639. There is a sufficiently close facial resemblance between the two pages in this and the portrait of Colonel Hutchinson to indicate that the twins were the sitters. These two portraits are truly a diptych of war and peace, unified by family love.

1 Hutchinson, p.16
2 *Ibid*, pp.14–15

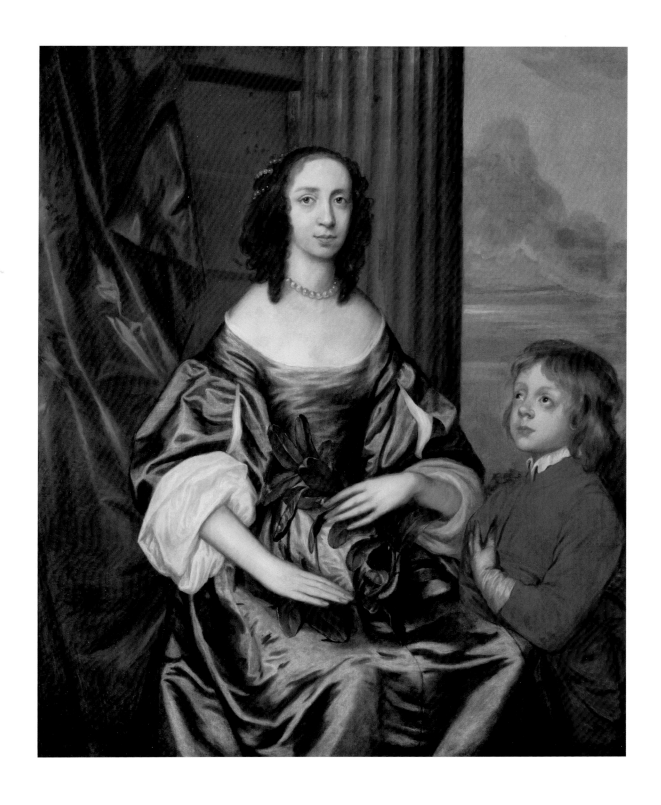

HENRY IRETON (1611–51)

PORTRAIT ATTRIBUTED TO ROBERT WALKER

PARLIAMENTARIAN COMMANDER

'The Armie's Alpha and Omega'
'The cunningest of Machiavellians' [1]

I reton was a good soldier and Cromwell's son-in-law. He was a constitutional revolutionary, a committed Puritan and an extremist Republican who set in motion fundamental changes to the laws of England. He was a man convinced of God's favour, something which those who encountered him on the battlefield, in Parliament or in court, might not entirely agree with.

Ireton fought at the Battle of Edgehill and at the Second Battle of Newbury.

At the Battle of Naseby, Ireton commanded the left wing whilst Cromwell commanded the right. Ireton's forces were bested by the charge of Prince Rupert's cavalry and he was taken prisoner, only achieving his freedom by Cromwell's eventual rout of the royalist forces and the subsequent prisoner exchange.

Ireton was present at the Siege of Bristol in 1645 and became MP for Appleby in the same year. On 15th June 1646, Ireton married Bridget, daughter of Oliver Cromwell.

It was during the late 1640s that Ireton's political voice was particularly prominent. Military and civilian radicals, in particular the Levellers, were invited to debate their proposals about changes to the Constitution before the General Council of the Army. The Levellers demanded universal suffrage for every man in England. Cromwell and Ireton opposed this, claiming that the vote should only be open to landowners.

> *… No person hath a right to an interest or share in the disposing of the affairs of the kingdom, and in determining or choosing those that shall determine what laws we shall be ruled by here – no person hath a right to this, that hath not a permanent fixed interest in this kingdom …* [2]

Although compromises were reached, the king's escape from Hampton Court in November 1647 brought the debates to an end and precipitated the Second Civil War.

Thereafter Ireton was convinced that it was not possible to deal with the king. In September 1648, he drafted the *Remonstrance of the Army*, which was a justification for ending negotiations with the king and a justification for bringing him to trial. This document proclaimed the sovereignty of the people and contained many elements of the Leveller rhetoric from the Putney Debates the previous year. It was Parliament's refusal to consider this document which eventually led to Pride's Purge in 1648. In 1649 Ireton was amongst the first signatories of the king's death warrant.

Ireton was a major-general during the campaign in Ireland and in 1650 became Lord Deputy. There seems little doubt that he was responsible for severe treatment of the Irish Catholics during his campaigns and he was on a self-proclaimed mission to root out Catholicism and the military threat to England. In so doing he also acquired almost 14,000 acres of land in Counties Kilkenny and Tipperary, a hypocrisy from which his reputation has perhaps never recovered.

It was his siege of Limerick which finally led to his succumbing to a fever and then death. Parliament granted him a funeral with considerable ceremony and expense, as well as a lavish monument in Westminster Abbey. At the Restoration, this monument was destroyed and he suffered a posthumous execution, together with the bodies of Cromwell and John Bradshaw.

This portrait is another example of Walker's style of Van Dyck-inspired portraiture employed for the Cromwellian inner circle. For many years the portrait was thought to be by a follower of Samuel Cooper since the head seemed to derive from a miniature by Cooper (Fitzwilliam Museum, Cambridge). This attribution was discounted after the miniature was shown to be by George Perfect Harding, an eighteenth-century miniaturist who, admittedly, often copied portraits from the sixteenth and seventeenth centuries.

Nevertheless, on the grounds of style and iconography, an attribution to Walker is more persuasive. Walker was the painter of Cromwell, Hesilrige, Hutchinson, Lambert and others and it seems likely that the 'court' painter would have been employed for Cromwell's son-in-law.

A peculiarity of this picture is the emphasis placed on the tented camp behind Ireton. Although possibly fanciful the artist has seemingly

Fig. 1

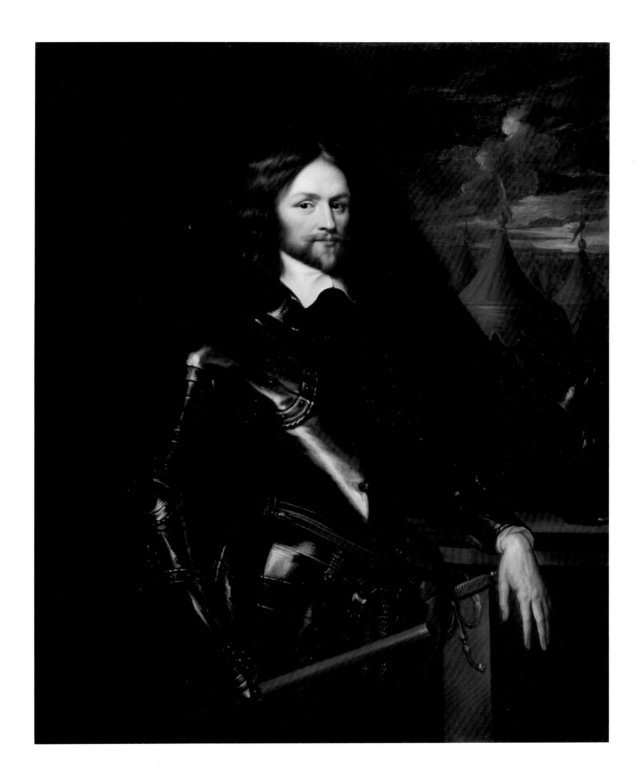

chosen a design for the tents based on Ottoman military encampments. The details of the finials at the apex of each tent as well as the pelmet which runs along the top edges of the tents are both found in oriental military design (Fig. 1 – eighteenth-century engraving by Luigi Marsigli from *L'Etat Militaire de l'Empire Ottoman*, published in 1732).[3]

The shape of the tents is intended to be echoed by the sweep of Ireton's open visor. The artist chose to reinforce this sense of sweeping dynamism by employing the canvas of a tent behind the sitter as an equivalent to the drapery or foliage often seen in Van Dyck's portraiture. This is a moment of brave artistic creativity, even if the fact that it casts much of the portrait into grim darkness makes it not altogether successful.

1 Lilburne, pp.31 and 35

2 Putney debate, 29th October 1647 – see Woodhouse, pp.53–54

3 Scalloped pelmets are not exclusively Ottoman – see David Teniers, *The Drummer*, 1647 (Royal Collection, UK)

MAJOR-GENERAL JOHN LAMBERT (1619–83)

PORTRAIT BY ROBERT WALKER

PARLIAMENTARIAN COMMANDER

'Such was the gallantry of Major-General Lambert, that had it not been for his armor he had been lost, a brace of bullets being found between his coat and his arms.' [1]

John Lambert was one of the most gifted soldiers of his generation and one of the Commonwealth's most powerful politicians.

Lambert played an active part in many of the battles of the Civil Wars in the north of England, including the battles of Nantwich and Marston Moor. Whilst he was in London, he advised his commander-in-chief, Sir Thomas Fairfax, of political developments and constructed a powerful network of relationships within the army. Lambert was the man responsible for the *Instrument of Government*, which was the legislation and constitution by which Cromwell was created Lord Protector and, at Cromwell's installation, Lambert rode with him in his carriage.

Lambert existed in a role of semi-independence from Cromwell. He was a major-general, as well as a leading member of the ruling council, thus giving him invaluable influence with both Parliament and the army. Lambert was instrumental in implementing the rule of the major-generals, the aim of which was to create a form of federal government. The rule of the major-generals was eventually ended by Cromwell, a factor which perhaps created enmity between the two men.

Lambert was wholly averse to any form of kingship and, in discussions with Cromwell he expressed the army's dismay that the latter might be considering accepting the crown. Although Cromwell did not do so, Parliament decided to impose an oath of loyalty on all its councillors. Lambert refused to swear the oath of allegiance to Cromwell in his role as Lord Protector for life and, as a consequence, he was ordered to surrender all his commands.

The imagery of this double portrait suggests a strong sense of friendship and partnership. Cromwell and Lambert fought together throughout the Civil Wars and forged a personal closeness which reached its zenith during the years 1653–57. The split between the two men only came in 1657 and, given this chronology, the portrait is likely to have been painted *circa* 1655–56, after Cromwell's inauguration as Lord Protector, but prior to Lambert's eventual deposition. It is interesting that Cromwell holds the baton of office and Lambert holds his hand outstretched. It seems possible that this picture captures the moment when Cromwell appoints Lambert as one of the ten major-generals. The red cloak which Cromwell wears is perhaps intended to recall the *paludamentum* worn by a Roman general or emperor. If so, Lambert is marked in his subordinate status by only wearing a crimson band on his arm.

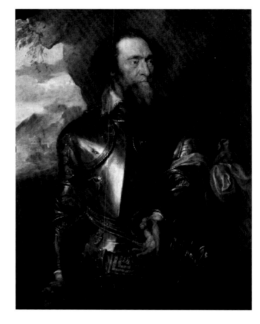

Fig. 1

The imagery of this portrait, like so much of Walker's oeuvre, owes a debt of gratitude to Van Dyck. Not only was Van Dyck an influential proponent of the double portrait but, more specifically, Lambert's pose derives from Van Dyck's portrait of Count Hendrik van den Bergh[2] (Fig. 1 – Museo del Prado, Madrid).

This work had been in the royal collection until it was sold at auction in 1650 after the king's execution. It seems likely that Walker viewed these auctions and would have been familiar with the portrait.

Walker openly acknowledged that he was familiar with the work of Van Dyck and the stock compositions of his studio, and happily conceded that he himself was not an innovator of pose and composition. When asked 'why he did [not] make some of his own postures', his candid reply was, 'If I could get better [compositions] I would not do Vandikes.'[3] Walker is known to have worked as a copyist of Italian old masters, including a number of Titians in the royal collection of King Charles I.[4]

Notwithstanding Walker's self-admitted deficiencies, he was successful in creating a consistent language for Parliamentarian interregnum portraits which effortlessly conveys the required spirit of loyalty, adherence to a 'just' cause, combined with a healthy dose of martial spirit and testosterone.

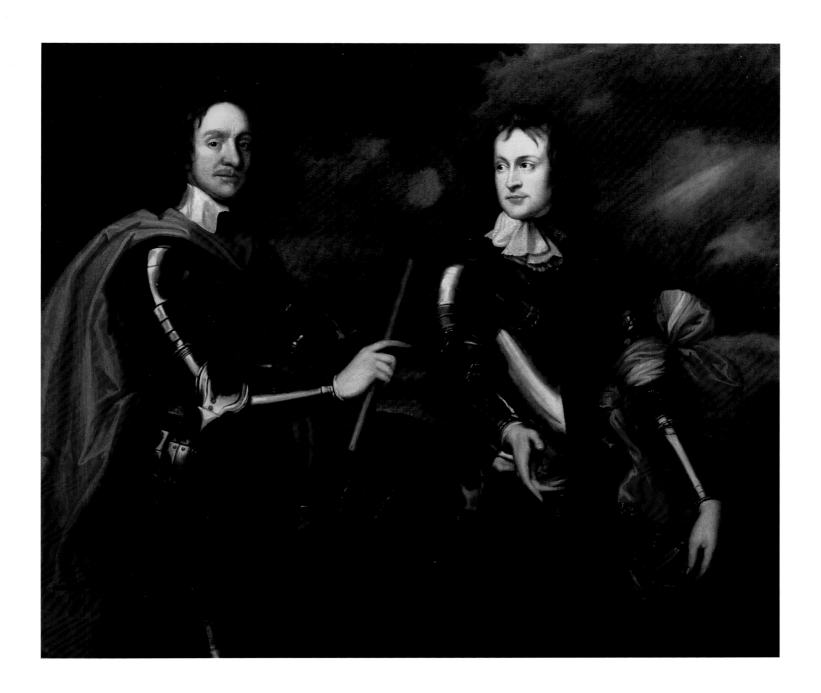

It is tempting to think that this portrait hung at Wimbledon Manor House, which Lambert had acquired when it was sold as part of the dispersal of the Crown Lands in 1649. It was here that Lambert 'turned florist, and had the finest tulips and gilliflowers that could be got for love or money'.[5] From general to gardener, Lambert was a man of deceptively varied talent.

1 *Mercurius Politicus*, 24–31 July 1651, p.965
2 Barnes, De Poorter, Millar, and Vey, III.69, pp.302–3
3 Whinney and Millar, p.77
4 Walpole, Vol. II, p.423
5 Coke,1697, p.406

ARCHBISHOP WILLIAM LAUD (1573–1645)

PORTRAIT BY SIR ANTHONY VAN DYCK

ARCHIBSHOP OF CANTERBURY AND ROYALIST CLERIC

'A man of great parts, and very exemplary virtues, allayed and discredited by some unpopular natural infirmities … no man had ever a heart more entire to the king, the church, or his country.' [1]

L aud was one of the most important and divisive religious figures of the Civil Wars. As Archbishop of Canterbury, he became the man whom the Puritan, Calvinist and other heterodox communities regarded as their enemy. His trial for treason and, the injustice of his subsequent execution, was perhaps the inevitable result of the religious tensions of the Civil Wars.

Laud was constantly accused of Catholic sympathies and, when finally he was appointed as Archbishop of Canterbury in 1633, his desire to impose uniformity and ritual on the Church of England, combined with a pedantic and 'peevish' manner, made him deeply unpopular. However, he was much a victim of his own era and he showed little of the manipulative cunning exemplified by Cardinal Wolsey or Cardinal Richelieu in their own dealings with Church and State.

Laud was the tenth child of William Laud and his wife, Lucy, and his low birth was a source of irritation to him throughout his life at court. This sense of social inferiority finds a clear voice in this portrait.

Painted *circa* 1638, Laud appears ill at ease. He wears a black chimere over his white rochet and his left hand fiddles nervously with the folds of the fabric. His right hand hangs loosely over the edge of a stone ledge. This pose was first used by Van Dyck for his portrait of another cleric, Abbé Scaglia (National Gallery, London) and Van Dyck seems to have re-used the pose having seen a work by Titian which he recorded in his Italian sketchbook.

Abbé Scaglia was an urbane cleric, connoisseur and diplomat who seems effortlessly at home in front of Van Dyck. By contrast, Laud seems nervous and the intensity of his stare suggests a hint of fear. It is possible that, as he stood in front of the great artist, Laud remembered his own words that he considered Van Dyck one of Charles I's unnecessary extravagances. [2] There may be an additional reason for Laud resting his arm on the pedestal. He was a man of no great height and this pose aggrandised his stature.

Van Dyck has painted the fabric with great verve. Van Dyck's love of fabric is well known and documented, but Laud himself was the son of a clothier and it seems that the colour and quality of the fabrics was important to him. Laud was sensitive to comments about his low birth and, despite having risen to the top of the Church, the deep blue garments and the expensive soft hat meant more to him than simple apparel.

1 Clarendon, 1955, pp.103 and 107
2 Jaffe, p.602

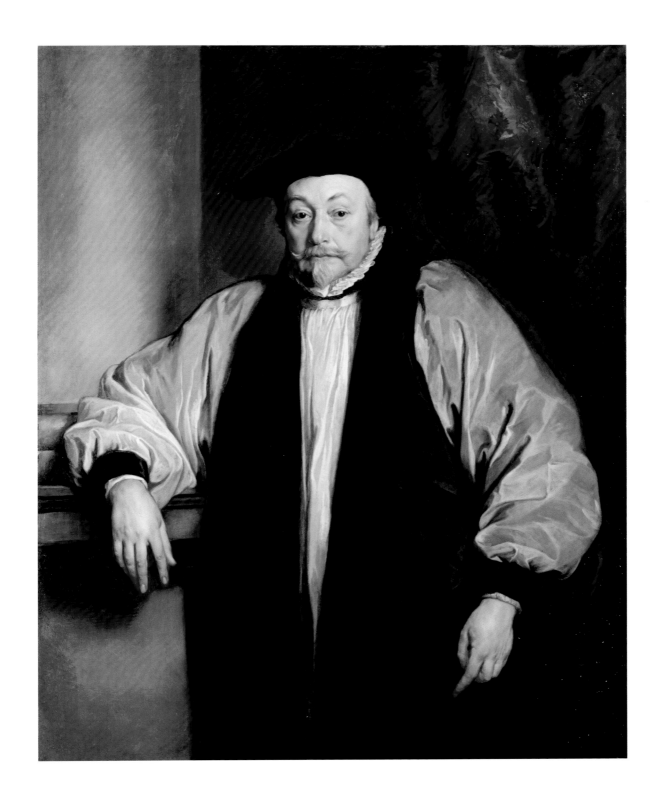

WILLIAM LENTHALL (1591–1662)

PORTRAIT BY EDWARD BOWER

SPEAKER OF THE HOUSE OF COMMONS

'May it please your Majesty, I have neither eyes to see nor tongue to speak in this place but as the House is pleased to direct me, whose servant I am here.' [1]

It was Lenthall's great fortune to hold great office at a time of constitutional chaos and change. To do so was his equal misfortune.

He was a lawyer and speaker of the House of Commons, and his dignified defiance of Charles I was legendary and, posthumously, the subject of a famous picture by Charles West Cope in the Palace of Westminster.

Nevertheless, Edward Hyde, Earl of Clarendon regarded him as a timorous individual without the presence to command respect in the House. Certainly his response to Charles I when he entered Parliament in his attempt to arrest five members may have been adroit but it was also craven, a characteristic for which he seems to have been well known.

At the outbreak of war, Lenthall sided with Parliament. At the Restoration, he claimed to have sent as much as £3,000 to the king but, nonetheless, did not find favour with Charles II.

This wonderful, and monumental, family portrait captures the dignity for which Lenthall was well renowned and perhaps the pliancy for which he was well used. Overt displays of affection were rare in seventeenth-century portraiture and there is a tenderness with which Lenthall gently holds the hand of his wife, Elizabeth. This tenderness is amplified by the detail of the youngest child who tucks his hand into the heavy folds of his father's cloak. Lenthall was survived by one son, John Lenthall (1624/25–81) who, presumably, is the gentleman with the red cloak standing behind Lenthall's shoulder.

The bush of red carnations in the stone urn is probably intended to symbolise love and family affection. Bower clearly included the details of the decorated garden bench, the columns and the distant trees to indicate a garden setting and the corresponding wealth of owning such space. Lenthall himself was an enthusiastic collector of pictures and may have acquired a number of works from the auctions of the late king's good.

Bower's technique in this portrait may be somewhat pedestrian but his eye for composition is both striking and original. With all the members of the family gathered together in a single space, Bower has created a 'conversation piece', long before Hogarth, Devis and others produced similar compositions in England. This style of portraiture originates with the group portraits of students and guilds in the Netherlands. It would eventually morph into a grand Continental style of painting, epitomised by the work of Charles Le Brun and Jean Nocret, in particular his portrait of the family of King Louis XIV, before becoming a ubiquitous compositional motif in English eighteenth-century painting.

Edward Bower worked primarily in London and, although he is now most famous for his portrait of King Charles I at his trial, his clientele was drawn almost entirely from the non-aristocracy.

1 Chisolm, ed., 1911, p.429

LIEUTENANT-GENERAL ALEXANDER LESLIE, 1ST EARL OF LEVEN (*c.*1580–1661)

PARLIAMENTARIAN COMMANDER

'Such was the wisdome and authoritie of that old, little, crooked souldier, that all, with an incredible submission, from the beginning to the end, gave over themselves to be guided by him, as if he had been Great Solyman.' [1]

Born the illegitimate son of George Leslie and a 'wench of Rannoch', Leslie became a soldier of distinction in the Netherlands under Sir Horace Vere and subsequently under King Gustavus Adolphus of Sweden during the Thirty Years War.

Leslie returned to Scotland a wealthy man where he succumbed to the rhetoric of the Covenanters and, by May 1639 he had been appointed as general of all Scottish forces 'for the defence of the covenant, for religion, croune and countrie'. [2]

He was successful in his opposition to Charles I during the First and Second Bishops' War and was referred to as the 'Lion of the North'.

Until this point, one of Leslie's major advantages had been his lack of social rank combined with his reliability as a soldier. However, in 1641, he was created 1st Earl of Leven by Charles and his ennoblement was accompanied by the Governorship of Edinburgh Castle, a seat on the Privy Council of Scotland and a gift of 100,000 merks. Although he was appointed general of the army sent to subdue the Irish Catholic uprising in 1641, his appetite for conflict with armed enemies as well as his own subordinates seems to have been exhausted.

At the outbreak of the Civil Wars, Leven took the parliamentary side but displayed little of his former success. He was forced to flee the battlefield at Marston Moor. His Scottish loyalties turned against Cromwell in 1650 and he was nominally in charge of Scottish forces at their defeat at the Battle of Dunbar. Thereafter, his political and military involvement largely ceased.

The present work is one of many portraits which Jamesone painted in his Edinburgh studio of professional soldiers returning from the Continent. Jamesone's impressive career relied heavily on his spirited emulation of portraits of military commanders by Dutch portraitists such as Michiel Jansz van Miereveldt and his pupil, Jan Anthonisz van Ravesteyn. His English and Scottish sitters were mostly soldiers of fortune who had fought with Sir Horace Vere and who had neither the social grandeur nor the funds to commission portraits larger than a half length. Equally, professional soldiers in the seventeenth-century, by nature of their profession, would have been itinerant, always moving in search of their next paymaster and their next campaign. Full- or three-quarter length portraits would have been cumbersome to transport whereas half-length portraits could travel with their owners as easily as provisions, pistols and pewter.

Jamesone's portraiture is elegant but it can sometimes approach the formulaic, with each sitter turned three-quarters, facing left to right, wearing a lace lawn collar combined with a hint of luxury, such as, in this instance, the embroidered tunic and gold chain of office which might relate to his Governorship of Edinburgh Castle. Leven wears a lovelock in his hair which trails over his left shoulder. This was an old fashioned hairstyle which survived in a few cases into the later seventeenth century. William Prynne wrote a treatise denouncing lovelocks, describing them as 'unlovely, sinfull, unlawful … unseemly' and many other adjectives sufficient to fill 63 pages (William Prynne, *The Unloveliness of Lovelocks*, 1628).

1 Laing, Vol. I, p.213
2 Fraser, p.166

General Leslie.

SIR CHARLES LUCAS (1613–48)
PORTRAIT BY WILLIAM DOBSON

ROYALIST COMMANDER

'By the command of Fairfax in cold blood barbarously murdered' [1]

Lucas seems to have been a talented cavalry officer and a devoted Royalist but it is the manner of his death which made him an important martyr to the royalist cause and severely damaged Fairfax's reputation for fair dealing.

At the outbreak of the Civil Wars, Lucas became the Earl of Newcastle's Lieutenant of Horse. In 1643 he was appointed commander-in-chief in Suffolk and Essex. At the battle of Marston Moor, he routed Sir Thomas Fairfax's cavalry but was later taken prisoner. He was released and defended Berkeley Castle and was subsequently appointed, in 1645, as Lieutenant-General of the King's Cavalry. He fought alongside Sir Jacob Astley at Stow on the Wold. This appears to be the moment when Lucas was released on parole on the grounds that he agreed not to bear arms against Parliament in the future. At the outbreak of the Second Civil War, Lucas broke his parole and returned to his birth town of Colchester, which he defended during a bitter and protracted siege.

Lucas was finally forced to surrender and he was sentenced to death by a court martial. He debated cleverly with Ireton that no justification could cover such a sentence, since he was only serving his sovereign monarch. Lucas and his fellow prisoner, Sir George Lisle, were nevertheless executed by firing squad and became martyrs to Charles's cause. Lucas was buried in Colchester and in 1661 a grand procession took place to honour him posthumously.

Lucas presumably sat for Dobson in Oxford in 1645. The baton which he holds may relate to Lucas's appointment as Lieutenant-General of the King's Cavalry in 1645. The small background detail of a groom leading a horse recalls Van Dyck's portrait of *Charles I on Horseback with M. de St Antoine* (Royal Collection, UK).

It is a noticeable feature of Dobson's oeuvre that he felt the debt to Van Dyck's portraits weigh heavily upon him. He consistently strove to find new ways of depicting familiar subjects but, in so doing, his work sometimes slips into parody. Lucas's right hand holds the baton vertically, with his index finger on the top. This is certainly a different way of depicting a familiar subject but it also looks as though Lucas is about to step out for a country walk aided by a walking stick. However, it is the detail of Lucas's armour in the lower right-hand corner which is particularly peculiar. Lucas has clearly removed the armour from his forearm and his hand rests upon it, but the compositional effect is to suggest that, either he has painfully dislocated his arm or that someone else's arm has entered the painting from stage right.

1 *Mercurius Publicus*, 6–13 June 1661

COLONEL SIR THOMAS LUNSFORD (*c.1610–c.1656*)

PORTRAIT BY CIRCLE OF JOHN HAYLS

ROYALIST ARMY COMMANDER

'A young outlaw who neither fears God nor man, and who, having given himself over to all lewdness and dissoluteness, only studies to affront justice … a swaggering ruffian.' [1]

L unsford was a tough soldier. He was loyal to his king and showed a talent for trouble as well as a consistent ability to avoid the worst effects of it.

He was part of Charles's bodyguard when the king entered the Houses of Parliament in 1642 in search of the five members who had defied him. Lunsford was a good example of the 'type' of brutal hard man on whose grit, determination and fists Charles relied during his wars with Parliament. However, he seems rather too much to have enjoyed the clashing of swords and heads with rioters in London and a pamphlet of the 1640s illustrates an image of 'Colonel Lunsford assaulting the Londoners at Westminster Hall with a great rout of ruffianly Cavaliers'. He seems later to have acquired a ludicrous reputation for cannibalism which was, again, presumably the work of Parliamentarian pamphleteering.

There is no doubt that he was hot headed, as well as red haired and, in his late twenties, Lunsford went into self-imposed exile for the attempted murder of his kinsman, Sir Thomas Pelham. Apparently, he fired twice upon Pelham as he stood in the doorway of a church. The story is perhaps less interesting as an illustration of his 'ruffianly' character and more telling that, as a supposedly competent soldier, he missed with both shots. Whilst in exile, he served in the French infantry and eventually he returned to England, his original crime pardoned by Charles who was, perhaps naïvely, impressed by his rough

soldierly behaviour. Charles appointed him Lieutenant of the Tower of London, but it was an appointment so unpopular that he lasted only 96 hours in office. He seems to have fought bravely at the Battle of Edgehill but was captured and imprisoned in Warwick Castle until 1644. Ultimately, Lunsford was a soldier of fortune who, when he judged that the Stuart cause was lost, emigrated to America for a new life in Virginia and a third wife.

This full-length portrait would have been expensive. Lunsford is wearing an interesting combination of high fashion and field dress. Everything from his spurs to his breastplate indicates his readiness for battle. The style of breeches with 'points' of lace or ribbon which would have attached to boot hose was also worn by Arthur Goodwin. There is no evidence, however, to suggest that Lunsford had a disposable income anything close to the wealth of Goodwin. Nor does his biography suggest the vanity which would normally precipitate the desire for a full-length portrait. He was, however, through his second wife, Katherine, the brother-in-law of Colonel Neville, a man of greater financial means who had employed Dobson for his own portrait. Katherine died in 1649 and there is the tantalising hypothesis, therefore, that this extravagant portrait was commissioned before her death by Richard Neville as a means of rehabilitating the tarnished reputation of his kinsman.

1 Lord Dorset, see Newman, p.242

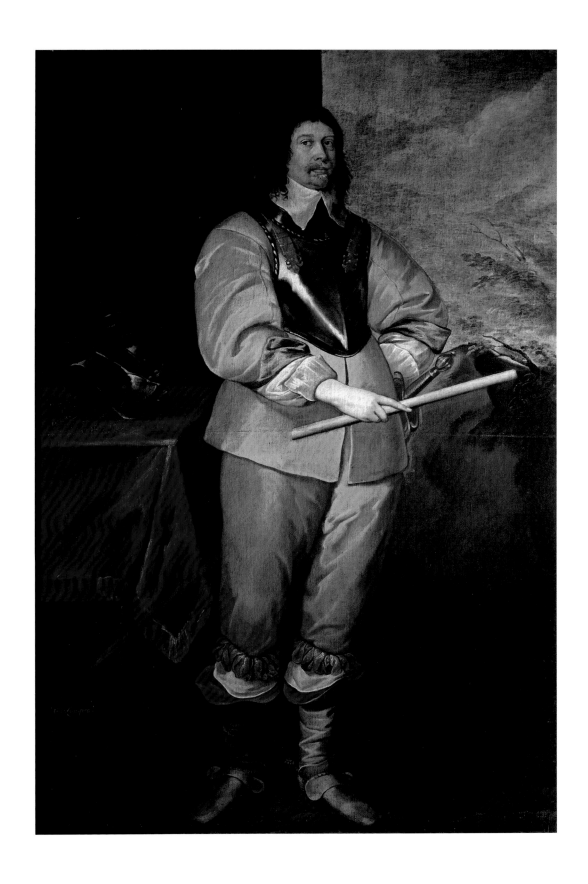

EDWARD MONTAGU, 2ND EARL OF MANCHESTER (1625–72)

PORTRAIT BY SIR PETER LELY

PARLIAMENTARIAN COMMANDER

'If we should beat the King ninety nine times and he beat us but once we should all be hanged.' [1]

Manchester was a talented soldier and a man of principle. The wise simplicity of his philosophy well suited a leader who saw the Civil Wars for the nuanced madness that they were.

In an era before a standing army, Manchester displayed his greatest talent for managing supplies and logistics. His army was consistently well provisioned and he tried to instil a piousness and discipline in his men, without which the New Model Army is unlikely ever to have come into being and without which it certainly would never have been so professional.

It is, nevertheless, the conflict of personalities which emerged between Manchester and Oliver Cromwell on which his reputation mostly rests. Both Cromwell and Manchester studied at Sidney Sussex College, Cambridge. Both men subsequently served as MPs for Huntingdonshire and, at the outbreak of the First Civil War, both men served in the Army of the Eastern Association, Manchester as major-general and Cromwell as his subordinate.

At the battle of Marston Moor, the cavalry of Manchester and Cromwell were largely responsible for the victory which placed the north of England under parliamentary control and which largely brought the First Civil War to an end.

It was at this point that Cromwell complained to Parliament about Manchester's handling of the war. Manchester may not have been a 'dove' but he certainly did not believe in continuing a conflict against the king which would bring ruin to all. Anticipating the Self-Denying Ordnance, Manchester resigned his command. He seems to have spent the succeeding years negotiating for a settlement with the king and moving effortlessly from his first marriage to his fifth. During the Protectorate he retired from political life but subsequently energetically campaigned for the Restoration. He was duly rewarded by Charles II who made him a Knight of the Garter. He was rewarded by his wives with nine children.

This portrait of a man in a buff jerkin and breastplate belies the grandeur of his birth and Manchester was clearly keen to portray himself as a plain and honest soldier. The ox hide jacket was often worn by officers on both sides of the conflict. These jackets are the same ones referenced by Cromwell when he remarked, 'I had rather have a plain russet-coated captain that knows what he fights for … than that which you call a gentleman and is nothing else.'[2] They may have protected the soldier from a musket ball fired at long range but are unlikely to have stopped a close range impact.[3]

In contrast with so many portraits of this period where the fingers of the sitter merely tickle the baton of command, in this portrait Manchester's hand grips the wooden baton so firmly, one feels that it might break. His other hand does not so much rest on his hip as anchors itself there. Importantly, his left hand is not painted with an open palm but with the fingers curled into a fist. This is a portrait of a man of determination and action. It is interesting, therefore, that this work was painted by Lely who, at the court of Charles II, would enliven and dazzle his audience with his bravura technique and theatrical eroticism. One can only imagine Manchester explaining to Lely in kindly but firm terms that there was merit in muted.

1 See *The Quarrel Between the Earl of Manchester and Oliver Cromwell: an episode of the English Civil War*. Unpublished documents relating thereto collected by J. Bruce, with fragments of a historical preface by Mr Bruce, annotated and completed by D. Masson, under the heading 'Notes of Evidence against the Earl of Manchester', printed for the Camden Society, p.99

2 Oliver Cromwell's letter to his friends, Sir William Spring, Bt., and Maurice Barrow, 11th September 1643 – see Carlyle, p.170

3 For a fuller discussion of these ox hide coats, see *Military Illustrated*, November 1992.

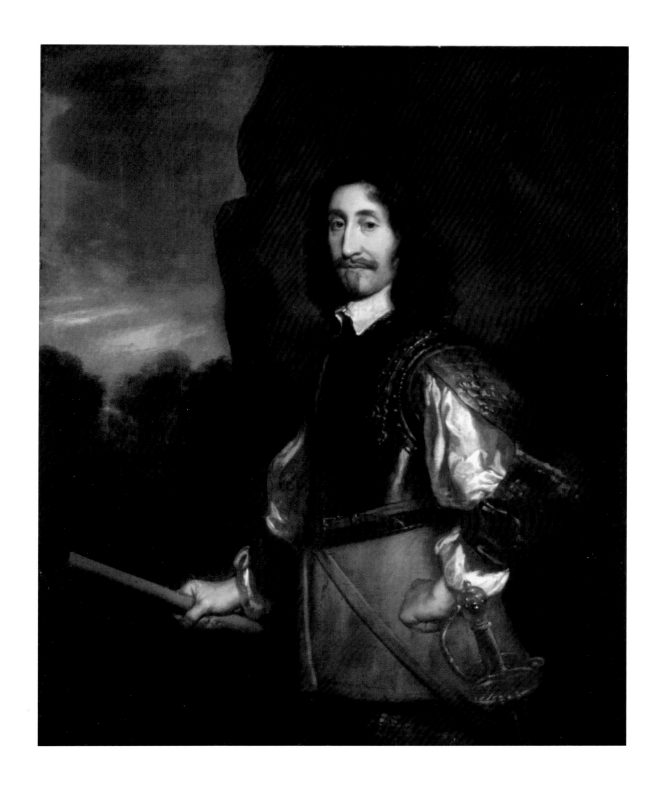

PRINCE MAURICE, COUNT OF THE PALATINE (1621–52)

PORTRAIT BY WILLIAM DOBSON

ROYALIST COMMANDER AND ROYAL NEPHEW

'He understood very little more of war than to fight very stoutly when there was occasion.' [1]

This rather uncharitable remark from Clarendon does little justice to a man who was brave and always loyal to his uncle.

Prince Maurice was the son of Elizabeth, Queen of Bohemia, the nephew of King Charles I and the grandson of King James I. At the outbreak of the Civil Wars, Maurice and his brother, Prince Rupert, raced to England to lend assistance to their uncle. Both men were present at the raising of the Royal Standard at Nottingham in August 1642, but in the course of the ensuing conflict, the star of Prince Rupert has always shone brighter. Arguably, however, Maurice was no less the fighter, nor indeed the lesser strategist.

At the outbreak of war Maurice was appointed colonel of a cavalry regiment. He showed flair as a commander and his unit was accounted as 'the most active regiment in the army'. After some considerable success in the West Country against Sir William Waller, Maurice was confirmed in his post of general of the western forces.

He fought under the command of his brother at the Battle of Naseby. He was banished by Parliament in 1646 and was drowned when his ship was caught in a hurricane whilst sailing for the West Indies.

This portrait is peculiarly sober and restrained for a portrait of Charles's immediate family. Maurice's brothers, Prince Rupert and Prince Charles Louis, Elector Palatine, never lost the opportunity to appear martial, grand and dashing.

Given the swagger of so many of Dobson's portraits of the king's entourage in Oxford, the iconographic restraint and diffidence must surely have been Prince Maurice's deliberate request. It offers a meaningful insight into the sitter's temperament to consider that the prince requested that he be portrayed as a simple and honest soldier rather than the flamboyant Cavalier.

This interpretation gains weight from the fact that this portrait seems to have been conceived as a companion work to Dobson's portrait of Colonel William Legge, to whose descendants both works descended, together with a portrait of Prince Rupert. Colonel Legge became Governor of Oxford in January 1645, a role which he lost following the Siege of Bristol (23rd August – 10th September 1645) and whose 'modesty and diffidence of himself never suffered him to contrive bold councils'.[2] The same modesty seems to have been a virtue of poor Prince Maurice.

1 Clarendon, 1826, Vol. IV, p.603

2 See exh. cat., London, 1983–84, p.76

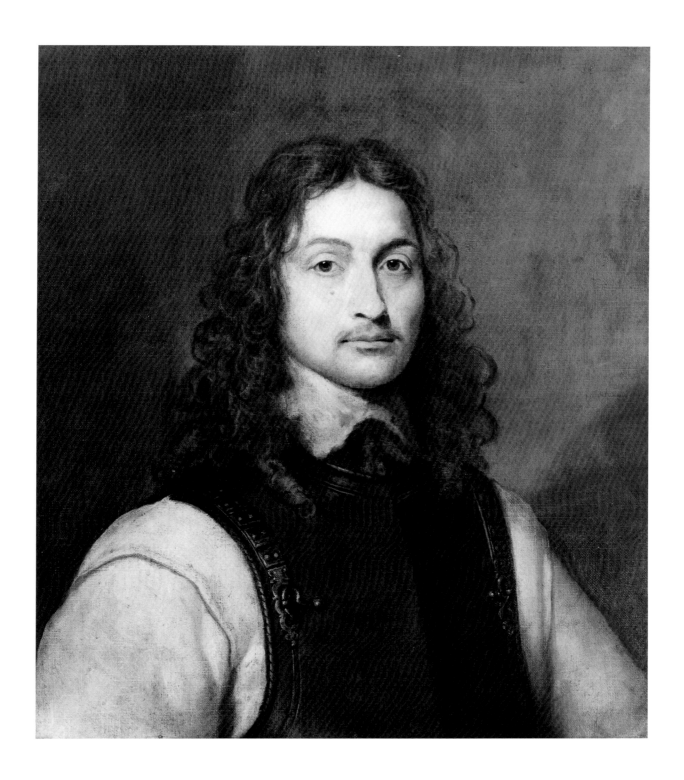

SIR JOHN MENNES (1599–1671)

PORTRAIT BY SIR ANTHONY VAN DYCK

ROYALIST ARMY AND NAVY COMMANDER

'The true wit of a million' [1]

A consistently intriguing character, Mennes might have made a better actor than a soldier.

It was his fate, however, on 1st May 1642, to be appointed as Rear-Admiral of the Royal Fleet. By 1st July he seems to have lost all control of his king's navy to Parliament.

Mennes spent the years of the Civil Wars as a rather dissatisfied, but seemingly competent, infantry commander and in 1648 briefly regained the opportunity to command some ships. After the king's execution, he joined the court of Charles II in exile and was said to have served as a secret agent. One presumes that he was an effective spy since the sources have almost nothing to report on his activities although it seems likely that he was involved in negotiations for the restoration of the king.

At the Restoration, he was rewarded for his services with appointment as Comptroller of the Navy. Samuel Pepys regarded this appointment as disastrous and Mennes's ability as inadequate.

Despite the best efforts of Pepys to oust him from the role, Mennes died still Comptroller of the Navy and it must be concluded that this 'dolt', 'dotard',[2] 'old fool',[3] who would have better served his king to have been paid 'to have sat still'[4] was well connected and well liked. At least Pepys had the charity to acknowledge that, as a dinner companion, poet and mimic,[5] Mennes was excellent company.

Mennes had the distinction to ferry Rubens from the Netherlands to London in 1629 and, subsequently, to transport Queen Henrietta Maria from London to the Netherlands at the outbreak of Civil Wars. During his last voyage at sea, in 1662, he performed a similar role of go-between when he escorted a second queen, Catherine of Braganza, to meet her new husband, Charles II. Such distinguished company can only have been grateful for his 'wit in a million'.

The present portrait is a typical 'swagger' product from the hand of Van Dyck. It is important to acknowledge that, although a portrait by Van Dyck was expensive, costing approximately £20[6] for a half length, the costume worn by his sitters was a far greater expense. The red satin doublet and hose might have cost Sir John Mennes £200.[7,8] Van Dyck himself was the son of a haberdasher and he showed an intense interest in fabrics and fashion. Notwithstanding the addition of a breastplate to indicate the sitter's standing as a martial hero, it seems unlikely that Mennes would have worn this costume as either a naval or infantry commander. Many of the costumes in which Van Dyck's sitters appear find their fashion origins in the court masques of the 1630s and, had Sir John Mennes encountered himself wearing such a dashing suit of pyjamas, his rapier wit might well have been usefully deployed.

1 Herrick, p.225, quoted as part of a poem entitled 'to his honoured friend, Sir John Mynts'
2 Samuel Pepys, diary entry, 23rd June 1663 – see Wheatley, Vol. III, p.166
3 *Ibid*, Vol. III, p.81
4 *Ibid*, Vol. VII, p.127
5 *Ibid*, Vol. V, p.175
6 Brown, p.162.
7 Reynolds, 2013, pp.27–28
8 £20 and £200 in 1640 is the equivalent of approximately £2,300 and £23,000 in today's currency.

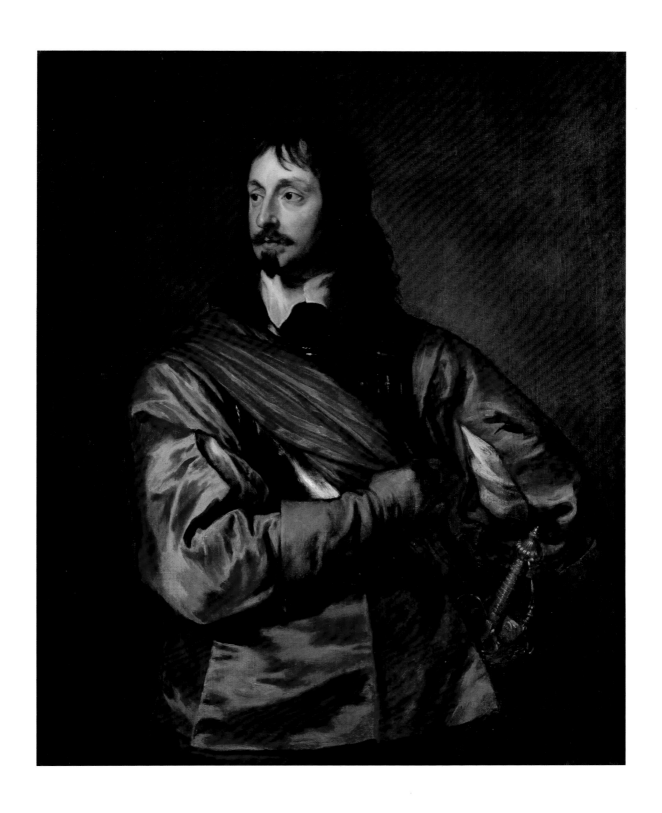

JAMES GRAHAM, MARQUESS OF MONTROSE (1615–90)

PORTRAIT BY WILLIAM DOBSON

ROYALIST ARMY COMMANDER

'The Great Montrose' [1]

Montrose was one of the most romantic figures in seventeenth-century Scottish history. His valiant support of Charles I and his son during the Civil Wars, his gruesome death by hanging, drawing and quartering, the subsequent scattering of his body parts, the recovery of his heart under cover of darkness, and the presentation of the embalmed organ to Montrose's heir in the Netherlands, enhanced the myth and, with every re-telling, he became a saintlier martyr to the royal cause. At the Restoration, his body parts were re-gathered, re-combined and he was finally rewarded with a State ceremony of significant pomp.

The sitter was the son of John Graham, 4th Earl of Montrose (1573–1626) and his wife Margaret Ruthven, daughter of the 1st Earl of Gowrie (*c.*1545–84). As a student at the University of St Andrew's, he seems to have been inspired by the tales of military glory recorded by writers such as Xenophon, Lucan and Caesar and, at the outbreak of war, he seems to have aspired to be the equal of these Greek and Roman martial heroes.

Between 1644 and 1645 Montrose won a series of impressive victories over Parliamentarian forces in the Highlands and he has been described as 'perhaps the most brilliant natural military genius disclosed by the Civil War'.[2]

In September 1645, he was finally defeated at Philiphaugh and the following year he retreated into exile where he continued to support the royalist cause until being re-appointed as Lieutenant-Governor and Captain-General of Scotland by the exiled Charles II. In April 1650 he was captured and brutally executed.

This painting was probably painted in Oxford. The figure of Montrose looms forward towards the viewer. This is emphasised by the almost square format and the fact that the sitter has been bisected at the waist. There is no technical evidence to suggest that the portrait has been cut down. However, it seems likely that Dobson originally intended to paint a conventional full-length portrait and was perhaps constrained by lack of materials, time or money. A square format is highly unusual for portraiture of this period and Montrose's arms slightly ignominiously disappear into space, without the supporting attributes of a faithful hound, a baton of command or legs. There is a brief swish of umber in the lower right-hand corner, raising the interesting suggestion that Montrose has removed the armour from his lower arm, thus revealing the leather jerkin beneath. This would support the suggestion that, originally, Dobson intended his sitter to be holding an attribute. Dobson does his best to moderate these deficiencies by including the prominent details of the goddess Minerva and a fearsome looking helmet. Dobson has placed the helmet precariously on a raised shelf, the reason for which seems to be his desire to create an X-shaped composition between all the details. Certainly if one plots the central point of the canvas, it rests neatly beneath Montrose's face bathed in almost saintly light. It has been remarked that there is also a compositional resemblance between this portrait and Titian's *Portrait of Francesco Maria I della Rovere, Duke of Urbino* (Uffizi Gallery, Florence). A replica or copy of this portrait may have been in the collection of the Earl of Arundel during the artist's lifetime and Dobson may have seen it but the more likely model is the full-length portraits by Van Dyck.

Minerva, goddess of wisdom and martial strength, spectates from the background, as if she were Montrose's personal deity. Iconographically, one would expect Minerva to hold a sword, an owl or an *aegis* in her hand. In this portrait, she seems to hold a small fruit, perhaps an apple. If it is an apple, Dobson has confused his mythology since it was the goddess Venus who was awarded the golden apple at the Judgement of Paris. Dobson uses the detail of a classically inspired statue in many of his compositions but, as allegorical props, they are often used lazily and without a proper understanding of the meanings. Dobson seems to have been a more talented artist than a classicist.

1 Buchan, p.385
2 Sir John Fortescue – see Hastings, p.13

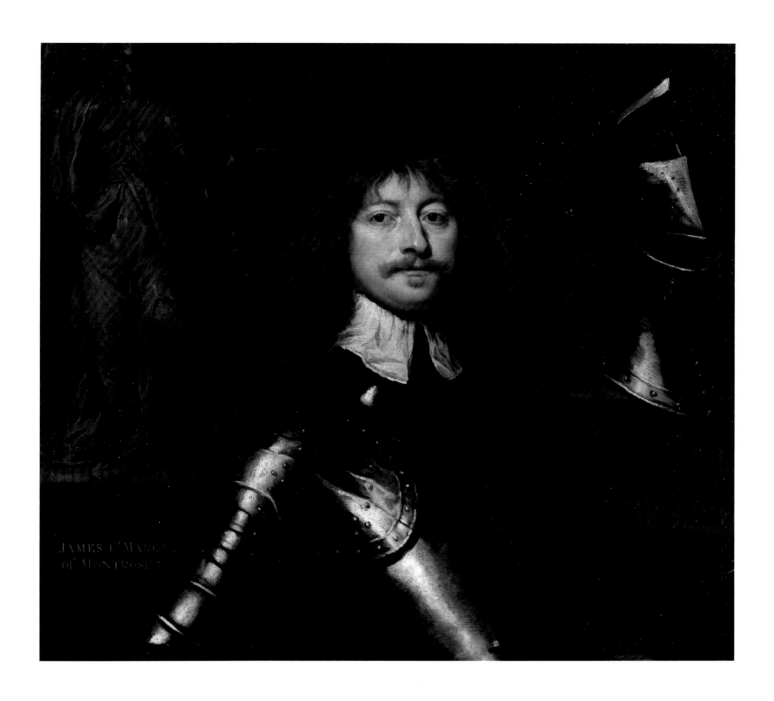

JAMES 1st MARQ^s
of MONTROSE

COLONEL RICHARD NEVILLE (1615–76)

PORTRAIT BY WILLIAM DOBSON

ROYALIST CAVALRY COMMANDER

'A court cully' [1]

Neville was a man of rash speech and bold actions. In 1641 he was informed against for declaring that the citizens of London needed their city 'burnt about their ears' and he was willing to employ his cavalry to plunder them. [2]

Neville was recognised for his bravery at the Battle of Newbury in 1643. He was with King Charles at Oxford in 1646. After the Restoration he served as MP for Berkshire as well as Deputy Lieutenant of the County although his parliamentary record seems undistinguished in comparison with his military actions. He was referred to as a 'cully', meaning a trickster or a cheat, in the *Flagellum Parliamentarium* in 1670.

Dobson's stylistic trait of dominating the canvas with the figure is again clear. Colonel Neville's pistol almost falls into the viewer's space, as if urging the spectator to pick up the weapon and to 'take up arms' on behalf of the king. Certainly there is a horizontal linear progression which passes from the panting hound, a timeless emblem of fidelity, through the pistol, eventually finishing with a crescendo at Neville's resting right hand on his helmet, perhaps indicating his own personal sense of martial fidelity to his own master, King Charles.

It is perhaps also important to emphasise that the red sash worn by Colonel Neville seems to have been the colour adopted by officers of the king.

Behind Neville's left shoulder, Dobson has included the details of a sculptural group which shows Mercury visiting Mars. Mercury is identifiable by his winged helmet and Mars can be identified by his spear, sword and the pile of armour at his feet. Although there does not seem to be an obvious classical prototype for this composition, the allegorical message is clear. Mercury, the messenger god, has been sent by Jupiter to instructed Mars, god of war, to fight on the rightful side of King Charles and the Royalists.

In this respect, Dobson probably intended the Civil Wars between the king and Parliament to be perceived as parallel with the Trojan War between the Greeks and the Trojans. Noblemen and rulers from the medieval period onwards regularly co-opted the story and imagery of the Trojan War as parallels for their own heroic actions. Nevertheless, if this was Dobson's intentional parallel, it was perhaps poorly chosen since, in the Trojan War, Mars supported the losing side.

1 Henning, p.132
2 Newman, no. 1039

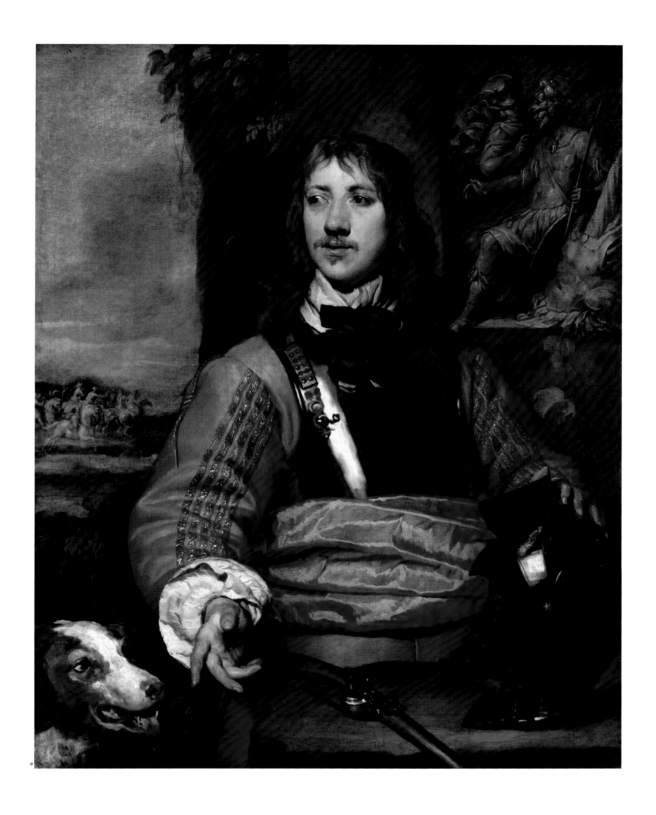

DAVID LESLIE, 1st LORD NEWARK (1601–82)

PORTRAIT ATTRIBUTED TO GEORGE JAMESONE

PARLIAMENTARIAN ARMY COMMANDER
SERVED CHARLES II AFTER 1649

*'Although we have upon all occasions, both abroad, and since our happy return,
declared ourself fully satisfied with your conduct and loyalty in our service; and
although, in consideration of the same, we have given you the title and honour of
a Lord, yet, seeing we are told that malice and slander do not give over to persecute
you, We have thought fit to give you this further testimony, and to declare, under
our hand, that while you was our Lieutenant General of our army, you did, both
in England and Scotland, behave yourself with as much conduct, resolution, and
honesty, as was possible, or could be expected from a person in that trust; and, as
We told you, so do We again repeat it, that if We had occasion to levy an army fit
for ourself to command, We would not fail to give you an employment in it fit for
your quality.'* [1]

h to receive such a character reference from none other than the monarch.

It is perhaps not surprising that King Charles II should so fulsomely praise Lord Newark's character – Newark was a talented soldier who had vigorously opposed Charles I during the Civil Wars but who, following the execution of Charles in 1649, had changed sides and could be perceived as a valuable 'scalp' in the royalist war of propaganda.

David Leslie fought in Sweden on behalf of Gustavus Adolphus, together with Alexander Leslie, later Lord Leven (No. 40). Both men returned to Scotland to fight in the covenanter army and, at the outbreak of war, Leslie fought bravely on the parliamentary side, notably at the Battle of Marston Moor.

He achieved a great victory over the Marquess of Montrose at the Battle of Philiphaugh, for which he was rewarded with 50,000 marks and a chain of gold.[2] However, his reputation as a commander has been diminished by his, seemingly, appalling record for civilian massacres. Tradition relates that 80 Irish women and children were thrown from a bridge and drowned at his command.[3] One suspects that the friends and relatives of the camp followers who were massacred immediately after the Battle of Philiphaugh, would not have regarded him with the same equanimity as displayed by Charles II.

After the execution of Charles I, Leslie supported Charles II and fought at the Battles of Dunbar and Worcester after which he was captured and imprisoned in the Tower. At the Restoration, he was ennobled as Lord Newark.

As with the portrait of Lord Leven, this portrait, also likely to be by Jamesone, is in the style of those commanders who fought in the Low Countries during the Thirty Years War. These portraits are almost always half lengths since anything larger might have been too grand and too expensive, as well as too awkward to transport from camp to camp. Newark's neckwear reflects a similar compromise. The 'falling band' was most expensive when it was woven entirely from lace. In this instance, Newark wears a plain linen collar trimmed with lace, which would have been considerably cheaper.

1 A letter from King Charles II to Lord Newark – see Lodge, pp.96–7
2 Newman, p.119
3 *Ibid*

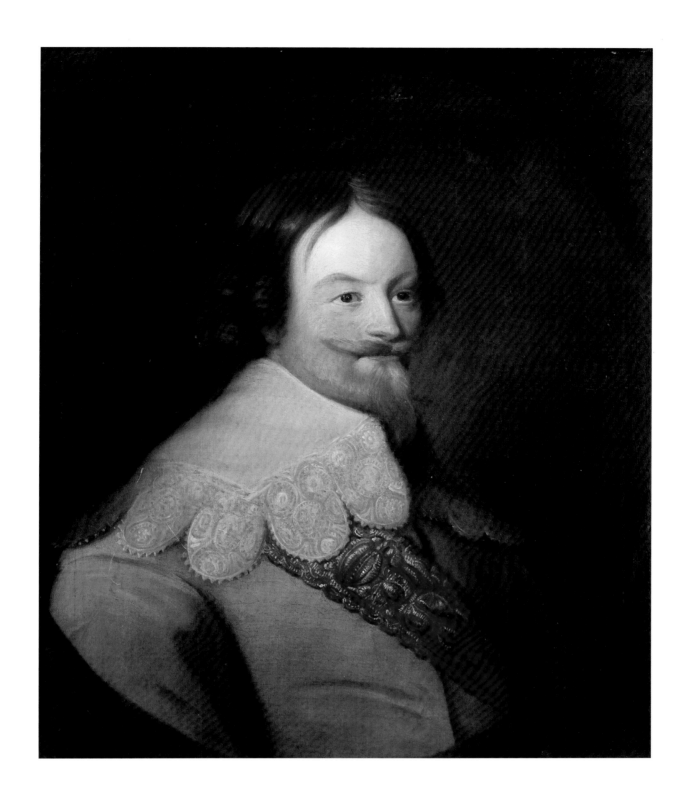

WILLIAM CAVENDISH, 1st DUKE OF NEWCASTLE (1593–1676)

PORTRAIT BY ABRAHAM VAN DIEPENBECK

ROYALIST

'A very lamentable man, and as fit to be a general as a bishop' [1]

Newcastle was a loyal and dedicated commander during the First Civil War and a useful ally to the exiled Charles II during the Second Civil War. However, he is probably better remembered as a patron of the arts, a true Renaissance figure who wrote treatises on the training of horses, as well as plays and sonnets. He was also well known as a devoted husband.

During the First Civil War, Newcastle was given command of the northern counties. Despite some success, he was eventually surrounded by the Scottish army marching south and the combined forces of Manchester and Fairfax marching north. He retreated to York where he was besieged and at the Battle of Marston Moor, which soon followed, his regiment of Whitecoats, or 'Newcastle's Lambs', fought heroically but were nonetheless slaughtered.

After this he regarded the cause as lost, went into exile, and eventually made his home in the old house of Peter Paul Rubens in Antwerp. He converted one of Rubens's studios into a riding school and in 1658 published *Le Methode Nouvelle et Invention Extraordinaire de Dresser des Chevaux*.

At the Restoration he was raised to a dukedom and installed as a Knight of the Garter but he seems never to have had much influence at the court of Charles II and he retired to his northern estates to race horses and write plays.

The iconography of this portrait does not conform to any easy categorisation of Royalist or Parliamentarian. Everything about this work emphasises the love which Newcastle had for his passion for riding and manège. Newcastle is performing a *croupade*, a difficult dressage move in front of the family seat of Bolsover.

Countless Roman emperors and European kings had been portrayed performing similar dressage moves, such as the *levade*, for the reason that the image of a ruler controlling a mute beast with such ease could function as a metaphor for the ease with which this same ruler could control his subjects. The most pertinent comparison would be the equestrian portrait of Charles I (see No. 8; National Gallery, London) painted by Van Dyck just before the outbreak of Civil Wars. In the case of Newcastle, he simply loved riding.

1 Clarendon, 1786, Vol. III, p.20

Bolsover

Monseigneur le Marquis
à Cheval.

Croupades par le Droite.

HUGH PETERS (1598–1660)
PORTRAIT BY ENGLISH SCHOOL, *c*.1650

PARLIAMENTARIAN CHAPLAIN

'Men and brethren, whilst we are disputing here, they are perishing there, and going to hell by the droves. If I know anything, what you have gotten by the sword must be maintained by the word.' [1]

A charismatic and inspiring preacher, Peters was one of the most hated figures in the Civil Wars. He was not present on the day of the king's execution and was, subsequently and almost certainly erroneously, rumoured to have been the king's executioner.

Peters was born at Fowey in Cornwall, the son of Thomas or Peter Dickwoode, a Dutch emigré from Antwerp. Peters graduated from Trinity College, Cambridge in 1618 and a few years later was ordained a priest at Rayleigh in Essex. Over the next few years, he proved himself a zealous and passionate preacher, but his views were also regarded as seditious and his activities were closely scrutinised.

In 1635 Peters and his wife sailed for New England where he became a popular minister for Salem. It was here that he clashed with Sir Henry Vane the Younger over Anne Hutchinson and her antinomianism. He returned to England in 1641 and immediately took up a role as chaplain to the naval forces which were sent to subdue Ireland. At the outbreak of the Civil Wars, he rapidly emerged as a promoter of Parliament's cause and was particularly popular with Sir Thomas Fairfax and Cromwell.

Peters tirelessly accompanied Parliament's forces during the Civil Wars and was present at the surrender of Oxford in June 1646 and Worcester in July. His preaching was regarded as particularly effective. In 1646 he delivered his best known sermon, 'God's Doings and Man's Duty', at a thanksgiving for the conquest of the west of England. During this sermon, he expressed concern for the orphans and widows of those who had died in the wars. He questioned why poor debtors were kept in prison and displayed a greater humanity than he has been credited with. He later also preached to the army to inspire them before their march on London for Pride's Purge.

In 1650 Peters was appointed as chaplain to the Council of State, a role he continued faithfully to perform under the Protectorate. At Cromwell's funeral he preached on the text, Joshua 1:2, 'Moses my servant is dead.' At the Restoration, Peters was exempt from Royal Pardon and was executed on 16th October 1660.

The portrait is a rather prosaic representation of one of the most respected as well as most reviled figures of the Civil Wars. The iconography is that of any number of mid-seventeenth-century clerical portraits and the artist does not seem to have attempted any flattery. If we compare his depiction in the present portrait with the manner in which Peters is shown in his double portrait alongside Bradshaw (No. 5), the latter work displays far greater sense of vitality and character. For the lack of this in the present work, we must perhaps blame the pedestrian nature of the artist's brush. Peters appears as a miserable Puritan painted with an unedifying, palette of black and white. The very fact, however, that the portrait was commissioned at all indicates a growing middle-class consumerism, the catalyst for which was the social upheaval created by the Civil Wars.

Until the mid-seventeenth century, the only religious figures to be immortalised tended to be the rich and powerful ecclesiastical patrons – popes, bishops, cardinals or those responsible for profound changes in the church. One thinks, perhaps, of Raphael's portrait of Pope Julius II (National Gallery, London), Titian's portrait of Alessandro Farnese (Museo Nazionale di Capodimonte, Naples), or Cranach's portrait of Martin Luther (Royal Collection, UK).

The fact that Peters sought to immortalise himself in oil illustrates that he was keen to harness the social opportunities afforded him to raise his profile. The problem which Peters faced is that in order to achieve this aim he needed to employ a greater talent than the artist whom he chose, or could afford. The date of this 'immortalisation' is likely to correspond to his appointment as chaplain to the Council of State in 1650.

By tradition, this portrait has hung in the President's Lodge of Queen's College, Cambridge, since the Restoration. A seventeenth-century president of the college presumably decided to add the inscription 'The Seditius [sic] Misleader'. By the eighteenth century this portrait hung beside a portrait of Oliver Cromwell which bore an inscription in the same hand 'The Usurper'. These later inscriptions were, presumably, added to make a statement of loyalty to the Crown. However, their very presence in the President's Lodge seems, arguably, to celebrate two figures of revolutionary republicanism.[2]

1 Hugh Peters – see Gardiner, Vol. III, p.84
2 I am grateful to Murray Milgate for guiding me towards John Towell Rutt's, *Diary of Thomas Burton*, London: Henry Colburn, 1828 where this history is explained in a footnote, p.244.

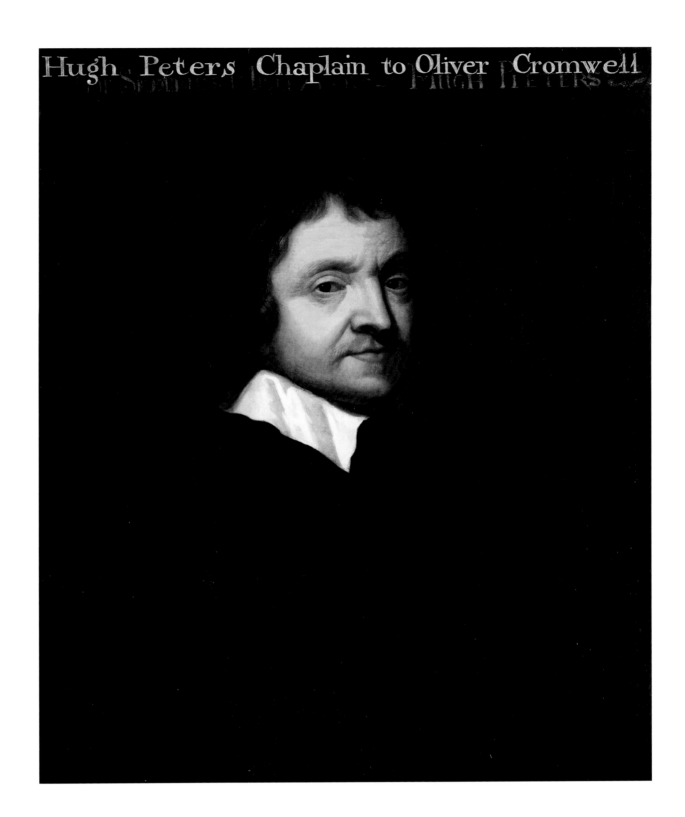

Hugh Peters Chaplain to Oliver Cromwell

JOHN PYM (1584–1643)

PORTRAIT AFTER EDWARD BOWER

PARLIAMENTARIAN POLITICIAN

'No man had more to answer for the miseries of the kingdom, or had his hand or head deeper in their contrivance; and yet, I believe, they grew much higher even in his life, than he designed.' [1]

John Pym was one of the most vocal and influential opponents of King Charles I in the years leading up to the English Civil Wars. He was the son of Alexander Pym and his second wife, Philippa Colles. He was educated at Broadgates Hall, now Pembroke College, Oxford, and subsequently entered Middle Temple, before beginning a long and successful career as a politician. He served first as an MP for Calne in Wiltshire and subsequently for Tavistock in Devon.

Over the course of the Short and the Long Parliaments, Pym gradually acquired the unofficial status as leader of the opposition to the king. Clarendon certainly regarded him as 'the most leading man' in Parliament.[2]

Pym's prime interests were the defence of the rights of Parliament and, as a staunch Puritan, the defence of the Protestant faith against Catholic influence. He was instrumental in the attempted impeachment of George Villiers, 1st Duke of Buckingham, as well as the legal attacks on the Earl of Strafford and Archbishop William Laud, both of whom were subsequently executed. In 1641 he helped draft the Grand Remonstrance of grievances which was presented to the king and, as a consequence of this, Pym was one of five members of Parliament whom the king sought to arrest for treason when he entered the House of Commons on 5th January 1642. At the outbreak of the Civil Wars later that year Pym was appointed as Lieutenant-General of Ordnance. In this capacity he successfully put the parliamentary finances and logistics in good order. In many respects this work foreshadowed the professionalisation of the parliamentary forces which culminated in the creation of the New Model Army in 1645. Pym died in 1643 and was buried in Westminster Abbey. At the Restoration, however, his body was exhumed and thrown into a ditch.

The present work is a lively portrait of an arch Puritan. There is a hesitant vanity to this portrait. His black doublet is embroidered with an elegant pattern and his hair and beard have the neatly combed waves of a self-conscious schoolboy. Pym's cheeks are ruddy, his face youthful and plump, and the artist has made considerable efforts to inject some charm into a man who seems likely to have lacked this quality.

Another oil portrait is related to this work (National Portrait Gallery, London) which shows an almost identical iconography with the sitter facing in the opposite direction and with rather older features. Both portraits are likely to have been painted at the exact time of his attempted arrest by King Charles in 1642 and a woodcut portrait, which clearly relates to the iconography of both oil portraits, was used as the frontispiece for the text of Pym's speech in Parliament. The date printed on this woodcut is 1641. This date indicates that the printmaker was using the Old Style calendar since the events took place in 1642.

The desire to create an iconography of the man at this particular moment is consistent with Pym's ascendancy in Parliament. However, multiple engraved images of Pym emerge after his death when the stern image could be fully leveraged for propagandist purposes. One of these engravings, by George Glover, cites the original portraitist for these images as Edward Bower.

1 Clarendon, 1826, Vol. III, p.321
2 *Ibid*, p.322

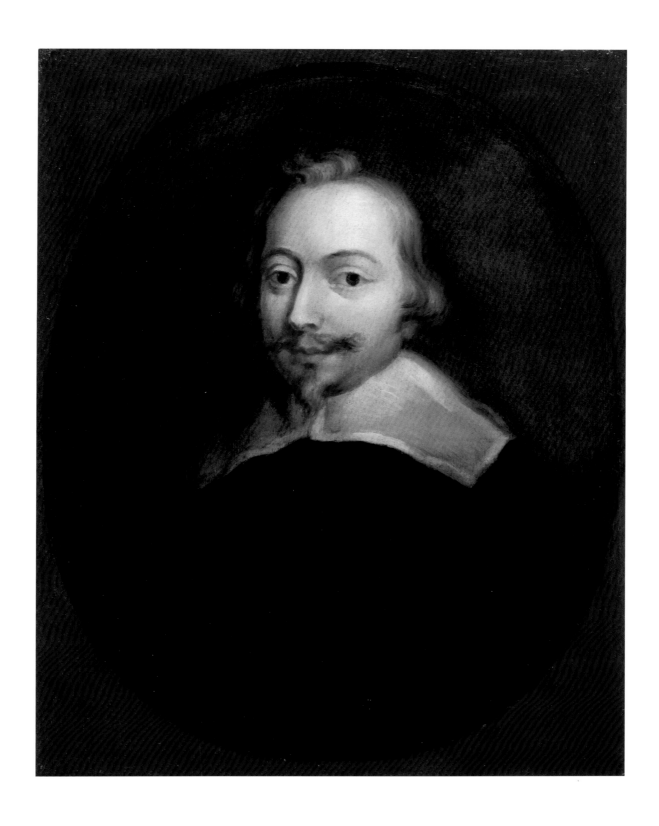

PRINCE RUPERT, COUNT PALATINE OF THE RHINE (1619–82)

PORTRAIT BY GERRIT VAN HONTHORST

ROYALIST CAVALRY COMMANDER AND ROYAL NEPHEW

*'He was rough and passionate, and loved not debate; liked what was proposed,
as he liked the persons who proposed it; and was so great an enemy to Digby and
Colepepper, who were only present in the debates of the war with the officers, that
he crossed all they proposed. The truth is, all the army had been disposed, from the
first raising it, to a neglect and contempt of the council; and the king himself had
not been solicitous enough to preserve the respect due to it, in which he lessened his
own dignity.'* [1]

Prince Rupert was the epitome of the royalist Cavalier. He was the nephew of Charles I, the cousin of Charles II and James II, and his sister was the mother of the future King George I.

He was as brave as he was reckless. He was defeated as often as he was victorious. In victory and defeat he was loyally accompanied by his standard poodle, Boye, whom he had received as a present whilst imprisoned in Linz. Whilst imprisoned, he had conducted an affair with his gaoler's daughter.

He was elected as a Fellow of the Royal Society in 1664 and submitted research into a diverse number of areas, such as navigational instruments, weapons and artistic aids. He seems to have been one of the earliest practitioners of the mezzotint technique in England. Surely no situation was too great for such a man and, in short, the myth of Rupert as the romantic Cavalier hero has grown with every passing year from the point of his death.

Rupert was the son of Frederik V, Elector Palatine of the Rhine and Elizabeth, the sister of Charles I. He was of unusual height for the age and, coupled with good looks and a robust constitution, he cut a dash throughout Europe. At the outbreak of war, Rupert was present with Charles I to see the raising of the Royal Standard and he was appointed as commander of the royalist cavalry. His cavalry charged in close formation at the Battle of Edgehill, firing their pistols as they rode and scattering the infantry before them. As effective as this was, it was often difficult to persuade the cuirassiers to regroup and charge again. Rupert employed the same tactic at the Battle of Marston Moor. All were swept before his cavalry with the exception of Cromwell's own cavalry regiment, whom Rupert remarked had 'stood like an iron wall', which seems the likely etymology of the term

'Ironsides'. Although Marston Moor was won by the parliamentary side, Rupert retained high favour with the king. After the Battle of Naseby and his surrender of the City of Bristol, Rupert was dismissed from his command and was subjected to a court martial, although he was subsequently cleared of treason. His war in England was not re-ignited until 1648 when he took command of the Royal Navy. He seems to have proved himself an energetic but uninspiring naval commander and only at the Restoration did his fortunes improve. He may never have married but a number of illegitimate children attest to his enthusiasm as a lover.

Rupert's dress in this portrait is glamorous but understated and the curls of long Cavalier hair and the silk scarf at his neck obscure the highly decorated armour. Nevertheless, the split, studded strips of leather over his shoulder clearly emulate Roman military dress. Rupert's imperial red cloak further emphasises the sitter's desire to appear in the guise of a Roman general. The silk handkerchief at his neck is the artist's interpretation of the Roman *focale* or *sudarium*. Usually, this was a linen or woollen cloth, worn at the neck to prevent the armour chafing.[2] In the case of Prince Rupert, this cloth is expensively decorated with gold thread. All the iconography of this portrait points towards Rupert's desire to appear the embodiment of a Roman emperor or an Arthurian knight.

This portrait was painted by the man who had been appointed court painter to Elizabeth, Queen of Bohemia. In this capacity he also taught Rupert and his sister, Louise Hollandine, to paint. This work was painted only a few months before the outbreak of the English Civil Wars, Rupert's subsequent arrival in England, and the beginning of the 'legend'.

1 Clarendon, 1793, p.128
2 Panel XXIV of Trajan's Column clearly depicts cavalry and infantry soldiers wearing *focalia*.

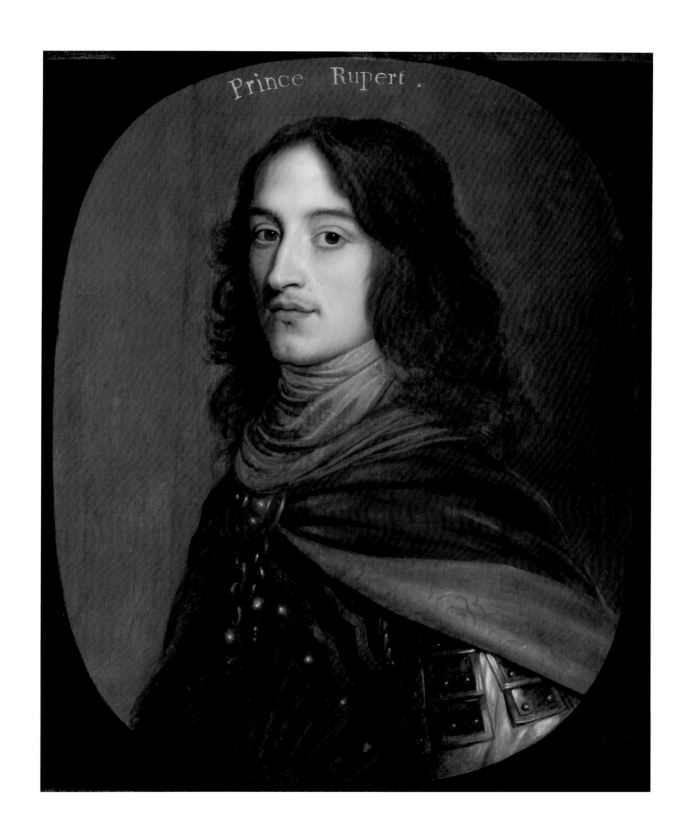

Prince Rupert.

COLONEL THE HON. JOHN RUSSELL (1620–87)

PORTRAIT BY JOHN MICHAEL WRIGHT

ROYALIST INFANTRY COMMANDER

'Held the rank of Colonel in the Civil War and … suffered imprisonment for his loyalty.' [1]

C olonel Russell was a founding member of The Sealed Knot, a role which perhaps appealed as much to his vainglorious nature than to anything else.

Russell was the younger brother of William, 1st Duke of Bedford. He was elected as a MP for Tavistock in 1641 and served until 1644. He led Prince Rupert's regiment of blue-coats at the assault of Leicester in 1645.

One presumes that he was also in command of the regiment at the Battle of Naseby later that year. All around, the infantry regiments had fallen with the exception of 'The Blue regiment of the King' who 'stood to it very stoutly … and stirred not, like a wall of brasse'. [2]

At the Restoration Russell raised the King's Regiment of Guards which he commanded for 21 years. This regiment would later become amalgamated with Lord Wentworth's Regiment to form the Grenadier Guards.

Russell was clearly a man of considerable vanity and, in addition to this swagger portrait, he sat thrice for William Dobson and at least twice for John Hayls. He appears with Prince Rupert and Colonel William Murray in the triple portrait by Dobson, formerly at Ombersley Park.

Wright has taken some of the familiar compositional tropes and injected them with a greater degree of individuality. For example, Russell rests his hand on the military field drum which he has accurately depicted with the leather sliders. The drums were the voice of a seventeenth-century infantry regiment and they communicated many things, including the commanding officer's orders. The beats could be heard across a camp or battlefield. In the traditional iconography of Van Dyck, the sitter would rest his hand on a trusty hound, symbolising loyalty. The replacement of the hound with the alternative of a drum conveys a language of authority and, by extension, trust in command and the regiment. This sense of Russell's dedication to his command is further emphasised by the depiction of the field tent, again accurately shown with its guide ropes. The gold brocade trim on the tent flaps indicate Russell's status as a commander.

However, the artistic point is not perhaps solely the aggrandisement of a vain man but a subtle emphasis on the practical application of his abilities as a commander. Russell wears luxurious items of clothing, such as his brocaded sash, but the item which draws the attention is the functional field dress of his leather jerkin.

This portrait was painted in 1659, only months before Charles II was restored to the throne. Russell is keen to remind the soon-to-be king of his loyal service. This portrait was owned by Elizabeth, Countess of Dysart, who gave significant support to Charles II during his exile and was even reputed also to have been a member of The Sealed Knot. Elizabeth's second husband, John Maitland, 1st Duke of Lauderdale, was a member of Charles II's so-called 'Cabal Ministry' which consisted of a small number of ministers who acted as the king's inner circle. Consequently, this portrait which hung at Ham House is very likely to have been seen by Charles II. Russell and the Countess of Dysart would have known that it would be seen and the iconography was chosen accordingly.

1 Dalton, p.7
2 *The Kingdomes Weekly Intelligencer*, 10–17 June, 1645 – see Evans, p.75

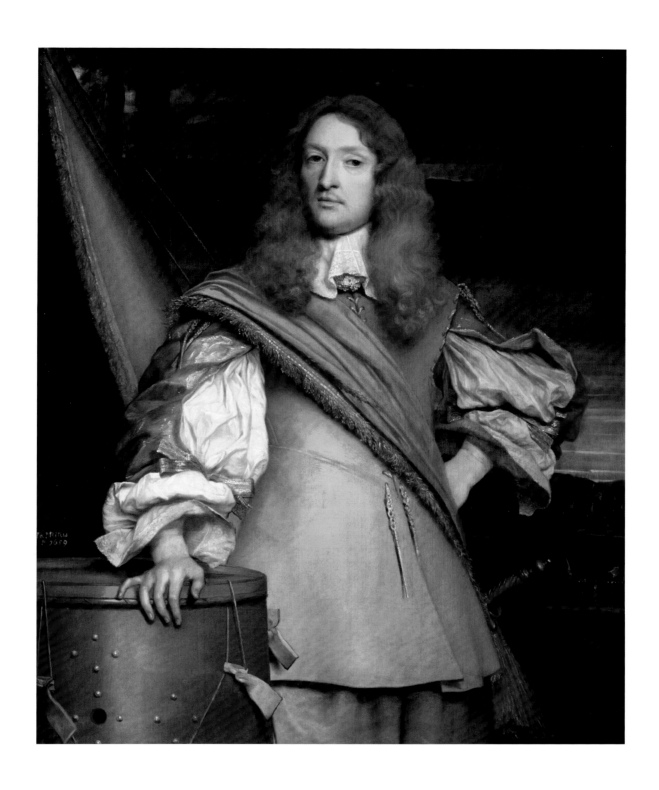

JOHN THURLOE (1616–68)

PORTRAIT BY CIRCLE OF ROBERT WALKER

PARLIAMENTARIAN – SECRETARY OF STATE

'One of the forefathers of espionage and intelligence gathering in England' [1]

John Thurloe was Cromwell's spymaster and general factotum. He was to the Lord Protector what Sir Francis Walsingham had been to Elizabeth I and what, perhaps, J. Edgar Hoover would be to a number of successive American presidents.

Trained as a lawyer and, after a successful mission as an ambassadorial secretary in the Netherlands, Thurloe was appointed Secretary of State in 1652. One of his principal responsibilities was the gathering of intelligence and he is credited with having recruited as a double-agent, Sir Richard Willys, one of the leaders of The Sealed Knot. His network of spies and his natural ability enabled him to prevent many of the royalist plots. At Cromwell's death, Thurloe was active in reinforcing the validity of Richard Cromwell's succession but following the recall of the Rump Parliament in 1659 he was dismissed. His fortunes improved with the arrival of General Monck but he eventually retired into obscurity.

In 1655 Thurloe became Postmaster General, a position which can only have strengthened his intelligence network. His greatest success resulting from the interception of mail came with the unveiling of Edward Sexby's plot against Cromwell. In a story worthy of John le Carré, Sexby had served with Cromwell as an 'ironside' and as a Parliamentarian spy. Disaffected by Cromwell's role as Lord Protector, Sexby turned sides. Thurloe intercepted correspondence which revealed his treachery and Sexby was captured at the point of escaping to Flanders, 'disguised as a poor countryman'.

Like spies of all eras, Thurloe employed ciphers to encrypt his correspondence. These were in likelihood devised by one of Thurloe's most important recruits, John Wallis, an outstanding mathematician from Cambridge who served as Chief Cryptographer for Parliament and who made significant contributions to algebra, geometry and calculus. When Thurloe was ousted from office in 1659, he refused to surrender his cipher. His personal papers were eventually discovered during the reign of King William III, hidden above a false ceiling in his former official chambers.

The present portrait must date from the 1650s and depicts Thurloe as the loyal administrator and secretary. Rather than swordplay, horsemanship or muscular strength, Thurloe employed the pen and secret correspondence as his armoury. If we compare the iconography of the present work with that of many of Thurloe's Civil War contemporaries, the letter which he holds may as well represent his baton of office and the quill in its inkwell a sheathed sword, both ready to strike. The artist has also adopted the standard Van Dyck-ian trope of the hand, languidly placed on the edge of the table with a hint of insouciance. Appropriately, an eighteenth-century copy of this work hangs at Vauxhall Cross, the home of MI6.

1 Marshall, p.304

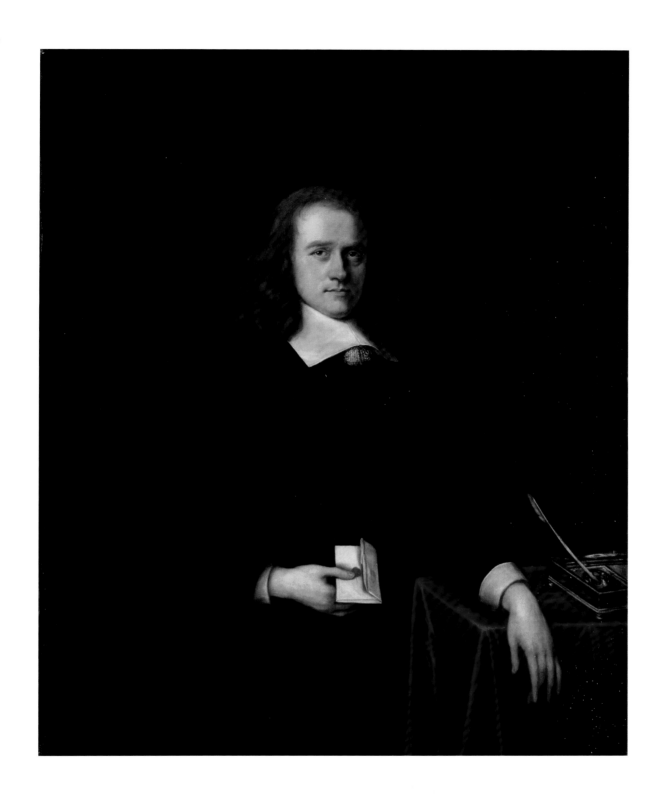

SIR HENRY VANE THE YOUNGER (1613–62)

PORTRAIT ATTRIBUTED TO GERARD SOEST

PARLIAMENTARIAN

*'He changed not his colour or speech to the last, but died justifying himself and
the cause he had stood for; and spoke very confidently of his being presently at the
right hand of Christ; and in all things appeared the most resolved man that ever
died in that manner, and showed more of heat than cowardize, but yet with all
humility and gravity.'* [1]

Governor of Massachusetts and an early supporter of the foundation of Harvard College, Vane was an administrator of considerable skill. He displayed a consistent and ardent desire for religious tolerance.

Vane was educated at Westminster School where one of his classmates was the young, future Parliamentarian general, Sir Arthur Hesilrige. In 1635, after a number of impressive public roles abroad, his intense and public Puritan beliefs compelled him to pursue his future as part of the Massachusetts Bay Colony. After two years of impressive work as a law-maker and diplomat, he became Governor. His fall from grace centred, amongst other things, on the religious debate about antinomianism, a religious heterodoxy close to Anabaptism. A lady called Anne Hutchinson was at the centre of this debate. She was supported by Vane but opposed by, amongst others, Hugh Peters, the firebrand preacher and future 'Prince of army chaplains'. [2]

On his return to England in 1639, Vane was appointed as Treasurer of the Royal Navy, which compelled him to collect Ship Money. At the outbreak of war, he was a key Member of Parliament who campaigned for the removal of the Earl of Essex from command. Vane refused to sit as one of the king's judges.

After Charles's execution, Vane was elected to the Council of State, retiring from office only when Cromwell took the role of Lord Protector in 1653. He returned to Parliament in 1659–60 and, at the Restoration, was initially granted clemency by Charles II but, ultimately, was beheaded.

This portrait ostensibly shows a man in simple dress. However, the plain style of Vane's linen collar contrasts with the ostentation of his silk cloak, which would have been highly expensive. His three-quarter turned pose recalls the works of Van Dyck but it is unusual that one does not see at least one hand. Vane has shrouded himself in his cloak, as if protecting himself against either the cold or the chill words of his enemies and there is a hunted, defensive air to this portrait. The artist has not added any extraneous details to the background. There is only a moody, *sfumato*, background which swirls around the sitter offering nothing more than an air of mystery.

The artist is likely to have been Gerard Soest, who generated a successful practice in London, although he failed to achieve access to the more fashionable clientele. Walpole commented on Soest's painting that 'his draperies were often of satin, in which he imitated the manner of Terburgh, a Dutch painter of conversations, but enlarged his ideas, on seeing Vandyck …' [3] The melancholic aspect of this portrait might have been a product of the artist's own temperament. Towards the end of his life, Soest is known to have 'grown out of humor with the public, but particularly with the ladies'. [4] He would often open the door to his female clientele, pretending to be his own servant, and then flee the house, leaving his wife to explain the situation. Another common feature of Soest's portraiture is the dark clouds which dominate his backgrounds. A native of Westphalia in northwestern Germany, Soest must have been familiar with the poor weather which he encountered in England. It is interesting to note that, with some important exceptions, the majority of foreign artists who came to work in England during the seventeenth century came from Protestant countries. It seems likely that they felt comfortable both with the religious practice as well as with the intolerable English weather. In amusing contrast, Charles I had invited the great Italian painter, Guercino, to his court, who politely declined on the grounds of Roman Catholicism and too much rain.

1 Samuel Pepys, diary entry, 14th June 1662
 – see Wheatley, Vol. II, p.242

2 Gardiner, Vol. III, p.84

3 Wornum, Vol. II, p.127

4 Collins Baker, 1912, Vol. I, pp.205–06

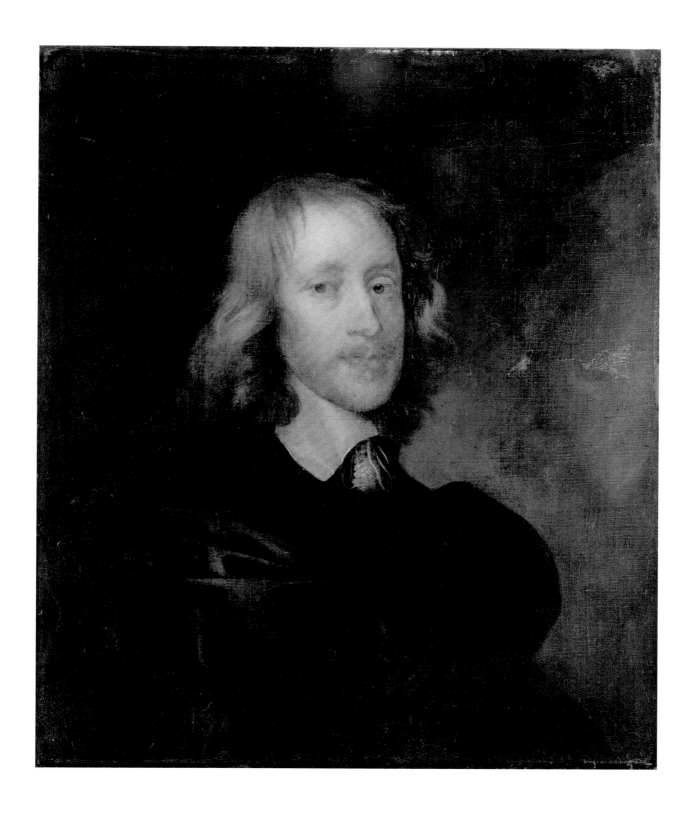

SIR EDMUND VERNEY (*c.1590–1642*)

PORTRAIT BY SIR ANTHONY VAN DYCK

ROYALIST STANDARD BEARER

'I do not like the quarrel, and do heartily wish that the king would yield and consent to what they desire, so that my conscience is only concerned in honour and in gratitude to follow my master. I have eaten his bread, and served him near thirty years, and will not do so base a thing as to forsake him: and choose rather to lose my life.' [1]

Verney was a committed and fiercely loyal supporter of the king. By contrast, at the outbreak of hostilities, his son supported the side of Parliament, and Sir Edmund's story is but one of the many examples of families divided and destroyed by the Civil Wars.

Verney had been a member of Prince Henry's household and, on Henry's premature death, he was appointed as a gentleman of the Privy Chamber in the household of Prince Charles. Verney travelled with Charles in Europe and it was these formative years which forged the unbreakable loyalty to his future king. Such loyalty seems, in part, to have been given as a defence against the infantile and deleterious influence which Verney perceived that the Duke of Buckingham held over the young prince.

Contemporary stories abounded of Prince Charles, the Duke of Buckingham, Sir Edmund and other members of the royal entourage riding through Europe wearing false beards and calling themselves by false names. This may have been perceived by commoners in London as romantic derring-do but such behaviour was at odds with Verney's fundamentally sober lifestyle.

Verney fought and died at the Battle of Edgehill where he was the king's Standard Bearer. By possibly apocryphal tradition, his hand, separated from the rest of his body, was discovered on the battlefield, still holding the standard. Apocryphal or not, this story was intended to recall the tradition of Roman standards or eagles, known formally as the *signa militaria*, the protection of which was regarded as a great honour and responsibility.

Verney was a staunch Protestant and, although he wore his hair long in the Cavalier fashion and was a member of the king's household, he desired religious simplicity and opposed Archbishop Laud's attempted reforms of the church. Ultimately, Verney seems to have sympathised with the aims of Parliament but his honour would not allow these sympathies to compromise his sense of loyalty.

It was perhaps these qualities which led Robert Walker, encouraged by his sitter and patron, Oliver Cromwell, to re-use the iconography of this portrait almost a decade later. The composition of the portraits of Verney and Cromwell are identical. Not only does this fact clearly illustrate Walker's knowledge of Van Dyck's oeuvre but it also debunks the idea that, from an iconographic perspective at least, Parliamentarians and Royalists were somehow different and should be represented with a different language. Portraiture frequently illustrates the language of power and it was more powerful for Cromwell to be painted like Sir Edmund by Van Dyck than for a new and unique voice of portraiture to be created.

Van Dyck has painted Verney's hands with particular delicacy. His left hand lies on his helmet as if the angular, metal object were a favoured hound which, in fact, would have been a more fitting symbol of his fidelity. The long fingers of Verney's right hand rest lightly, almost hesitantly, on his baton of command. With such a sensitive rendering, Van Dyck seems to imply some of his sitter's conflict and ambivalence.

It is intriguing to think that Van Dyck may have left the background unfinished. Certainly he seems to have begun his application of a dark ground around the sitter's head but abandoned it in favour of the lighter tones. In actuality, this rough halo probably indicates where the hand of Van Dyck stops and his studio begins. The bold decision to leave such a dramatic tonal contrast may have been the decision of Van Dyck, the family or both.

1 Gardiner, Vol. 1, p.5

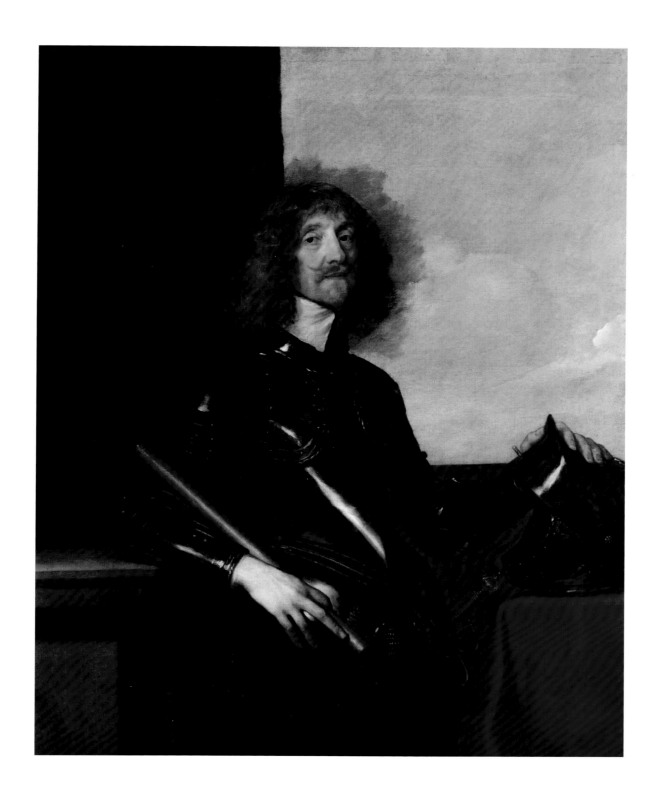

ROBERT WALKER (*c.*1599–*c.*1658)

SELF-PORTRAIT

PARLIAMENTARIAN PAINTER

*'He lived in Oliver Cromwell's days, and drew the portraits of that usurper, and
almost all his officers, both by sea and land.'* [1]

R obert Walker was the most important painter of the parliamentary elite during the period of the Civil Wars.

Little is known of Walker's early life. We do not even know the date of his birth. We are familiar, however, with his appearance since at least five self-portraits survive. The finest of these is the work illustrated (Ashmolean Museum, Oxford). It is tempting to date this self-portrait to 1640–50, a date after Van Dyck's departure from England, but one prior to the end of the Civil Wars and the iconographic triumph of Puritanism.

Although there is no primary evidence to suggest that Walker personally knew Van Dyck or worked in his studio, this self-portrait is incontestable evidence of the fact that Walker was familiar with the paintings of Van Dyck, who had first arrived in England in 1632. The composition of Walker's self-portrait derives directly from Van Dyck's own self-portrait with a sunflower (Duke of Westminster, Eaton Hall) which was painted *circa* 1633. Walker has adopted a similar swagger. In place of a sunflower, Walker gestures at a statue of Mercury, displaying a rakish, almost Cavalier appearance. The inclusion of this detail presumably alludes to Walker's ability to reference the classical language of the past in his painting and any artist who thought it appropriate to paint five, highly finished, almost identical self-portraits cannot have lacked confidence or vanity.

Walker openly acknowledged that he was familiar with the work of Van Dyck and the stock compositions of his studio, and happily conceded that he himself was not an innovator of pose and composition. When asked 'why he did [not] make some of his own postures',[2] his candid reply was, 'if I could get better [compositions] I would not do Vandikes'.[3]

In addition to Van Dyck, it is clear that Walker was influenced by a number of other old master painters. A signed picture, now untraced, of gentlemen playing cards, which is dated 1637, recalls the *chiaroscuro* style popularised by Caravaggio and other artists of the Italian Baroque (Fig. 1). Walker is also known to have worked as a copyist of Italian old masters in the Royal Collection of King Charles I, including a number of Titians. Richard Symonds, a royalist soldier and antiquary, recorded in one of his notebooks[4] that Walker was

Fig. 1

asking £50 for a copy of a Titian's *Naked Woman and a Man Playing the Organ*[5] (Museo del Prado, Madrid). This was a considerable sum in the mid-seventeenth century,[6] and such an asking price reflects the esteem in which Walker was held, or perhaps held himself, as a copyist. According to the same manuscript, which was later quoted by George Vertue:

> *R. Walker, painter, likes best fine cloth to paint on, for, says he, the strong cloths of Italy, they lay so much colour on them that they crack if rolled up. Walker cries up de Cretz for the best painter in London … He had £10 for Mr Thomas Knightley's wife's picture – she sat three times, and four or five hours each time – to the knees. He had £10 for A Philosopher he did from poor old men. £10 each from an English gentleman, July 1652, half bodies. He paid £25 for his Venus pulling on her Smock, which was the King's, and valued it at £60, so Mrs. Boardman told me who copied it.*

This brief contemporary catalogue of Walker's painting neither does justice to the artist who was capable of such fluidity and technical skill

1 Buckridge, p.434

2 Whinney and Millar, p.77

3 *Ibid*

4 B.M. Egerton MSS, 1636, ff.98v, 101

5 After the execution of Charles I, the original painting by Titian was acquired by the Spanish ambassador and now hangs in the Prado.

6 £10, £25, £50 and £60 in 1640 are the equivalent of, approximately, £1,150, £2,900, £5,800 and £7,000 in today's currency.

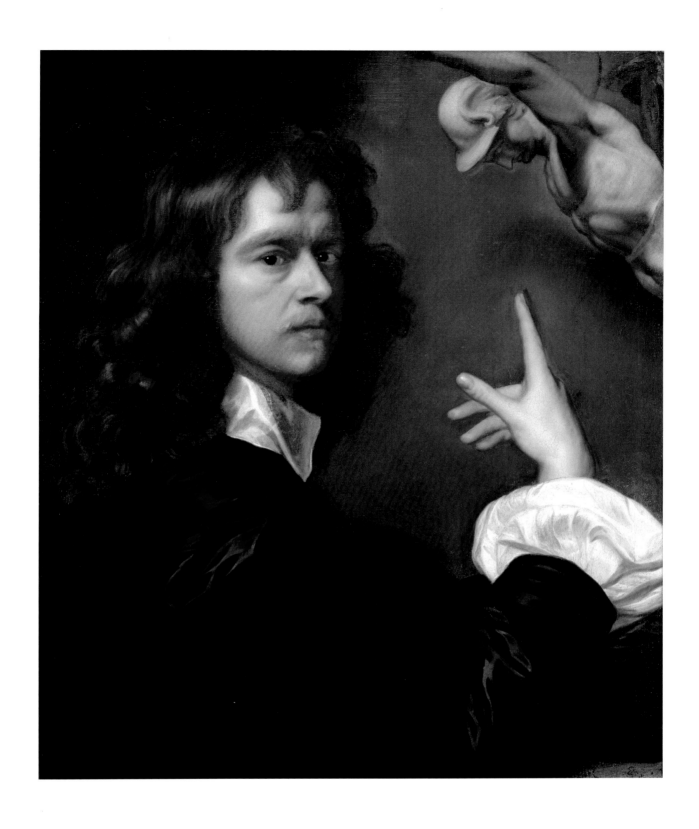

as is displayed in his self-portraits, nor does it reflect the extent to which Walker was regarded highly by other contemporaries. Sanderson, in his *Art of Painting*, which was published in 1658, referred to Walker as one of the modern masters of his age:

> *Our Modern Masters comparable with any now beyond seas: Not to take upon me to enrol them in order and degree of merit; each one hath his deserts. In the Life, Walker, Zowst, Wright, Lillie, Hales, Shepheard, de Grange, rare Artizans.*[7]

The diarist, John Eveyln, was also an admirer of Walker's work and, after a visit to Walker's studio, wrote that he had seen an 'excellent' copy of a Titian.[8] Evelyn himself sat for Walker, as he records in his diary for 1648, 'I sate for my Picture, in which there is a Death's head, to Mr. Walker, that excellent painter.'[9] The result was a portrait of almost metaphysical eccentricity (Fig. 2 – National Portrait Gallery, London). Evelyn rests his hand on a skull in a moment of contemplation on mortality. This is emphasised by the quotation from Seneca inscribed on the portrait which translates as 'no one escapes death except he who has reconciled himself to it long before it arrives'. Such a melancholic, almost penitential attitude fits well with Evelyn's own attitudes. At the outbreak of the Civil Wars, he had sided with the king and had been present at the Battle of Brentford in 1643. Shortly after this, probably in a move of calculated neutrality, he decided to absent himself from England and spent the next four years travelling on the Continent, not to return until the summer of 1647. This portrait was painted shortly before the king's execution and Walker clearly intended to recall the sixteenth-century, old-master portrayals of the Penitent Magdalen.

A portrait of a gentleman tutor and his pupil appeared on the art market[10] which, on stylistic grounds, should be ascribed to Walker (Fig. 3 – Private Collection) and dated no later than 1650. Walker has painted a mannered, moralising portrait. Both tutor and pupil are simply dressed, but the painting is not without a lightness of touch. The inscription in Greek on the ledge of the bookcase translates as 'Ever growing older and learning less.' This would appear to be an ironic parody on an elegiac couplet by Solon, a Greek law-giver of the seventh to sixth centuries BC.

Fig. 2

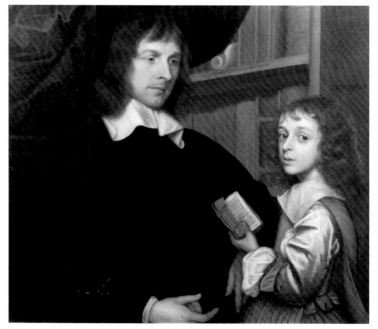

Fig. 3

7 Sanderson, p.20
8 John Evelyn, diary entry, 6th August 1650 – see Braybrooke, p.177
9 John Evelyn, diary entry, 1st July 1648 – see Braybrooke, p.166
10 Sold Sotheby's, 8th April 1992, lot 17

Robert Walker remains most well known, however, for 'being the principle painter employed by Cromwell'.[11] His portraits of Cromwell proved immediately popular and, as a consequence, a great number of versions were produced for dispersal both at home and abroad.[12] It is through the filter of these portraits that we can most clearly see Walker's artistic style.

Over the course of his career, Walker produced a number of portrait 'types' which show Cromwell in similar, but nevertheless distinct, poses. It is possible to reconstruct an approximate chronology for these portraits, the earliest of which is the portrait of Cromwell, standing, three-quarter length, wearing armour and holding a marshal's baton. A fine example of this portrait is in the Cromwell Museum, Huntingdon (No. 14). This portrait is likely to have been painted shortly after the king's death in January 1649, when Cromwell's star was in the political ascendant, but before Cromwell's departure to Ireland in mid-August of the same year.[13]

Walker seems also to have painted his portrait of Hesilrige at the same time (No. 32) as well as another portrait of Cromwell in armour, this time, his sash being tied by a page (Fig. 4 – National Portrait, Gallery, London). A version of this portrait at Temple Newsam House is inscribed with the date 1649, which gives us a firm date. The iconography of this portrait derives from Van Dyck's double portrait of Mountjoy Blount, 1st Earl of Newport, and George, Lord Goring (No. 28).

It is important to question why Cromwell was keen to associate himself with an image of Lord Goring. The answer may lie in an analysis of their respective services during the Civil Wars. Lord Goring and Cromwell were both talented cavalry commanders who fought at Marston Moor on opposite sides of the battlefield. In 1649 Cromwell was a successful general in command of the New Model Army, and Cromwell may have been flattered that the imagery formerly employed for the king's cavalry commander should have been transferred to him.

At the same date Walker must have employed the same imagery of the page for his portrait of Colonel Hutchinson (No. 34). The Goring

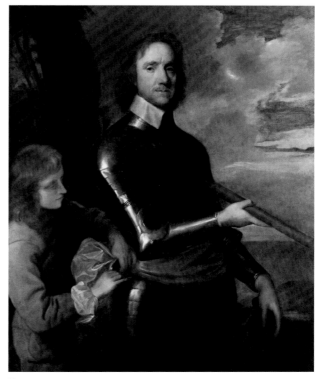

Fig. 4

type proved sufficiently popular that Walker later adapted it, with the slight variation that he placed the page on Cromwell's left hand side (Fig. 5 – The Chequers Trust). In this instance, Cromwell's pose derives from Van Dyck's portrait of Prince Charles Louis as part of the double portrait with his brother, Prince Rupert (Musée du Louvre, Paris). The iconographic, and chronological, crescendo of these early portraits is completed with Walker's double portrait of Cromwell and John Lambert (No. 37).

In 1650 Walker had been made a member of the Painter-Stainers' Company and two years later, on 18th October 1652, Walker had been chosen to be one of the two stewards of the company for the following year.[14] Such an appointment highlights Walker's central

11 Walpole, Vol. II, pp.421–22

12 If all these versions were actually by Walker then he would have had little time other than to paint one man for his entire career. More importantly, the poor quality of many of these portraits often ascribed to Walker is at variance with the fact that a number of signed and documented paintings, some of which have already been mentioned, indicate that he was an accomplished painter.

13 Piper dates this portrait *circa* 1649 – see Piper, 1952–54, p.39.

14 See *Booke of Orders* ..., i.f.155; ii. ff.8, 21

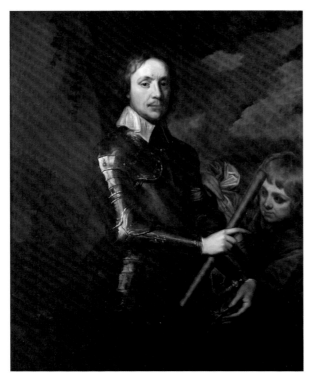

Fig. 5

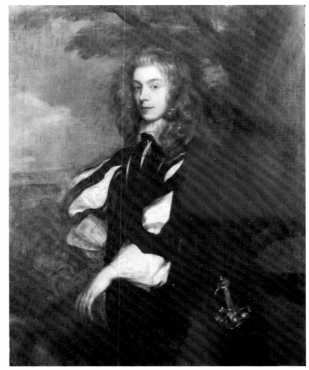

Fig. 6

presence in the artistic establishment of the interregnum. Such an appointment may also have emboldened him to broaden his style.

Walker's portrait of a gentleman, probably a member of the Shirley family, signed and dated '1656' (Fig. 6 – Private Collection), shows the sitter without the formulaic costume of a suit of armour. The sitter's slashed doublet, his arm akimbo, and the prominent sword hilt, which glints at the viewer in the corner of the canvas, all combine to project the image of a dashing courtier of a bygone age. There is an animation to the sitter's features and an elegant *contrapposto* which sets this portrait apart from much of Walker's work during the Civil Wars.

It should also be noted that the years 1650–52 had seen the sale and distribution of Charles I's art collection. The auctions had provided an unprecedented opportunity for every artist in London to study one of the finest collections of old master painting. However, the motivation for such a change in style may also have derived from Walker's exposure to the work of one of England's finest seventeenth-century artists: Sir Peter Lely.

Lely was an émigré Dutchman who had arrived in England shortly after the departure of Van Dyck. He quickly established himself as a portraitist with a talent for conveying beauty, swagger and élan. As a consequence, he found great favour after the Restoration painting the beauties of the court of Charles II. One can only imagine the influence that such an urbane artist must have had on Walker and the other humbler, indigenous painters of England.

Certainly Walker's portraits of the 1650s display a style strongly influenced by Lely. Walker's portrait of the three children of Richard Sackville, 5th Earl of Dorset,[15] for example, is painted in a romantic style with both Charles, Lord Buckhurst and Edward portrayed wearing classical dress (Fig. 7 – Sackville Collection, Knole). The youngest sitter, in the centre of the composition, is Mary Sackville who was born in 1646. She would appear to be about five or six years old in the painting, thereby suggesting a likely date of execution in the early 1650s. This was the very period in which Lely was painting children in Arcadian costume.

It is Walker's portrait of Mary Capel, 1st Duchess of Beaufort, however, which most explicitly recalls the work of Sir Peter Lely (Fig. 8 – Private Collection). Lely himself had painted Mary Capel in a double portrait with her sister, Elizabeth, Countess of Carnarvon *circa* 1658 (Fig. 9 – Metropolitan Museum of Art, New York). The Capels were among Lely's most important patrons during the interregnum and a comparison of the two portraits illustrates the extent to which Walker was keen to adopt elements of Lely's style. Walker has employed the same seated pose with a slight twist at the waist. This is a technically difficult pose to render and one which Walker usually avoided in favour of the standing portrait. Walker's inclusion of the architectural element of a sculpted urn illustrates his growing sophistication as an artist. It also illustrates that such artistic sophistication was necessary in order to prevent himself being superseded by a technically superior artist. Sadly for Walker, this portrait of Mary Capel represents his last known attempt to keep pace.

15 An inscription on the lining canvas, which was presumably transcribed from the original canvas, cites Walker as the artist.

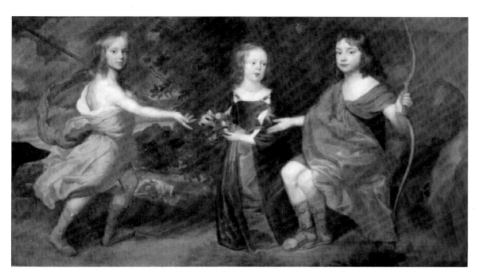

Fig. 7

Fig. 8

The date of Walker's death is almost as unclear as the date of his birth. It is generally accepted to have been shortly before the Restoration. There is little doubt, however, that without the patronage of Cromwell and his officers, Walker's practice as a portraitist was severely compromised. With the death of Cromwell and the likelihood of Restoration, artists such as Lely, John Michael Wright and Wissing began to dominate the resurgent aristocratic demand for portraiture in a grand style.

Whilst he lived, it was Walker's great fortune to have painted during an age sandwiched between the artistic geniuses of Van Dyck and Lely but dominated by neither. Walker absorbed, emulated and combined elements from both these artists, and successfully generated a short-lived English style. Once he was dead, it was Walker's great misfortune for his painting to be regarded as a poor imitation of the work of these two geniuses. Walker bequeathed to art history an indigenous style of English painting. His portraits illustrate the artistic zeitgeist of the interregnum and they do not deserve to be ignored or overlooked.

Fig. 9

SIR WILLIAM WALLER (1597–1668)
PORTRAIT ATTRIBUTED TO EDWARD BOWER

PARLIAMENTARIAN COMMANDER

'That great God who is the searcher of my heart knows with what a sad sense I go upon this service, and with what a perfect hatred I detest this war without an enemy; but I look upon it as sent from God.' [1]

A devoted Puritan and a talented general, Waller's abilities have been rather overlooked by the fact that he was on the losing side of the puritanical faction which won the war. Conversely, the nature of his victories seem also to have been somewhat magnified.

Waller trained in the art of war on the Continent, serving Elizabeth, Queen of Bohemia. After the defeat at the Battle of the White Mountain, Waller and his friend, Ralph Hopton, accompanied the queen to Frankfurt.

Waller returned to England in 1622 and, despite a 20-year hiatus from battle, at the outbreak of war he achieved high command almost immediately. This was combined with significant military successes, such as the capture of Portsmouth and Winchester. In 1643 the Earl of Essex appointed Waller as Major-General of the West, at which point he found himself fighting opposite his friend, Hopton, for control of the West Country, most notably at the Battle at Lansdown. Waller was soundly beaten at the Battle of Roundway Down and, despite a number of valuable successes in 1645 he eventually renounced his command and pursued a political career. In this he seems to have been both unsuccessful and unsatisfied.

The words quoted above are in fact from a letter which Waller wrote to Hopton dated from 16 June, 1643 when the two friends confronted each other on opposing sides of the battlefield. His poignant words echo the sentiment, expressed by many, that war divides and destroys and that man must ultimately endure God's will. This letter is thought to be the last known communication between the two men and they were never to meet again. [2]

In this portrait, the dates 1648, 1649, 1650 and 1651 refer to the years Waller was imprisoned, most notably after Pride's Purge in December 1648 when Waller and four other members were accused of inviting the Scots to invade England. The device of the tower, combined with the inscribed name Windsor, refer pointedly to Windsor Castle where Waller was imprisoned before being moved to Denbigh Castle. Cromwell had, in fact, occupied Windsor Castle after the Battle of Edgehill and it remained a prison for the remainder of the Civil Wars.

Waller had been imprisoned at Windsor alongside Commissary-General Copley, General Richard Brown, Sir John Clotworthy and Sir William Lewis. The portraits of these men, presumably painted by the same hand, were all eventually hung in the main hall at Sprotborough. Each portrait of this fascinating 'Imprisonment Series' portrays each man with simple dress and a direct, bright-eyed gaze and each carries the device of Windsor Castle.

The series of portraits is repeated at Weald Hall, Essex. However, here, the portrait of Lewis is missing and has been substituted by that of General Massy, who escaped his imprisonment at the beginning of the period.

Waller is dressed in simple black clothing which belies nothing of his military background. The iconography of his dress recalls academics and divines, a fact which fits with his writing *Vindication ... of Sir William Waller* which he composed during his imprisonments. It seems clear that the portrait series was intended to vindicate rather than antagonise.

Waller was referred to as Parliament's 'famous and fortunate commander'[3] and was clearly by no means a revolutionary Parliamentarian. He declared, 'I was borne under a monarchy: and I desire to dy under it.'[4] In this regard, at least, he achieved satisfaction.

1 Polwhele, p.16
2 The words themselves might not originally have been those of Sir William Waller since another source quotes them as first having been spoken by Sir Edmund Verney and later echoed in a letter by Sir William Waller.
3 Vicars, p.375
4 Waller, p.317

Sr Wm Waller.

BULSTRODE WHITELOCKE (1605–75)

PORTRAIT BY ENGLISH SCHOOL

PARLIAMENTARIAN – LAWYER AND DIPLOMAT

*'A man of sense, learning, integrity, spirit, temper … and knowledge
of the world'* [1]

With such a striking name, Bulstrode Whitelocke was destined for greatness or abject failure. At his christening, the vicar having expressed some hesitation at the choice of name, was forcibly informed that the child was to be called 'Bulstrode or Elizabeth, let them choose which they please'.[2] Unquestionably, the sitter seems to have achieved greatness but in such an unassuming manner that, on the basis of this portrait, one might be forgiven for interpreting it as failure.

Whitelocke was educated first at Eton and subsequently at Merchant Taylors' School. After a series of scuffles with students from St Paul's School, he was selected by his schoolmasters to act as an ambassador to the 'enemy' school. This childhood role foreshadowed his adult career as a mediator and later as an ambassador to Sweden. He entered the Inn of Middle Temple and went on to make a very good living as a barrister. He was a man of cultivation and, in 1634, was entrusted with the responsibility for the music at a royal masque, *The Triumph of Peace*, which was to be presented by the Four Inns of Court in the Banqueting Hall, Whitehall. The production was designed by Inigo Jones and the plot was a diplomatically delicate theme of justice, peace and good governance descending to honour the monarch. In the same year, Whitelocke's first wife, Rebecca, died and the following year he married Frances Willoughby, daughter of William, 3rd Lord Willoughby of Parham, with whom he enjoyed 14 years of happy marriage.

Whitelocke seems always to have adhered to a strong moral code. He supported John Hampden's opposition to Ship Money and it was with great reluctance that he served as chairman of the committee which was to prepare the impeachment of Thomas Wentworth, Earl of Strafford. During the Civil War itself, he continually advocated peace and served as a commissioner to arrange peace talks on more than one occasion. He spoke against the trial of Charles I and, on the day of his execution Whitelocke stayed at home as a statement of non-involvement. Later in 1649 Frances died, and the following year he married Mary, as his third wife.

In August 1653 Whitelocke was named as Ambassador to Queen Cristina of Sweden. It is likely that this appointment was a means of removing from the political scene a man whom Cromwell found to be troublesome and no longer loyal to the 'cause'. It was possibly during this visit that a gift of a portrait of Oliver Cromwell was presented to the queen.[3] His diplomatic mission was very successful and he returned to England in 1654, whereupon he was appointed as a commissioner of Parliament's new great seal. He served as one of the twelve pall bearers at Cromwell's funeral. He lost many allies in the months leading up to the Restoration but was eventually pardoned by Charles II under the Act of Indemnity. He retired from public life and devoted himself to writing, most importantly his *Memorials of the English affairs from the beginning of the reign of Charles I*, which was published in 1682.

Whitelocke had been elected as an MP as early as 1626. He regarded the Commons as the 'best school in Christendom'[4] and he often wore a long black coat like a cassock, causing MPs to call 'Mr Deane, Mr Deane', in derision of his overtly academic appearance. The air of the don was clearly something which Whitelocke cultivated and one should not exclude the possibility that such modest, unassuming iconography was employed as a safe language which would cause offence neither to the reigning Parliamentarians nor to the exiled or disenfranchised Royalists. Whitelocke was a diplomat and this portrait, which might be regarded as sombre and boring by some, exemplifies why he was a talented one.

1 Morton, Vol. I, p.4

2 See Spalding, p.27

3 According to a label on the back of this portrait of Cromwell (Inv. No. NMGrh 1213), it was given to the Castle of Gripsholm by the Dowager Countess Gylleborg in 1830 and that by tradition it had been a gift of Oliver Cromwell to Queen Christina of Sweden, presumably via the hands of Whitelocke himself.

4 *The History of Parliament: the House of Commons 1604–1629*, 2010

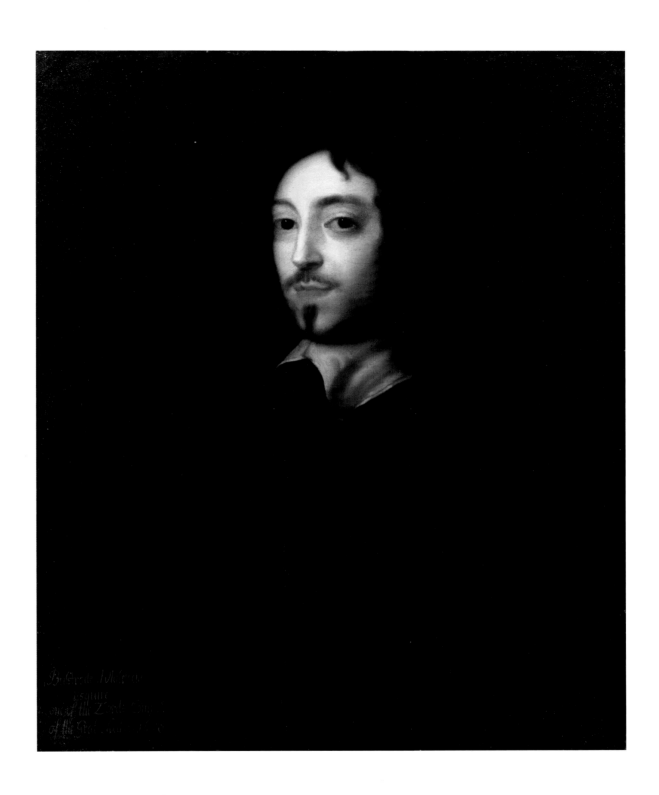

SIR RICHARD WILLYS, BARONET (1614–90)

PORTRAIT BY WILLIAM DOBSON

ROYALIST – FOUNDER OF THE SEALED KNOT

'The gentleman accused [Sir Richard Willys] had from the beginning to the end of the war given testimony of his duty and allegiance, and was universally thought to be superior to all temptation of infidelity. He was a gentleman, was very well bred, and of very good parts, and in truth of so general a good reputation, that if the King had professed to have any doubt of his honesty his friends would have thought he had received ill infusions without any ground.' [1]

Willys was a soldier, an ineffectual conspirator and an even more ineffective double agent with a talent for consistently evading the effects of bad luck.

Although initially destined for a career in the law, he abandoned Gray's Inn for military service in Holland. He distinguished himself at the siege of Breda and in 1641 was made a member of the king's guard. During the First Civil War, he served as Colonel of Horse under Viscount Grandison and, subsequently, under Prince Rupert.

In 1645 Willys served as Governor of Newark, a role from which he was soon dismissed, the reasons for which perhaps illustrate his poor judgement. As Prince Rupert approached the city, insistent for an audience with the king, Willys marched out of the city to greet him in a gesture of courtesy, loyalty and affection for his old comrade in arms. Rupert, at that time, was *persona non grata* to the king and Willys's gesture of loyalty to his old friend showed disloyalty to his monarch. Willys's tactless and wilful behaviour seems soon to have been pardoned and, as a bonus of reconciliation, he was created a baronet.

Willys's greatest claim to fame is as one of the six founding members of The Sealed Knot, an inner ring of royalist conspirators who aimed at achieving the restoration of Charles II. The Knot came into existence in November 1653, shortly before Cromwell assumed his role as Lord Protector, and thereafter proceeded to achieve very little. This was perhaps not aided by the infighting amidst the members. Willys had challenged another member of the Knot, Sir John Belasyse, to at least one duel and probably a second, and the organisation was riven with personal tensions.

Willys himself eventually became an informer for Cromwell's spymaster, John Thurloe, on the basis that none of the information that he provided would lead to the death of any Royalist. One of Thurloe's assistants, Samuel Morland, eventually denounced Willys to King Charles II and Edward Hyde, Lord Clarendon. At the restoration, Willys was pardoned on the basis that he never again enter the king's presence. He died without an heir, his baronetcy became extinct, and Willys seems to have departed this world as quietly as he entered it, albeit with a great deal of noise in the middle.

X-ray photographs taken of this portrait in the 1990s indicate that Dobson started his portrayal of Willys in profile, eventually changing to the more glamorous three-quarter turned pose which we now see.

This vainglorious portrait, with Willys bearing a haughty expression, seems to be a *mélange* of compositional elements taken from a number of Dobson's portraits. The element of the horse and groom, which itself derives from Van Dyck's portrait of Charles I, *Charles I on Horseback with M. de St Antoine* (Royal Collection, UK), features in Dobson's portrait of Sir Charles Lucas (No. 41). The statue of Minerva features in Dobson's portrait of James Graham, Marquess of Montrose (No. 46) and, although intended to allude to wisdom, the presence of Minerva seems strangely inappropriate for a man such as Willys.

1 Clarendon, *1826*, Vol. VI, p.114

APPENDIX OF IMAGES

1. GEORGE MONCK, 1st DUKE OF ALBEMARLE (1608–70)

Portrait after Samuel Cooper
Head and shoulders, wearing armour and the sash of the Order of the Garter
Oil on canvas
76.5 × 63.5 cm, 30" × 25"

Provenance:
B. Barnett;
Acquired in 1863 by the National Portrait Gallery, London

Literature:
Holme and Kennedy, pl. 32
Piper, 1963, p.3

2. HENRY FREDERICK HOWARD, 15TH EARL OF ARUNDEL (1608–52)

Portrait by Sir Anthony van Dyck (1599–1641)
Half length, standing, wearing armour, resting his helmet on a stone ledge
Inscribed on the ledge: *Droit et Avant*
Oil on canvas
142 × 111.8 cm, 56" × 44"

Provenance:
Presumably commissioned by the sitter and thence by family descent to Edward Fitzalan-Howard, 18th Duke of Norfolk, Arundel Castle

Literature:
Barnes, De Poorter, Millar and Vey, 2004, p.438, IV.12

3. JACOB ASTLEY, 1st BARON ASTLEY OF READING (1579–1652)

Portrait attributed to Adriaen Hanneman
Three-quarter length, standing, wearing a breastplate and an embroidered gold doublet
Inscribed upper left with the identity of the sitter, and further inscribed centre right: *Aetat:61 / Anno Do / 1640*
Oil on canvas
80 × 71.5 cm, 31½" × 28¼"

Provenance:
Wroxton College, by whom sold, Sotheby's, 23rd November 2006, lot 23 where it was acquired by Philip Mould

This picture might be the portrait recorded in the collection of Lord Hastings, Melton Constable Park which descended to Lady Hastings, Swanton House (see Duleep Singh, p.13, no. 52 illustrated; Ketton-Cremer, 1969, illustrated opposite p.290). A second or third version was with Clovis Whitfield in 1985.

This portrait was engraved by Houbraken for Clarendon's *History of the Rebellion*. A pencil drawing by Thomas Worlidge (sold Christie's, 21st November 1978, lot 9) clearly derives from this portrait. It is not an *ad vivum* portrait and, according to an engraving, was executed in 1757.

4. JOHN BELASYSE, 1st LORD BELASYSE OF WORLABY (1614–89)

Portrait by Sir Anthony van Dyck (1599–1641)
Three-quarter length, standing, wearing a doublet and a cuirass
Oil on canvas
99 × 78 cm, 39" × 30¾"

Provenance:
Anon, sale, Sotheby's, Milan, 2nd December 2003, lot 127;
Luigi Koelliker, Italy

Exhibited:
Paris, 2008–09, no. 24

Literature:
Barnes, de Poorter, Millar and Vey, 2004, p.447, IV.26

There is a copy at Serlby Hall and another at Newburgh Priory. An inferior copy is at Althorp and a small copy is at Stonor Park.

5. JOHN BRADSHAW (1602–59)

Portrait by Circle of William Dobson
Double portrait of John Bradshaw and Hugh Peters
Both half length, wearing black dress
Later inscribed along the lower centre: *Lord President Bradshaw / of ye High Court of Justice ye condemned Charles Ist to death … Hugh Peters* and inscribed lower right: *By Dobson*
Oil on canvas
53 × 79 cm, 21" × 31"

Provenance:
Lord Tollemache, Helmingham Hall

6. GEORGE DIGBY, 2ND EARL OF BRISTOL (1612–76)

Portrait by Justus van Egmont (1601–74)
Three-quarter length, wearing armour, the sash and jewel of the Order of the Garter, holding a baton and gesturing towards a cavalry charge
Oil on canvas
124.5 × 99 cm, 49" × 39"

Provenance:
The Board of Trustees of the Royal Armouries, Leeds

Exhibited:
London, 1995–96, no. 17

A second, potentially superior, version is at Sherborne Castle. This version is charged with the family coat of arms. Another version of this portrait with the coat of arms was sold at Christie's, 6th February 1953, lot 58.

7. JOHN BYRON, 1st BARON BYRON (1598/99–1652)

Portrait by William Dobson (1611–46)
Three-quarter length, standing beside a black pageboy holding his charger, two Solomonic columns beyond
Oil on canvas
142 × 120 cm, 55¾" × 47"

Provenance:
By descent from the sitter's brother-in-law, Sir Peter Leicester, to Lt-Colonel J.L.B. Leicester-Warren, after whose death the work was sold to the University of Manchester as part of the Tabley House Collection

Exhibited:
Manchester, 1857, no. 41 (as Van Dyck);
London, 1884, no. 2;
London, 1951, no. 1;
Worcester, 1951, no. 2;
London, 1960–61, no. 2;
London, 1983–84, no. 11

Literature:
Spencer, 1937, no. 4;
Whinney and Millar, 1957, p.87

8. KING CHARLES I of ENGLAND, SCOTLAND AND IRELAND (1600–49)

Portrait by Sir Anthony van Dyck (1599–1641)
Full length, mounted on a charger, wearing armour, accompanied by a page
Oil on canvas
367 × 292 cm, 145" × 115¼"

Provenance:
Commissioned by King Charles;
Acquired by the National Gallery in 1885

Literature:
Barnes, De Poorter, Millar and Vey, 2004, p.468, IV.51

9. KING CHARLES I of ENGLAND, SCOTLAND AND IRELAND (1600–49)

Portrait by Edward Bower (fl. 1635–67)
King Charles I at his trial
Three-quarter length, seated, wearing black robes and the Order of the Garter
Signed and dated lower left: *Edw Bower / Att Temple Barr / fecit 1648*
Oil on canvas
105.5 × 86.5 cm, 41½" × 34"

Provenance:
Said to have been commissioned by Sir John Carew, 3rd Bt., of Antony, Cornwall (1635–92);
Presumably thence by descent to Sir John Crewe Pole, Bt. and thence by descent to Sir Reginald Pole Carew (1849–1924);
Thence by family descent at Antony House

Exhibited:
London, 1960–61, no. 1

Literature:
Collins Baker, 1912, Vol. I, p.114

There are numerous versions of this portrait. One is recorded at Belvoir Castle (signed identically to the present portrait), with others in All Souls College, Oxford, in the Duke of Beaufort's collection, and at the University of St Andrews.

10. CHARLES, PRINCE OF WALES (1630–85)

Portrait by William Dobson (1611–46)
Three-quarter length, standing, wearing the Lesser George and an embroidered breastplate, accompanied by his page
Oil on canvas
153.6 × 130 cm, 60½" × 51¼"

Provenance:
Presumably commissioned in Oxford by the sitter or his father;
Grinling Gibbons, his sale, 15th November 1722, lot 24;
Thomas Walker, by whom bequeathed to his daughter, Emma, who married William Harvey;
By descent to his daughter, Mrs John Drummond and thence by descent to her son-in-law, Sir Campbell Munro;
Sir Torquil Monro from whom acquired in 1934 by the Scottish National Portrait Gallery, Edinburgh

Exhibited:
London, 1951, no. 2;
London, 1960–61, no. 23;
London, 1972, no. 155;
London, 1983–84, no. 9

Literature:
Vertue, 1936, Vol. XXIV, pp.25, 178;
Walpole, 1849, Vol. II, p.353;
Spencer, 1937, no. 6

11. KING CHARLES II (1630–85)

A set of five works by Isaac Fuller (1606–72)

Charles II at White Ladies Priory with Richard Penderel;
Richard Penderel introducing Colonel Careless to King Charles II in Boscobel Wood;
King Charles II and Colonel William Careless in the Royal Oak;
King Charles II on Humphrey Penderel's Horse;
King Charles II and Jane Lane Riding to Bristol

All oil on canvas
A) 213.3 × 185.4 cm, 84" × 73"
B) 213.7 × 188 cm, 84¼" × 74"
C) 212.7 × 315.6 cm, 83¾" × 124¼"
D) 214 × 238 cm, 84¾" × 93¾"
E) 212 × 237.8 cm, 83½" × 93¾"

Provenance:
Possibly painted for Henry Carey, 4th Viscount Falkland, from whom it may have passed to his first wife, Rachel, Viscountess Falkland (d. 1717/18);
Presumably by descent until sold at auction, February 1743–44;
Robert Jocelyn, 3rd Earl of Roden and Baron Clanbrassil, Tullamore Park, County Down;
By descent to his daughter, Lady Jocelyn who married Arthur Gore, 5th Earl of Arran;
By descent to Arthur Gore, 6th Earl of Arran, by whose executors sold, Christie's 23rd March 1979, lot 156;
Acquired by the National Portrait Gallery, London

Exhibited:
On loan to the Banqueting House, Whitehall

Literature:
Walpole, 1849, Vol. III, pp.10–11;
Collins Baker, 1912, p.125;
Waterhouse, 1953, p.58

12. SIR THOMAS CHICHELEY (1614–99)

Portrait by William Dobson (1611–46)
Half length, wearing a cuirass, and a buff coat with gold and red stripes, his right hand on the head of a hound
Oil on canvas
101.5 × 77.5 cm, 40" × 30½"

Provenance:
Presumably commissioned by the sitter and thence by descent to his daughter, who married Richard Legh of Lyme, Cheshire;
Thence to Elizabeth Legh who married Sir Streynsham Master (1640–1724);
Thence by family descent until sold Christie's, 10th April 1992, lot 11, bt. £101,200

Exhibited
London, 1983–84, no. 17

Literature:
Master, 1874, p.102 (when hanging at Barrow Green House, Surrey)

A copy of this portrait hangs at Narford (Captain Fountain) and another appeared in the Earl of Oxford's sale, 11th March 1742 as lot 29 (sold for 15 guineas to Coleraine). A third version of this portrait was in the possession of the Grocers' Company, London which was destroyed in a fire in 1966.

13. SIR WILLIAM COMPTON (1625–63)

Portrait by Henry Paert the Elder (c.1637–c.1697), after Sir Peter Lely (1618–80)
Half length, standing, wearing a breastplate and a leather jerkin
Inscribed lower right: *Sir Willm Compton / From Vandyck. Paert pinxt*
Oil on canvas
127 × 101.5 cm, 50" × 40"

Provenance:
National Portrait Gallery, London

The prime version of this portrait by Lely hangs at Ham House.

14. OLIVER CROMWELL (1599–1658)

Portrait by Robert Walker (c.1599–c.1658)
Three-quarter length, standing, wearing armour, holding a baton of office, resting his left hand on his helmet
Oil on canvas
134.5 × 109 cm, 53" × 43"

Provenance:
Said to have been given to Bridget Cromwell on the occasion of her marriage to Henry Ireton in 1646;
Presumably thence by descent to Henry Ireton, her grandson;
Thence by descent to David Polhill, his nephew, and thence by descent in the Polhill-Drabble family;
In 1958 the painting was in the collection of the Rt Hon. Sir Isaac Foot;
By descent to Lord Foot, his son, until acquired by the Cromwell Museum, Huntingdon, in 1978

Literature:
Piper, 1952–54, p.39, 1.c; plate VII c.)

A number of versions of this type are known:
1) The painting exhibited, London, 1960–61, no. 24 (lent by the executors of G.E. Luttrell).
2) The painting recorded as belonging to Commander M. Ewant-Wentworth, R.N., by whose executors sold, Christie's, 28th June 1946, lot 43, bought by Mallett.
3) The painting in the Burghley House Collection.
4) The painting, with the addition of a page to the right of the composition, which was attributed at the time to Henry Stone, was sold by O.D. Wakeman at Christie's on 7th March 1958, lot 115 bought by Samuels for 80 guineas.
5) The painting recorded in the collection of George Brown, Bournemouth (see Heinz Archive, National Portrait Gallery, London).

15. OLIVER CROMWELL (1599–1658)

Portrait by Samuel Cooper (1609–72)
Head and shoulders, wearing gold-studded armour and a lawn collar
Signed lower right with initials and dated 1649
Watercolour on vellum, oval
5.5 × 4.5 cm, 2¼" × 1¾"

Provenance:
Sotheby's, 4th July 1983, lot 57, where acquired by the National Portrait Gallery

Piper (1952–54, p.39) records a potentially earlier miniature at Burghley House, signed and dated 1647. This portrait is no longer in the collection and was possibly sold during a dispersal of property in 1958. Piper (*ibid*) believed the date to be suspect.

16. OLIVER CROMWELL (1599–1658)

Portrait by Sir Peter Lely (1618–80), after Samuel Cooper (1609–72)
Half length, wearing armour
Signed and inscribed: *OLIVER. Lely.fc CROMWELL. Ptor.*
Oil on canvas, in a sculpted cartouche

Provenance:
Birmingham City Art Gallery

Literature:
Piper, 1952–54, p.40, pl. IX A

Other versions of this portrait include:
1) The portrait in the National Gallery of Ireland, Dublin.
2) The portrait in the Cromwell Museum, Huntingdon.
3) The portrait owned by Colonial Williamsburg, Virginia (formerly, Christie's, 7th April 1993, lot 10A).

17. OLIVER CROMWELL (1599–1658)

Attributed to Thomas Wyck
Full length, seated on a grey charger, wearing armour and holding a marshal's baton, attended by a black page who hands him his helmet
Oil on canvas
90 × 74 cm, 35¼" × 29¼"

Provenance:
Erasmus Earle (1590–1667) and thence by family descent;
William Bulwer-Long, Heydon Hall, Norfolk and thence by descent until sold, Christie's, 10th July 1998, lot 145 where acquired by the Weiss Gallery;
Anon. sale, Christie's, 8th June 2006, lot 18

18. RICHARD CROMWELL (1626–1712)

Portrait by John Hayls (c.1600–1679)
Half length, wearing armour
Later inscribed lower centre on a label attached to the canvas: *Richard Cromwell / eldest son of the / Protector*
Oil on canvas, oval
76 × 64 cm, 30" × 25¼"

Provenance:
In the possession of Mary Esther Russell (d. 1891) by 1880, on whose death the picture presumably passed to her niece, Avarilla Oliveria Cromwell Russell (1826–93), who married the Rev. Paul Bush (1822–1904);
Thence by descent in the Bush family

Literature:
Waylen, 1880, p.348, no. 11 in the list of portraits at Bishops-Teingnton;
Waylen, 1897, p.226, no. 3;
Ramsay, 1935, p.viii, illustrated as frontispiece;
Powley, 1965, no. 19;
Piper, 1963, p.99

19. RICHARD CROMWELL (1626–1712)

English School, c.1659
A satire of Richard Cromwell being offered the crown
Oil on panel
48 × 48 cm, 19" × 19"

Provenance:
Bush Family, on loan to the Cromwell Museum, Huntingdon

20. WILLIAM DOBSON (1611–46)

Portrait after William Dobson
Half length, wearing a black cloak
Oil on canvas
72 × 60 cm, 28½" × 23¾"

Provenance:
Possibly Horace Walpole;
Possibly Strawberry Hill Sale, 1842, 21st Day, lot 109, bought by Preston;
Acquired in May 1870 by the National Portrait Gallery, London

Literature:
Piper, 1963, p.108

21. HENRY PIERREPONT, MARQUESS OF DORCHESTER (1607–80)

Portrait by English School, 17th century
Half length, wearing legal robes
Inscribed top and bottom: *Illustissimus. D.D, / Henricus Marchio / Durnovariae,*
Oil on canvas, oval
73.5 × 63.5 cm, 29" × 25"

Provenance:
In the possession of the Royal College of Physicians by 1866

Exhibited:
London, 1866, no. 850;
Nottingham, 1878, no. 25

22. EDWARD SACKVILLE, 4TH EARL OF DORSET (1591–1661)

Portrait by Studio of Sir Anthony van Dyck
Full length, standing, wearing a breastplate, the ribbon of the Order of the Garter and his key of office as Chamberlain to the Queen
Inscribed lower left with the identity of the sitter
Oil on canvas
218.5 × 132 cm, 86" × 52"

Provenance:
Presumably commissioned by the sitter and by family descent at Knole

Exhibited:
London, 1900, no. 93;
London, 1960–61, no. 12

Literature:
Barnes, De Poorter, Millar, and Vey, 2004, IV. A13

23. ROBERT DEVEREUX, 3RD EARL OF ESSEX (1591–1646)

Portrait by Daniel Mytens (1590–1647)
Full length, standing on a Turkish rug, wearing a black doublet and hose, with lace collar and cuffs
Oil on canvas
203 × 122 cm, 80" × 48"

Provenance:
Earl of Portland, Welbeck Abbey, on loan to the National Portrait Gallery

24. SIR THOMAS FAIRFAX (1612–71)

Portrait by Edward Bower (fl. 1635–67)
Three-quarter length, standing, wearing a breastplate, a slashed red doublet, a green sash, holding a baton of command
Signed and dated centre right: *Bower at Temple Bar. Fecit 1646*
Oil on canvas
121.9 × 91.5 cm, 48" × 36"

Provenance:
Presumably commissioned by the sitter;
Sir Matthew Richard Henry Wilson, 4th Bt of Eshton Hall, Yorkshire;
By descent to Sir Matthew Wilson, 5th Bt, by whose estate sold, Christie's, 10th April 1992, lot 4;
Private collection

Literature:
Piper, 1963, p.123

A version deriving from this portrait is known at Althorp which does not show the sitter wearing his jewel (exhibited Leeds, 1868, no. 3076). Other versions are recorded at Bilborough Hall (exhibited London, 1866. no. 706) and at Aynho Park. A similar picture, but with a helmet and a white plume in the background, 1870, was in the Fairfax Collection at Newton House, Kyme (see Markham, p.431).

25. LADY JANE FISHER (*c.*1629–89)

Portrait by John Hayls (*c.*1600–79)
Three-quarter length, wearing an oyster coloured dress, holding a crown
Inscribed on a scroll upper left: *Sic, sic, iuvat ire sub umbra*
Oil on canvas
108 × 91 cm, 42½" × 36"

Provenance:
Said to have belonged to the Earl of Tyrconnell;
Ainderby Vicarage, sold in 1848;
J. Hodgson and J.W. Darnbrough;
By descent to Adelaide Julia Darnbrough, by whom bequeathed, in 1917, to the National Portrait Gallery

Literature:
Piper, 1963, p.126

A portrait which closely relates to this work is recorded in the collection of 11th Earl of Aylesford, Packington Hall. This portrait shows the Hydra in the background.

26. LIEUTENANT GENERAL CHARLES FLEETWOOD (*c.*1618–92)

Portrait by Robert Walker (*c.*1599–*c.*1658)
Half length, wearing armour
Oil on canvas
76 × 63.5 cm, 30" × 25"

Provenance:
Presented by the Rev. Richard Edward Kerrich to the Society of Antiquaries in 1844

Exhibited:
London, 1866, no. 807

Literature:
Collins Baker, 1912, Vol. I, p. 109

27. ARTHUR GOODWIN (1593/94–1643)

Portrait by Sir Anthony van Dyck (1599–1641)
Full length, standing, wearing robes
Inscribed lower left and lower right
Oil on canvas
219 × 131 cm, 86¼" × 51¾"

Provenance:
By descent from the sitter to his daughter, Jenny, who married in 1637 Philip Wharton, 4th Baron Wharton;
By descent to his grandson, Duke of Wharton, by whom sold in 1725 to Sir Robert Walpole, later Earl of Orford;
Given by the above to 3rd Duke of Devonshire, and thence by descent

Literature:
Barnes, De Poorter, Millar and Vey, 2004, IV.105, p.513

A copy, and a copy of the head (recorded as belonging to Lord Wharton in 1926), are in the Pennington-Mellor-Munthe Trust.

28. GEORGE, LORD GORING (1608–57)

Portrait by Sir Anthony van Dyck (1599–1641)
Double portrait of Mountjoy Blount, 1st Earl of Newport (*c.*1597–1666), and George, Lord Goring (1608–57)
Both three-quarter length, wearing slashed doublets and breastplates, a landscape beyond, a page attending to Lord Goring's sash
Oil on canvas
128 × 151 cm, 50½" × 59½"

Provenance:
Petworth House, Sussex, The Egremont Collection (The National Trust)

Literature:
Barnes, De Poorter, Millar and Vey, 2004, IV.171, p. 562

An early copy was formerly in the collection of the Dukes of Manchester, Kimbolton Sale, 18th July 1949, lot 24. This picture was subsequently sold at Christie's, 10th November 1982, lot 25. A preliminary sketch by Van Dyck for this composition *en grisaille* was offered for sale at Sotheby's, 5th July 2012, lot 205.

29. SIR BEVIL GRENVILLE (1596–1643)

Portrait by a Follower of Cornelius Johnson
Three-quarter length, wearing armour and a white lace collar and red sash, holding a marshal's baton, a cavalry engagement beyond, the Grenville arms of three clarions charged upper left
Oil on canvas
122 × 102 cm, 48" × 40"

Provenance:
Sir Vincent Baddeley, from whom acquired in 1954 by the Victoria Art Gallery, Bath

The prime version of this portrait which, presumably, had been commissioned by the sitter's family eventually descended to the 4th Duke of Sutherland (by whose trustees sold, Christie's, 27th October 1961, lot 47, bought by Spencer for 90 guineas; subsequently sold, Christie's, 29th June 1962, lot 30, bought by Maione for 60 guineas).

In addition to the illustrated work, a number of other versions of this type are known, all deriving from the prototype:
1) Petworth House, Sussex, The Egremont Collection (The National Trust).
2) Sold at Lord Wharton's sale, 17th November 1948, lot 16.
3) Listed as belonging to Mrs Sydney Smith (NPG archive).
4) Hartland Abbey, Devon.

30. LADY BRILLIANA HARLEY (1598–1643)

Portrait by Follower of Theodore Russell
Half length, wearing a dress and a pearl necklace
Oil on canvas
76 × 63.5 cm, 30" × 25"

Provenance:
By family descent from the sitter

31. QUEEN HENRIETTA MARIA (1609–69)

Portrait by the Studio of Sir Anthony van Dyck (1599–1641)
Three-quarter length, seated, wearing a blue dress, holding roses, her crown on a table beside
Later inscribed lower right: *Queen Henrietta / Maria*
Oil on canvas
106.5 × 85 cm, 42" × 33½"

Provenance:
San Diego Museum of Art, California, USA

Literature:
Barnes, De Poorter, Millar and Vey, 2004, IV.A.19, p.635

32. GENERAL SIR ARTHUR HESILRIGE, 2ND BARONET (1601–61)

Portrait by Robert Walker (*c*.1599–*c*.1658)
Three-quarter length, standing, wearing armour, his left hand resting on his helmet, his right hand carrying a baton
Inscribed lower left: *Sr Arthur Hesilrige Bart/Son of Sr Thos/1640*
Oil on canvas
124.5 × 99 cm, 49" × 39"

Provenance:
Presumably commissioned by the sitter and by descent at Noseley Hall, until sold, Sotheby's, Noseley Hall sale, 28th September 1998, lot 14, when acquired by the National Portrait Gallery

Exhibited:
Leicester, 1937, no. 22

Literature:
Nichols, Vol. II, Part II, p.750 (as hanging in the Drawing Room)

A reduced half-length version of this portrait is recorded in the NPG archives. A three-quarter length portrait of the sitter, probably painted by a follower of Walker, was sold at Christie's, 12th April 1940, lot 38, and again on 7th October 1981, lot 151.

33. RALPH HOPTON, 1ST BARON HOPTON OF STRATTON (1598–1652)

Portrait by a Follower of Sir Anthony van Dyck
Three-quarter length, seated, wearing black robes, and the ribbon of the Order of the Bath
Later inscribed lower right: *Ralph / Lord Hopton. / Friend of Chillingsworth / See L. Clarendons History*
Oil on canvas
127 × 103 cm, 50" × 40"

Provenance:
Acquired in November 1987 by the National Portrait Gallery

Literature:
Piper, 1963, p.171

There is a related double portrait of Hopton and his wife also by a follower of Sir Anthony van Dyck, which is dated *Ao 1637*. This portrait was formerly in the collection of Lord Hastings, Melton Constable, Norfolk until it was sold at Sotheby's, 9th July 1997, lot 12.

34. COLONEL JOHN HUTCHINSON (1615–64)

Portrait by Robert Walker (*c*.1599–*c*.1658)
Three-quarter length, standing, wearing armour, attended by a page
Oil on canvas
127 × 101.5 cm, 50" × 40"

Provenance:
Private collection

Exhibited:
Worcester, 1951, no. 51;
London, 1960/61, no. 18

Literature:
Whinney and Millar, 1957, p.77

35. LUCY HUTCHINSON (1620–81)

Portrait by Robert Walker (*c*.1599–*c*.1658)
Three-quarter length, seated, attended by a page, holding a laurel wreath
Oil on canvas
127 × 101.5 cm, 50" × 40"

Provenance:
Private Collection

Literature:
Whinney and Millar, 1957, p.77

36. HENRY IRETON (1611–51)

Portrait attributed to Robert Walker
Three-quarter length, standing, wearing armour, holding a baton in his right hand, a tented encampment beyond
Oil on canvas
127 × 101.5 cm, 50" × 40"

Provenance:
By descent to Elizabeth Ireton, eldest daughter of the sitter and granddaughter of Oliver Cromwell, who married Thomas Polhill;
By descent to Charles Polhill, by whom exhibited in 1866, and by descent to his daughter, Beatrice Mary, on whose husband's death the work was sold, Christie's, 19th December 1913, lot 149, re-acquired by Robert Brownhill Polhill Drabble for £205-15-0;
Anon. Sale, 21st November 1945, lot 77, where acquired by the National Portrait Gallery

Exhibited:
London, 1866, no. 789

Literature:
Collins Baker, 1912, Vol. I, p.109
Piper, 1963, p.175

A three-quarter length version of inferior quality hangs in the Shakespeare Institute, Stratford (presented in 1960 by the Reverend F.H. Hodgson, Clopton House), and a half-length version hangs at Petworth House.

37. MAJOR-GENERAL JOHN LAMBERT (1619–83)

Portrait by Robert Walker (*c*.1599–*c*.1658)
Both three-quarter length, standing, wearing armour and red cloaks, Cromwell holding a baton, a cavalry unit beyond
Oil on canvas
138.5 × 164 cm, 54½" × 64½"

Provenance:
Presumably commissioned by the sitter;
Possibly sold in 1660 when Lambert's home, Wimbledon Manor House, was sold;
The Earls of Bradford, Weston Park, by whom possibly acquired at the above sale;
Anon. sale, Christie's, 22nd November 1974, lot 108, bought for 600 guineas by Reynolds;
Anon. sale, Sotheby's, 6th July 1983, lot 220, bought for £12,000 by the present owner;
Offered for sale, Sotheby's, 7th July 2016, lot 114

Literature:
Buckridge, 1754, p.434;
Pilkington, 1770, p.683;
Walpole, 1849, Vol. II, p.421;
Collins Baker, 1912, Vol. I, p.107;
Piper, 1963, p.92

A portrait of John Lambert standing alone, without the figure of Cromwell, hangs at Skipton Castle, and another is recorded as being at Eshton Hall, Gargrave, Yorkshire, in the collection of Walter Scott Bradford.

38. ARCHBISHOP WILLIAM LAUD (1573–1645)

Portrait by Sir Anthony van Dyck (1599–1641)
Three-quarter length, standing, wearing Convocation Dress
Oil on canvas
121.6 × 97.1 cm, 47¾" × 38¼"

Provenance:
The Fitzwilliam Museum, Cambridge

Literature:
Barnes, De Poorter, Millar, and Vey, 2004, IV.153, pp.549–50

39. WILLIAM LENTHALL (1591–1662)

Portrait by Edward Bower (fl. 1635–67)
All full length in an interior
Oil on canvas
244 × 270 cm, 96" × 106"

Provenance:
Presumably commissioned by the sitter and by descent in the Lenthall family at Burford and Besselsleigh Manor, Abingdon, Berkshire, until sold, Sotheby's, 12th November 1997, lot 33

Literature:
Vertue, 1932, Vol. XX, p.62; 1936, Vol. XXIV, p.180; Vol. XXV, pp.9, 135; Piper, 1963, p.202

40. LIEUTENANT-GENERAL ALEXANDER LESLIE, 1ST EARL OF LEVEN (*c*.1580–1661)

Portrait by George Jameson (1589–1644)
Half length, wearing a slashed doublet with a white lace collar
Inscribed upper left: *General Leslie.*
Oil on canvas
70 × 60 cm, 27½" × 23½"

Provenance:
Marquess of Lothian, by whom bequeathed in 1941 to the Scottish National Portrait Gallery

41. SIR CHARLES LUCAS (1613–48)

Portrait by William Dobson (1611–46)
Half length, wearing armour and a red sash with a silver fringe
Inscribed centre right: *Sr: Charles Lucas. / 1645*
Oil on canvas
94.5 × 78.5 cm, 37¼" × 30¾"

Provenance:
Presumably commissioned by the sitter and by descent to Philip Yorke, 1st Earl of Hardwicke (1690–1764);
Thence by descent to Lady Lucas, by whom offered for sale, Christie's, 16th November 1917, lot 42;
By descent to the present owner

Exhibited:
London, 1983–84, no. 43

Literature:
Vertue, 1936, Vol. XXIV, pp.105, 165;
Spencer, 1937, no. 22;
Whinney and Millar, 1957, p.87

A copy of this portrait was made by John Lewis Reilly in 1899 and now hangs in Moot Hall, Colchester.

42. COLONEL SIR THOMAS LUNSFORD (*c*.1610–*c*.1656)

Portrait by the Circle of John Hayls
Full length, standing, wearing a leather jerkin and a breastplate, holding his baton of office
Inscribed lower left with the identity of the sitter
Oil on canvas
214.6 × 137 cm, 84½" × 54"

Provenance:
Presumably commissioned by the sitter and by descent to his brother-in-law, Richard Neville of Billingbear;
Presumably thence by descent to Richard Neville-Aldworth, 2nd Baron Braybrook, who inherited Audley End;
Thence by family descent

43. EDWARD MONTAGU, 2ND EARL OF MANCHESTER (1625–72)

Portrait by Sir Peter Lely (1618–80)
Three-quarter length, standing in a landscape, wearing a cuirass and a jerkin, holding a baton
Oil on canvas
125.7 × 100 cm, 49½" × 39½"

Provenance:
Commissioned by the sitter and by descent to Alexander Montagu, 10th Duke of Manchester, by whom, in 1950, the portrait was presumably sold to Kimbolton School

Literature:
Piper, 1963, p.215 (as attributed to Lely)

44. PRINCE MAURICE, COUNT OF THE PALATINE (1621–52)

Portrait by William Dobson (1611–46)
Half length, wearing a leather jerkin and a breastplate
Oil on panel
67 × 60 cm, 26½" × 23½"

Provenance:
Traditionally said to have been given by the sitter or his brother, Prince Rupert, to Colonel William Legge, grandfather of the 1st Earl of Dartmouth and thence by descent

Exhibited:
Worcester, 1951, no. 5;
London, 1951, no. 9;
London, 1983–84, no. 37

Literature:
Harding, 1804, Vol. II, 292

45. SIR JOHN MENNES (1599–1671)

Portrait by Sir Anthony van Dyck (1599–1641)
Half length, wearing a tunic, a cuirass and a sash
Formerly inscribed upper right in the script used on portraits in the Clarendon Collection: *SIR IOHN MINNS*
Oil on canvas
107 × 80 cm, 42" × 31½"

Provenance:
1st Earl of Clarendon;
Thence by descent to Charlotte, granddaughter of the 4th Earl, who married the 1st Earl of Clarendon of the second creation;
Thence by descent until sold, Sotheby's, 8th December 2010, lot 16 (sold for £690,850)

Exhibited:
London, 1866, no. 663;
London, 1900, no. 78;
Plymouth, 1954, no. 22

Literature:
Barnes, De Poorter, Millar, and Vey, 2004, IV.165, p.558

Copies of this work are in the National Maritime Museum and in the NPG (formerly in the collection of the Earl of Sandwich at Hinchingbrooke, erroneously inscribed Ireton).

46. JAMES GRAHAM, MARQUESS OF MONTROSE (1615–90)

Portrait by William Dobson (1611–46)
Half length, wearing armour, a statue of Minerva on a stone ledge in the background
Later inscribed lower left with the identity of the sitter
Oil on canvas
82 × 88 cm, 32¼" × 34¾"

Provenance:
Presumably commissioned by the sitter and thence by descent in the family until sold, Sotheby's, London, 3rd July 2013, lot 5 (sold for £362.500)

Literature:
Napier, 1856, Vol. I, appendix pp.vii–xi, vol. II, reproduced as the frontispiece;
Walpole, 1849, Vol. II, p.353;
Vertue, 1930, Vol. XVIII, p.123, and 1936, Vol. XXIV, p.50;
Millar, 1984, p.52

Exhibited:
Glasgow, 1911;
Glasgow, 1938;
Worcester, 1951, no. 6;
London, 1951, no. 10;
London, 1983–84, no. 14

47. COLONEL RICHARD NEVILLE (1615–76)

Portrait by William Dobson (1611–46)
Three-quarter length, wearing a buff coat, cuirass and red sash, a rock carved with a relief of Mercury rousing Mars beyond and in the distance a cavalry charge
Oil on canvas
114 × 91.4 cm, 44¾" × 36"

Provenance:
Presumably commissioned by the sitter;
Thence by descent to the Hon. Robin Neville, Audley End, from whom it was purchased in 1981 by the National Portrait Gallery

Exhibited:
British Institution, 1817, no. 32 (as Lucas);
London, 1951, no. 8 (as Lucas);
Royal Academy, 1956–57, no. 77 (as Lucas);
London, 1970 (as a cavalry officer);
London, 1983–84, no. 20

Literature:
Sir William Musgrave, British Library, Add.Mss 6391, f.6r;
Walker, 1873, pp.23–24

Although formerly identified as Sir Charles Lucas, this portrait is believed to represent Colonel Neville. A version of this portrait is in the Methuen Collection, Corsham Court and a copy was acquired by English Heritage at the Tyninghame Sale in 1987 which now hangs at Audley End.

48. DAVID LESLIE, 1ST LORD NEWARK (1601–40)

Portrait attributed to George Jameson
Half length, wearing a jerkin, a white lace ruff and a red sash
Oil on canvas, in a painted oval
75 × 61 cm, 29½" × 24"

Provenance:
Anon. sale, Christie's, 4th December 1953, lot 59;
Anon. sale, Dreweatts, 30th May 2012, lot 69

49. WILLIAM CAVENDISH, 1ST DUKE OF NEWCASTLE (1593–1676)

Portrait by Abraham van Diepenbeck (1596–1675)
Full length, on horseback, with Bolsover Castle in the background
Signed lower left: *A.V.Diepenbeeck.F. (AVD in monogram)* and inscribed in the cartouche on the left: *Monseigneur le Marquis a cheval*, beneath the horse in the centre: *Groupades par Le droite*, and to the right of the castle: *Bolsover*
Pen and brush drawing in brown ink with grey wash and touches of white body colour
39.5 × 52 cm, 15½" × 20½"

Provenance:
Bequeathed by Hans Sloane to The British Museum in 1753

Literature:
Hind, vol. II, p.20

A reduced version of this composition was sold at Christie's, South Kensington, 9th July 2001, lot 191.

50. HUGH PETERS (1598–1660)

Portrait by English School, *c.*1650
Half length, wearing black dress and a white collar
Inscribed in a 17th-century script along the top edge: *The Seditius Misleader – Hugh Peters*
Later inscribed along the top edge: *Hugh Peters Chaplain to Oliver Cromwell*
Oil on canvas
75 × 60 cm, 29½" × 23¾"

Provenance:
Queen's College, Cambridge

A drawing which derives from this portrait is in the Sutherland Collection, Ashmolean Museum, Oxford.

51. JOHN PYM (1584–1643)

Portrait after Edward Bower
Half length, wearing a black doublet with tassels and a white collar
Inscribed twice on the reverse of the sheet with the identity of the sitter
Oil on copper
21 × 16.5 cm, 8¼" × 6½"

Provenance:
Owned by the author, by whom sold to the Palace of Westminster

A related portrait is in the National Portrait Gallery, either by or after Edward Bower. This portrait is charged with the sitter's coat of arms.

52. PRINCE RUPERT, COUNT PALATINE OF THE RHINE (1619–82)

Portrait by Gerrit van Honthorst (1592–1656)
Half length, wearing armour and a cloak
Inscribed with the identity of the sitter top centre
Oil on panel
74 × 59 cm, 29¼" × 23¼"

Provenance:
Craven Collection;
Purchased in 1967 by the National Portrait Gallery

Literature:
Judson and Ekkart, 1999, no. 356, plate 247, p.272

53. COLONEL THE HON. JOHN RUSSELL (1620–87)

Portrait by John Michael Wright (1617–94)
Three-quarter length, wearing a buff coat and a sash, resting his right hand on a field drum
Signed centre left above the drum: *Io. MRitus / P. 1659*
Oil on canvas
129 × 107 cm, 50¾" × 42¼"

Provenance:
Probably commissioned by the Countess of Dysart (later Duchess of Lauderdale) and certainly in her and her successors' possession at Ham House since 1683

Literature:
Collins Baker, 1912, Vol. I, pp.184–85;
Waterhouse, 1953, p.108;
Whinney and Millar, 1957, pp.185–86

54. JOHN THURLOE (1616–68)

Portrait by the Circle of Robert Walker
Three-quarter length, standing by a table, wearing black robes and holding a letter
Oil on canvas
127 × 101 cm, 50" × 39¾"

Provenance:
Presumably by descent from the sitter to his daughter, Ann, who married Francis Brace;
Presumably by descent to their son, John Thurloe Brace, who married Anna Maria Harris;
Presumably thence by descent to W.H. Alexander who presented the portrait in 1896 to the National Portrait Gallery, London

Literature:
Piper, 1963, p.344, pl.5f

This portrait is likely to be the source for an engraved portrait of Thurloe by Vertue as well as an eighteenth-century drawing by Bullfinch.

A head and shoulders version of this portrait, lent by Charles Polhill and attributed to 'Old Stone', was exhibited London, 1866, no. 812 (see Collins Baker, 1912, Vol. I, p.109; Piper, 1963, p.344).

An eighteenth-century copy of this portrait by Thomas Ross (fl. 1730–46) is in the Government Art Collection and currently hangs, appropriately, in Vauxhall Cross, the MI6 building (this picture was in the collection of Anne-Maria Copley, née Brace, wife of Godfrey Copley of Sprotborough Hall, Doncaster, by descent until sold, Christie's, London, 20th November 1925, lot 116, bought by Moore; Anon sale, Sotheby's, London, 22nd November 2007, lot 12, from which sale purchased by the Government Art Collection).

55. SIR HENRY VANE THE YOUNGER (1613–62)

Portrait attributed to Gerard Soest
Half length, wearing a black cloak and a white linen collar with tassels
Oil on canvas
76 × 63.5 cm, 30" × 25"

Provenance:
Charles Fairfax Murray, by whom bequeathed to the Dulwich Picture Gallery in 1911

Literature:
Collins Baker, 1912, pp.134 and 155, pl.IID

56. SIR EDMUND VERNEY (c.1590–1642)

Portrait by Sir Anthony van Dyck (1599–1641)
Three-quarter length, wearing armour, holding a baton in his right hand, his helmet on a ledge beside
Oil on canvas
135 × 109 cm, 53" × 43"

Provenance:
Possibly the sitter's son, Sir Ralph Verney, or Margaret, Lady Herbert;
Purchased in 1678 from her estate by Sir Ralph, and thence by descent to Sir Ralph Verney, 1st Bt of the new creation and thence by descent

Exhibited:
Placed on loan at the National Portrait Gallery in 1992

Literature:
Barnes, de Poorter, Millar and Vey, 2004, IV.230, p.608

A second version of this portrait is in a private collection (see Millar, IV.231) which is more finished but lacks some of the delicacy of this work.

57. ROBERT WALKER (*c.1599–c.1658*)

Painted by himself
Half length, wearing a black robe, pointing at a statue of Mercury
Signed: *R. Walker: pict et pinx*
Oil on canvas
75 × 62 cm, 29½" × 24½"

Provenance:
Ashmolean Museum, Oxford

A number of other autograph versions are known:
1) The portrait in the National Portrait Gallery (purchased in 1886).
2) The portrait in the Royal Collection (possibly acquired by Frederick, Prince of Wales 'Walker the painter his head by himself done' and thence by descent in the royal family).
3) The portrait belonging to the Duke of Rutland, Belvoir Castle.
4) The portrait sold at Sotheby's, 23rd November 2006, lot 20.
5) The portrait owned by the author.

58. SIR WILLIAM WALLER (1597–1668)

Portrait attributed to Edward Bower
Half length, wearing black dress and a white collar
Inscribed upper left with a tower and further inscribed: *Windsor 1648 / "1649 / "1650 / "1651* and later inscribed with the identity of the sitter centre right
Oil on canvas
69.9 × 59 cm, 27½" × 23¼"

Provenance:
Presumably commissioned by Commissary-General Lionel Copley and hung at Sprotborough Hall;
Thence presumably by descent at Sprotborough Hall until the Cromwell sale [Mrs Bewicke-Copley successfully laid claim to the dormant barony of Cromwell in 1923], Christie's, 20th November 1925, lot 105;
Acquired in December 1925 by the National Portrait Gallery

Literature:
Piper, 1963, p.368

Another version of this portrait belongs to the Tower family of Weald Hall where the sitter wears armour in place of the plain black doublet and his lawn collar is tied with an elegant black bow. A version of this type was sold at Christie's on 30th May 1947, lot 134. Another version is recorded in the Harcourt Collection, and there is a miniature version at Welbeck Abbey.

59. BULSTRODE WHITELOCKE (1605–75)

Portrait by English School, 1650
Half length, wearing a black coat and a white collar
Inscribed lower left: *Bulstrode Whitclocke / Esquire / one of the Lords Comms / of the Grat Seal: 1650*
Oil on canvas
75.6 × 62.2 cm, 29¾" × 24½"

Provenance:
P. Evans from whom acquired in 1867 by the National Portrait Gallery

Literature:
Piper, 1963, p.376

60. SIR RICHARD WILLYS, BARONET (1614–90)

Portrait by William Dobson (1611–46)
Half length, standing in front of a statue of Minerva, wearing engraved armour and holding a baton, a horse and groom in the distance
Later inscribed lower left with the name of the sitter
Oil on canvas
96 × 76 cm, 38" × 31"

Provenance:
A gift from Mr T. Haywood to Newark Town Hall in 1958

BIBLIOGRAPHY

Bailey, John Eglington, *The Life of Thomas Fuller, with Notices of his Books, his Kinsmen and his Friends*, London: Basil Montagu Pickering, 1874.

Barber, James, ed., *Faces of Discord: The Civil War Era at the National Portrait Gallery*, Washington D.C.: National Portrait Gallery, 2006.

Barnes, S., De Poorter, N., Millar, O., and Vey, H., *Van Dyck: A Complete Catalogue of the Paintings*, London: Yale University Press, 2004.

Barratt, John, *The Battle of Marston Moor 1644*, Stroud: History Press, 2008;

Beckett, R.B., *Lely*, London: Routledge & K. Paul, 1951.

Bickley, Francis, *The Cavendish Family*, London: Constable & Company, 1911.

Braun, H., *Gerard und Willem van Honthorst*, Göttingen, 1966.

Bray, William, ed., *Diary and Correspondence of John Evelyn, F.R.S.*, London: Routledge & Sons, 1906.

Brejon De Lavergnee, A., Foucart, J., Reynaud, N., *Catalogue Sommaire illustre des Peintures du Musée du Louvre, Ecoles Flamande et Hollandaise*, Paris: Editions des Réunion des Musées Nationaux, 1979.

Brown, Christopher, *Van Dyck*, Oxford: Phaidon, 1982.

Buchan, John, *Montrose – A History*, London: Nelson, 1928.

Buckridge, Bainbrigg, 'An essay towards an english school of painting', in R. de Piles, *The art of painting with the lives and characters of about 300 of the most eminent painters*, 3rd edition, London: Thomas Payne, 1754.

Bulstrode, Sir Richard, *Memoirs and Reflections*, London: Charles Rivington, 1721.

Burnet, Bishop Gilbert, *Bishop Burnet's History of his Own Time: From the Restoration of King Charles the Second to the Treaty of Peace at Utrecht, in the Reign of Queen Anne*, London, 1850.

Carlyle, T., ed., *Oliver Cromwell's Letters and Speeches*, London: Chapman & Hall, 1870.

Cattermole, Rev. Richard, *The Great Civil War of Charles I and the Parliament*, New York, Vols I and II, 1845.

Chaney, E. and Worsdale, G., *The Stuart Portrait: Status and Legacy*, Southampton: Southampton City Art Gallery, 2001.

Chisholm, Hugh, ed., *Encyclopaedia Britannica*, 11th edition, Cambridge: Cambridge University Press 1911.

Clarendon, Edward Earl of, *State Papers*, London, 1786.

Clarendon, Edward Earl of, *Characters of Eminent Men in the Reigns of Charles I and II*, Faulder, R., ed., London: Faulder, 1793.

Clarendon, Edward Earl of, *The History of the Rebellion and Civil Wars in England*, Vols I–VIII, Oxford: Clarendon Press, 1826.

Clarendon, Edward Earl of, *Selections from the History of the Rebellion and Civil Wars and The Life by Himself*, G. Huehns, ed., Oxford: Oxford University Press, 1955.

Coke, Roger, *A Detection of the Court and State of England During the Last Four Reigns and the Interregnum*, London: A. Bell, 1697.

Collins Baker, Charles Henry, *Lely & the Stuart Portrait Painters*, 2 vols, London: P.L. Warner, 1912.

Collins Baker, Charles Henry, and Constable, W.G., *English Painting of the Sixteenth and Seventeenth Centuries*, Florence: Pegasus Press, 1930.

Cooper, John, *Oliver the First, Contemporary Images of Oliver Cromwell*, London: National Portrait Gallery, 1999.

Dalton, Charles, ed., *English Army Lists and Commission Registers 1661–1714*, London: Eyre & Spottiswode, 1892.

Davies, James, *John Forster, A Literary Life*, Leicester: Leicester University Press, 1983.

De Beer, E.S., ed., *The Diary of John Evelyn*, London: Everyman's Library, 2006.

Du Fresnoy, C.A., *The Art of Painting*, translated into English by Dryden, J., with: 'A Short Account of the Most Eminent Painters, both Ancient & Modern' by Richard Graham, London, 1695.

Duleep Singh, Prince Frederick, *Portraits in Norfolk Houses*, Vol. II, Norwich: Jarrold & Sons, 1925–26.

Evans, Martin Marix, *Naseby: The Triumph of the New Model Army*, Oxford: Osprey Publishing, 2007.

Everett Green, Mary Anne, ed., *Letters of Queen Henrietta Maria Including her Private Correspondence with Charles the First, Collected from the Public Archives and Private Libraries of France and England*, London: R. Bentley, 1857.

Fanshawe, H.C., ed., *The Memoirs of Ann Lady Fanshawe*, London: John Lane, 1907.

Farr, David, *John Lambert, Parliamentary Soldier and Cromwellian Major-General, 1619–1684*, Rochester, NY: Boydell Press, 2003.

Finberg, A.J., 'A Chronological List of Portraits by Cornelius Johnson', London: *Walpole Society*, Vol. X, 1922.

Foskett, Daphne, *Samuel Cooper 1609–1672*, London: Faber, 1974.

Foster, J.J., *Samuel Cooper*, London: Dickinsons, 1914.

Fraser, William, '*The Melvilles – Earls of Melville and The Leslies, Earls of Leven*', 3 vols, Edinburgh, 1890.

Fuller, Thomas, *The Worthies of England*, London: George Allen & Unwin, 1952.

Gardiner, S.R., *History of the Great Civil War, 1642–1649*, 2 vols, London: Longman, 1894–1903.

Garlick, Kenneth J., 'A Catalogue of the Pictures at Althorp', London: *Walpole Society*, Vol. XLV, 1974–76.

Goke, R., *Studien zum Künstlerbild des 17 und 19 Jahrunderts in England*, 1999.

Granger, James, *A Biographical History of England*, London: William Baynes and Son, 1824.

Gregg, Pauline, *King Charles I*, London: Dent, 1981.

Guizot, M., *Richard Cromwell and the Restoration of Charles II*, London: Bentley, 1856.

Harding, G.P., *List of Portraits … in Various Mansions* (mss in National Portrait Gallery Archive), 1804.

Hastings, M., *Montrose, The King's Champion*, London: Gollancz, 1977.

Henning, B.D., *The History of Parliament: The House of Commons 1660–1690*, Vol. III (Members M-Y), London: Published for the History of Parliament Trust by Secker & Warburg, 1983.

Herrick, Robert, *Hesperides*, London: John Williams, 1648.

Hind, Arthur Mayger, *Catalogue of Dutch and Flemish Drawings preserved in the Department of Prints and Drawings in the British Museum*, 4 vols, London: British Museum Press, 1915

Holme, C. and Kennedy, H., *Early English Portrait Miniatures in the Collection of the Duke of Buccleuch*, London, 1917.

Hoogsteder, W.J., *De Schilderijen van Frederik en Elizabeth Koning en Koningin van Bohemen*, Volumes I–III, Utrecht: W. J. Hoogsteder, 1986.

Hutchinson, Lucy, *Memoirs of the Life of Colonel Hutchinson*, Hutchinson, Rev. Julius, ed., 10th edition, London: H.G. Bohn, 1863.

Jaffe, M., 'Van Dyck Studies I: The Portrait of Archbishop Laud', *The Burlington Magazine*, No. 955, London, October 1982.

Judson, J.R. and Ekkart, R.E.O., *Gerrit van Honthorst 1592–1656*, Doornspijk: Davaco, 1999.

Kelsey, Sean, *Inventing a Republic: The Political Culture of the English Commonwealth 1649–1653*, Manchester: Manchester University Press, 1997.

Ketton-Cremer, R.W., *Norfolk in the Civil War, A Portrait of a Society in Conflict*, London: Faber, 1969.

Knoppers, Laura Lunger, 'The Politics of Portraiture: Oliver Cromwell and the Plain Style', in *Renaissance Quarterly*, Vol. 51, 1998.

Laing, David, ed., *The Letters and Journals of Robert Baillie*, Edinburgh: Bannatyne Club, 1841.

Lewis, Thomas Taylor, ed., *Letters of the Lady Brilliana Harley, Wife of Sir Robert Harley, of Brampton Bryan, Knight of the Bath*, London: Camden Society, 1854.

Lilburne, John, *Liberty Vindicated Against Slavery*, London, 1646.

Lilburne, John, *The Legall Fundamentall Liberties of the People of England*, London, 1649.

Lodge, Edmund, *Portraits of Illustrious Personages of Great Britain, with Biographical and Historical Memoirs of Their Lives and Actions*, London, 1850.

Long, B., *British Miniaturists*, London: Geoffrey Bles, 1929.

Ludlow, Edmund, *The Memoirs of Edmund Ludlow, Esq; Lieutenant-General of Horse in the Army of the Commonwealth of England 1625–1672*, edited with appendices of letters and illustrative documents by C.H. Firth, MA, 2 vols, Oxford: Clarendon Press, 1894.

Markham, C.R., *Life of The Great Lord Farifax*, London: Macmillan & Co., 1870.

Marshall, A., *Intelligence and Espionage in the Reign of Charles II, 1649–60*, Cambridge: Cambridge University Press, 1973.

Master, Rev. George Streynsham, *Some Notices of the Family Master*, London, 1874.

Mathew, H.C.G. and Harrison, Brian, eds, *Oxford Dictionary of National Biography*, 60 vols, Oxford: Oxford University Press, 2004.

Millar, Oliver, *The Tudor, Stuart and Early Georgian Pictures in the Collection of Her Majesty the Queen*, 2 vols, London: Phaidon Press, 1963.

Millar, Oliver, 'Dobson at the NPG', *The Burlington Magazine*, Vol. 126, No. 970, London, January 1984.

Morton, Charles, ed., *Bulstrode Whitelocke's Journal of the Swedish Embassy*, London, Becket & Hondt, 1772.

Murdoch, J., *Seventeenth-Century English Miniatures in the Collection of the Victoria and Albert Museum*, London: Stationery Office in Association with the Victoria & Albert Museum, 1997.

Napier, M., *Memoirs of the Marquis of Montrose*, Edinburgh, 1856.

Nashe, T., *History and Antiquities of Worcestershire*, 2 vols, London, 1781.

National Maritime Museum (Staff Members), *Oil Paintings in the National Maritime Museum*, Woodbridge: Antique Collector's Club, 1988.

Newman, P.R., *Royalist Officers in England and Wales 1642–1660*, New York: Garland Publications, 1981.

Nichols, J., *The History and Antiquities of the County of Leicestershire*, London, 1798.

Pearson, Karl and Morant, G.M., *The Portraiture of Oliver Cromwell with Particular Reference to the Wilkinson Head*, London: Biometrika Office, 1935.

Peel, Albert, *Oliver Cromwell, England's Uncrowned King*, London: Congregational Union of England & Wales, 1937.

Pilkington, Rev. Matthew, *Gentleman's and Connoisseurs' Dictionary of Painters*, London: T. Cadell, 1770.

Piper, David, 'The Contemporary Portraits of Oliver Cromwell', London: *Walpole Society*, Vol. XXXIV, pp.27–41, 1952–54.

Piper, David, *Catalogue of Seventeenth-Century Portraits in the National Portrait Gallery, 1625–1714*, Cambridge: Cambridge University Press, 1963.

Polwhele, Richard, *Traditions and Recollections: domestic, clerical and literary – in which are included letters of Charles II., Cromwell, Fairfax, Edgecumbe, Macaulay, Wolcot, Opie … and other distinguished characters*, London: John Nichols & Son, 1826.

Poole, R.L., *Catalogue of Portraits in the Possession of the University, Colleges, City and County of Oxford*, Oxford: Clarendon Press, 1912–25.

Powley, E.B., *Temporary Catalogue of the Cromwell Museum in Huntingdon*, Huntingdon: Cromwell Museum, 1965.

Prestwich, Sir John, *Respublica Anglicana*, London: J. Nichols, 1787.

Ramsay, R.W., *Richard Cromwell*, London: Longmans & Co., 1935.

Reynolds, Anna, *In Fine Style: The Art of Tudor and Stuart Fashion*, London: Royal Collection Trust, 2013.

Reynolds, Graham, *The Sixteenth and Seventeenth-Century Miniatures in the Collection of Her Majesty the Queen*, London: Royal Collection, 1999.

Richter, Jean Paul, *Catalogue of Pictures at Locko Park*, London: Bemrose & Sons, 1901.

Royle, Trevor, *Civil War: The Wars of the Three Kingdoms*, London: Little, Brown, 2004.

Rushworth, John, *Historical Collections of Private Passages of State: Volume 1*, London: D. Browne, 1721.

Sanderson, William, *The use of the Pen and Pencil. Or the Most Excellent Art of Painting*, London: Robert Croft, 1658.

Spalding, Ruth, *Improbable Puritan, Life of Bulstrode Whitelocke 1600–1675*, London: Faber & Faber, 1975.

Spencer, B.M., *William Dobson*, MA thesis, University of London, 1937.

Sprigge, J., *Anglia Rediviva*, 1647 (republished Oxford: Oxford University Press, 1854).

Stevenson, Sara, 'Armour in Seventeenth-Century Portraits' in Caldwell, David H., *Scottish Weapons and Fortifications 1100–1800*, Edinburgh: John Donald Publishers, 1981.

Strong, Roy, *The English Icon: Elizabethan & Jacobean Portraiture*, London: Paul Mellon Foundation for British Art, 1969.

Thrush, Andrew and Ferris, John P., eds, *The History of Parliament: The House of Commons 1604–1629*, Cambridge: Cambridge University Press, 2010.

Trollope, Rev. Edward, *Handbook of the Paintings and Engravings Exhibited at Nottingham Illustrating the Caroline Civil War*, London: Henry Sotheran & Co., 1864.

Vertue, George, 'The Notebooks of George Vertue Relating to Artists and Collections in England', London: *Walpole Society*, Volumes XVIII (1930), XX (1932), XXII (1934), XXIV (1936), XXV (1937), XXVI (1938), XXX (1955) and index XXIX (1947).

Vicars, J., *Jehovah-Jireh*, London: For J. Rothwell and T. Underhill, 1644.

Vieth, David, ed., *The Complete Poems of John Wilmot, Earl of Rochester*, New Haven–London: Yale University Press, 2002.

Walker, R.J.B., *Audley End: Catalogue of the Pictures in the State Rooms*, 4th edition, London: Department of the Environment, 1973.

Waller, William, *Vindication of the character and conduct of Sir William Waller, Knight, Commander in Chief of the Parliament Forces in the West: Explanatory of his Conduct in taking up arms against King Charles The First*, London, 1793.

Walpole, Horace, *Anecdotes of Painting in England*, 3 vols, London: Henry G. Bohn, 1849.

Warner, Sir George Frederic, ed., *The Nicholas Papers*, London: Camden Society, 1886.

Warwick, Sir Philip, *Memoirs of the Reign of King Charles I*, London: Longman, 1701.

Waterhouse, Ellis, *Painting in England 1530–1790*, London: Penguin Books, 1953.

Waterhouse, Ellis, *The Collection of Pictures in Helmingham Hall*, Ipswich: W. S. Cowell, 1958.

Waterhouse, Ellis, *The Dictionary of 16th & 17th Century British Painters*, Woodbridge: Antique Collectors' Club, 1988.

Waylen, James, *The House of Cromwell and the Story of Dunkirk*, London: Chapman & Hall, 1880.

Waylen, James, *The House of Cromwell: A Genealogical History of the Family and Descendants of the Protector*, London: Elliot Stock, 1897.

Whinney, M.D. and Millar, O., *English Art 1625–1714*, Oxford: Clarendon Press, 1957.

Wheatley, H.B., *The Diary of Samuel Pepys*, London: 1918.

Whitelocke, Bulstrode, *Memorials of the English Affairs 1625–1660*, 4 vols, Oxford: Oxford University Press, 1853.

Wiles, Margaret, *The Making of the English Gardener, 1560–1660*, New Haven–London: Yale University Press, 2011.

Woodhouse, A.S.P., ed., *Puritanism and Liberty – Being the Army Debates (1647–49)*, London: J. M. Dent & Sons, 1938.

Wornum, R.H., *Anecdotes of the Lives of the Painters*, 3 vols., London; 1888.

EXHIBITIONS

London, British Institution, *Old Masters*, 1817

Manchester, *Manchester Art Treasures Exhibition*, 1857

London, *National Portrait Exhibition*, 1866

Leeds, *Fine Art Exhibition*, 1868

Nottingham, *The Long Gallery Grand Opening Nottingham Castle*, 1878

London, Royal Academy of Arts, *Exhibition of Old Masters*, 1884

London, Grosvenor Gallery, *Exhibition of the Works of Sir Anthony Van Dyck*, 1887

London, Royal Academy of Arts, *Exhibition of Works by Van Dyck*, 1900

Glasgow, *Scottish Exhibition of National History, Art and industry*, 1911

London, 45 Park Lane, *Age of Walnut*, 1932

Leicester, Leicester Art Gallery, *Catalogue of a Coronation Exhibition of Painting*, 1937

Glasgow, Scottish Pavilion, *Glasgow Exhibition*, 1938

London, Tate Gallery, *William Dobson 1611–46*, 1951

Worcester, City Art Gallery, *Tercentenary of the Battle of Worcester: Exhibition of Paintings from 1642 to 1651*, 1951

London, Royal Academy of Arts, *Flemish Art 1300–1700*, 1953–54

Plymouth, Plymouth City Museum and Art Gallery, *Paintings from the Clarendon Collection*, 1954

London, Royal Academy of Arts, *British Portraits*, 1956–57

London, Royal Academy of Arts, *The Age of Charles II*, 1960–61

London, National Portrait Gallery, *Winter Queen Exhibition*, 1963–64

Edinburgh, *British Portrait Miniatures*, 1965

London, Tate Gallery, *Endymion Porter & William Dobson*, 1970

London, Tate Gallery, *The Age of Charles I*, 1972

London, National Portrait Gallery, *Samuel Cooper*, 1974

Edinburgh, Scottish National Portrait Gallery, *Painting in Scotland 1570–1650*, 1975

Edinburgh, Scottish National Portrait Gallery, *John Michael Wright, The King's Painter*, 1982

London, National Portrait Gallery, *William Dobson 1611–46*, 21st October 1983–8th January 1984

Washington, National Gallery of Art, *The Treasure Houses of Great Britain*, 1985

London, British Museum, *Drawing in England from Hilliard to Hogarth*, 1987

London, National Army Museum, *By the Sword Divided: The Civil Wars 1642–1660*, 1992

London, Dulwich Picture Gallery, *Death, Passion and Politics*, 18th October 1995 – 14th January 1996

Edinburgh, Scottish National Portrait Gallery, *Miniatures from the Clarke Collection*, 22nd March – 17th June 2001

Paris, Musée Jacquemart-André, *Van Dyck*, 8th October 2008 – 25th January 2009

IMAGE CREDITS

INDEX OF NAMED SITTERS
